D0848274

Arthur Dove
Nature as Symbol

Studies in the Fine Arts:
The Avant-Garde, No. 49

Stephen C. Foster, Series Editor

Associate Professor of Art History
University of Iowa

Other Titles in This Series

Arthur Dove
Nature as Symbol

by
Sherrye Cohn

UMI RESEARCH PRESS
Ann Arbor, Michigan

Produced and distributed by
UMI Research Press
an imprint of
University Microfilms International
A Xerox Information Resources Company
Ann Arbor, Michigan 48106

Library of Congress Cataloging in Publication Data

Cohn, Sherrye, 1946-
 Arthur Dove: nature as symbol.

 (Studies in the fine arts. The avant-garde ; no. 49)
 Revision of thesis (Ph.D.)—Washington University,
 1982.
 Bibliography: p.
 Includes index.
 1. Dove, Arthur Garfield, 1880-1946—Criticism and
 interpretation. 2. Nature (Aesthetics) I. Title.
 II. Series: Studies in the fine arts. Avant-garde ;
 no. 49.
 ND237.D67C59 1985 759.13 85-5848
 ISBN 0-8357-1666-X (alk. paper)

For Kim

Contents

List of Figures

25. Illustration of lateral root cap, from Katherine Esau, *Plant Anatomy* (New York: John Wiley & Sons, 1960), p. 645.

26. *Long Island,* 1940, oil on canvas, 20″ × 32″, collection of Carl Lobell, New York.

27. *Chinese Music,* 1923, oil on wood, 21 1/2″ × 18 1/8″, Philadelphia Museum of Art, Alfred Stieglitz Collection.

28. Luigi Russolo, *Speeding Automobile,* 1913, oil on canvas, 41″ × 51 1/2″, Musée National d'Art Moderne, Paris.

29. Photograph of shell, from *Scientific Monthly,* vol. 81 (December 1955), p. 287.

30. Photograph of mackerel clouds, from F.H. Ludlam and R.S. Scorer, *Cloud Study: A Pictorial Guide* (London: John Murray, 1957), p. 71.

31. Photograph of sand dunes, from Vaughn Cornish, *Waves of Sand and Snow* (New York: Open Court Publishing Co., 1914), pl. 7.

32. *Sunrise No. 3,* 1936, wax emulsion on canvas, 25″ × 35 1/8″, Yale University Art Gallery, gift of Katherine S. Dreier to the Société Anonyme.

33. *Snow and Water,* 1928, oil on aluminum, 20″ × 27 1/2″, Currier Gallery of Art, Manchester, New Hampshire, gift of Paul and Hazel Strand.

34. *Golden Sun,* 1937, oil on canvas, 13 3/4″ × 9 3/4″, courtesy of a private collection.

35. *Moon and Sea No. 2,* 1925, oil on canvas, 24″ × 18″, Andrew Crispo Gallery.

36. *The Wave,* 1926, oil on wood, 20 1/2″ × 26″, Andrew Crispo Gallery.

37. *Telegraph Pole,* 1929, oil on aluminum, 28″ × 19 7/8″, Art Institute of Chicago, Alfred Stieglitz Collection.

38. Illustration from Claude Bragdon, *A Primer of Higher Space* (New York: Knopf, 1923, 2nd ed.), frontispiece.

xii *List of Figures*

Preface

The purpose of this book is to study the paintings of the American artist Arthur Dove—the implications of his break with representational art and his development of an expressive abstract imagery—in the context of the ideological tradition from which he emerged and the immediate cultural situation in which he worked.

During his own life, Dove's work was consistently reviewed by a small circle of critics who had come under the stimulating and beneficent influence of Alfred Stieglitz—Waldo Frank, Paul Rosenfeld, and Elizabeth McCausland. They wrote glowing, often effusive panegyrics, but without the historical comprehension and visual acuity which the criticism of a new art demands. Since Dove's death in 1946, his art has been treated mainly in exhibition catalogues which provide basic biographical and descriptive data. Most notable are those of Alan Solomon, 1954, Frederick Wight, 1958, and Barbara Haskell, 1975. Just last year an excellent *catalogue raisonné* with an accompanying essay by Ann Lee Morgan was published which documents the full breadth of this artist's achievement. However, because none of these authors has examined the specific character and content of individual paintings as they developed throughout the course of Dove's life, important aspects of the iconography and its relation to significant cultural events remain unexplored.

The want of scholarly attention to Dove's work can be explained by several factors. First, much of the writing on American art has been characterized by an anecdotal tone which emphasized biography above formal and thematic analysis. Second, the prevailing view of this artist as the simple innocent living in bucolic harmony with the sun and soil has hindered the recognition of his intellectual concerns. Third, Dove had a deep reserve, a reluctance to publicize his most personal beliefs for fear that exposure would travesty their importance. Finally, the view of Dove as a "revolutionary" tends to obscure the genuine nature of his accomplishment. As historical perspectives lengthen, modernism itself no longer appears the revolution it once did. Its continuities with the past become increasingly clear.

There is a need, then, to examine Dove's oeuvre—its content and context—in a more probing way. In the light of recent scholarship on early twentieth-century art and new evidence which illumines Dove's artistic intentions, it is possible to understand his achievement according to the goals he established for himself. Far from being the innocent naif that his contemporaries liked to imagine, he was a literate, thoughtful individual who consciously pressed towards a deeper understanding of himself and his relation to the world around him.

My sources for this study have been the large body of correspondence between Dove and Stieglitz which is in the Beinecke Rare Book and Manuscript Library, Yale University, New Haven, Connecticut; the artist's scrapbooks and diaries, also kept at times by his wife, which are on microfilm at the Archives of American Art, Washington, D.C. (hereafter referred to as AAA); the Elizabeth McCausland papers, AAA; and the correspondence between Dove and Duncan Phillips which is owned by the Phillips Collection, Washington, D.C. Especially helpful were the artist's unpublished writings— essays, fragmentary notes, poems—which were, at the time that I used them, in the possession of the artist's son, William Dove, but which have since been given to the AAA. The epigraphs come from this body of material, and in the notes it will be referred to as "Dove's writings." William Dove and Sue Davidson Lowe were kind enough to grant me interviews and answer numerous questions throughout the course of my research. I am grateful to the museums, galleries, and private collectors who granted reproduction rights. For the few works mentioned which are not reproduced, the list number from Morgan's *catalogue raisonné* has been provided (e.g., M.34.16).

This study will focus first on the ideological tradition of Romantic thought from which Dove emerged, for it is only by perceiving this larger connection with the past that the distinctive character of his historical achievement can be understood. Succeeding chapters will explicate how Dove's art is firmly rooted in the more immediate contexts of his intellectual concerns: science, occult religion, the quest for a national identity by American artists, and the challenge of European art.

Dove's oeuvre, like modernism itself, is syncretic, with multiple levels of correspondence and intrinsic allusions which are deeply interdependent. For this reason, it seemed best to avoid the strictly chronological approach, which is more commonly used, in order to isolate the individual threads which combine to make the unique texture of his art. My goal has been to illustrate the personal flavor he brought to the range of ideas with which he was concerned, and to elucidate the creative unity of their pictorial expression. Although diverse sources and influences inform Dove's work, a distinctive identity prevails, issuing from his highly personal response to the world and his lifelong reverence for nature.

Living in the first half of the twentieth century, Dove was very much caught up with the most important intellectual and artistic concerns of his time. His goal, indeed special accomplishment, was to create an art that was modern yet grounded in ideals of enduring, universal value; that was American yet equal to the challenge of Europe; that could accommodate his belief in science and also his need for spiritual faith. How his particular, dialectical vision took form in art is the subject of this book.

Acknowledgments

With gratitude, I would like to acknowledge the assistance of several people who were important to the realization of this study. Mr. William Dove, the artist's son, gave generously of his time and permitted me access to his collection of unpublished writings. Without his cooperation this project would not have been. Sue Davidson Lowe, daughter of Dove's closest friend and grandniece of Alfred Stieglitz, was also kind enough to meet with me and share her observations on Dove and the Stieglitz circle. Within the Department of Art and Archaeology, Washington University, I am indebted to Sidra Stich for her broad vision, sound critiques, and wise counsel and to Lawrence D. Steefel, Jr. for the inspiration and intellectual stimulation he has provided throughout the years and for his encouraging support. *Arts Magazine* graciously allowed me to reprint several sections of this book which first appeared in its pages. Others who assisted in this study are the staffs of the Beinecke Rare Book and Manuscript Library, Yale University, the Archives of American Art and the libraries of Washington University; Ann Lee Morgan; and Mrs. Elsie Dewald. Finally, I would like to thank my husband, Kimble Cohn, for his many kindnesses and his conversation.

Dove and the Romantic Tradition

> I look at nature, I see myself. Paintings are mirrors, so is nature.
>
> Arthur Dove

Nature in the Romantic Tradition

Nature—its forces, laws, and elemental rhythms—was the organizing principle of Arthur Dove's life and the paradigm of his art. It was the source of his motifs and the focus of his theory. It was his medium for thinking about existence. Though his diary entries are fragmentary and laconic, they are filled with statements evidencing his attunement to natural phenomena. Almost every day he recorded the temperature, wind direction, and barometric pressure, a habit he acquired during years of living on a boat. In the back of one diary, he sketched the circular dial of a barometer so that he could abbreviate readings in the daily pages by simply drawing a circle with the appropriate mark on the circumference. He diagrammed the wind currents, "streamers," he called them, coming in off the sea, named the cloud formations, noted a colorful sunrise. He studied the constellations, read books on astronomy, borrowed a neighbor's telescope. In addition he kept a log, his own almanac, recording such phenomena as when the first willow leaves appeared in spring or "the warmest Christmas since 1889," noting the eclipse of the sun, distinguishing between the halo and corona of the moon. Though his remarks tended toward the purely factual—"Full moon tonite with remnants of clouds passing over it"—Dove occasionally burst forth with paeans of praise—"These days are great. Too great." Like a farmer, he looked to nature for portents: "The geese are flying northward. It is a good sign." While he did not usually paint out-of-doors, he would frequently begin a work by going out to look for motifs—as his wife would say, "Arthur's gone prowling"—and perhaps do a small watercolor which he would later transfer onto a larger canvas. This bond, this deep reverential feeling for the natural world, was the wellspring of Dove's art. It determined his distinctive response to the immediate challenge of modernism

and at the same time established the roots of his vision in the traditions of the nineteenth century.

As a first-generation modernist, Dove is frequently viewed as a revolutionary who broke with the past—old forms and old knowledge—after his early exposure to vanguard art. There is, of course, some truth in this standard view. Stimulated by the ideas encountered during his stay in France (1907-9) and later as a member of the Alfred Stieglitz circle in New York, Dove was acutely aware of the latest artistic developments in this country and abroad (fig. 1). He began working in an abstract manner in 1910, when there was little precedent in America for vanguard activity of any kind. In a climate of relative indifference to the arts, he pioneered a mode of expression which would sufficiently encompass his consciousness of the modern world and which served as an important precedent for the next generation of vanguard Americans, the Abstract Expressionists. While Dove's art is then pictorially innovative, informed by the intellectual currents of his day, and a harbinger of the future, it is nevertheless firmly rooted in the past—the immediate American past and the larger Romantic tradition.

Romanticism began in Germany in the late eighteenth century with a small nucleus of idealistic philosophers. It was transmitted to England by way of Samuel Taylor Coleridge and Thomas Carlyle, and to New England by way of Ralph Waldo Emerson, Henry David Thoreau and Walt Whitman. Trancendentalism is Romanticism in its American guise. This philosophy is the belief that nature is formed and informed by spirit; that a leaf or pebble, mountain or star, is a symbol of a greater spiritual reality, both beyond and within; that God not only created nature but is *in* nature as well. It is the authority with which transcendentalism vested the physical world, as fact and symbol, that ultimately distinguished American Romanticism from the European varieties, and Dove's work from that of his European contemporaries.

American art history is discontinuous and derivative in many ways. However, transcendentalism, this implicitly mystical mode of apprehending the world, has provided an enduring tendency in our culture. It received its fullest artistic expression in the landscapes of the Hudson River School, which prefigure in many ways the nature abstractions of Arthur Dove. Although Dove's style was a direct response to vanguard European art, his content—the concept of nature which underlies his abstract form—is directly indebted to this body of work.

In such a characteristic example of Hudson River School art as Asher B. Durand's *Kaaterskill Clove* (fig. 2), nature is rendered as a majestic panorama, seen from above in order to aggrandize the perspective. The mountains are rhythmically layered to mark the progression into deep space, and the foreground has been pushed back from the picture plane to prevent access into

the scene, making it all the more exalted. Nature here is not a setting for human activity or habitation but a primeval paradise uncontaminated by history or civilization. It is vast, solitary, and rife with mythic potential, the perfect embodiment of a pantheistic philosophy.

This now familiar knowledge of the Hudson River School aesthetic must be kept in mind as the proper background for a consideration of Dove's art. Discontinuous as the link may at first appear, his art is rooted in this tradition's Edenic, spiritualized view of nature. While his bold move into abstraction was on one level a refutation of the past (the stronghold of realist painting in America), Dove gives the past (this Romantic vision of nature) new expression in modernist terms.

Kaaterskill Clove is fraught with philosophical implications, but it is also filled with concrete facts. The title refers to a particular spot. The trees can be recognized as pines and beeches. The textural qualities of the bark, foliage, and rocks in the foreground are carefully delineated. In the background, the mountains are shrouded in an evocative mist which implies the time of day and conditions of weather. The painting is both analytic and poetic, specific and mythic, full of physical details which have been imbued with spiritual value.

In her *American Painting of the Nineteenth Century,* Barbara Novak identified this unique polarity in the artist's vision as an essential and characteristic feature of American art. It explains, for example, how later American painters like Fitz Hugh Lane and William Sidney Mount could be attracted to mathematics and mechanical aids in their effort to understand the structure of the physical world and at the same time partake of the contemporary enthusiasm for spiritualism. It explains how Thomas Eakins could be attracted to the medical sciences and one-point perspective and yet create intensely introspective portraits. It explains how Martin Johnson Heade could create landscapes embodying transcendentalist principles and also flower and bird illustrations which won him the praise of natural scientists. As Novak wrote, "This Emersonian blend of reason and faith was the most cogent American solution to the dual need for the real and the ideal."[1] Most significantly, it is a solution which Dove also employed.[2]

As the study of his oeuvre reveals, a dualistic concept of nature provides the underlying dynamics of Dove's art and thought.[3] Nature is both object and presence, fact and symbol, the raw data of physical perception and a mystic organism—marvelous, mysterious, and alive. It is both a scientific construct which can be empirically investigated and the projection of Dove's value-seeking imagination. It is an impersonal physical force indifferent to human existence and also the locus of transcendental truth. Like his nineteenth-century predecessors, Dove sought the pictorial means which could encompass this dualistic concept, but for him these means had to be consonant with the artistic values of the vanguard. To this end, he invented a highly personal style

of painting informed on the one hand by contemporary discoveries in biology and physics and on the other by the literature of the occult. Contradictory as they may appear, science and occultism gave Dove new ways of depicting this hybrid vision. Together they formed the matrix for an abstract, pictorial language which was true to his indigenous ideals and equal to the challenge of European modernism.

Thus, Dove's abstract art was an effort to see beyond appearances to that order of reality where oppositions are reconciled, to break down the barrier between objective fact and subjective value, to realize the ideal inherent in physical nature. From its inception Romanticism has been about the resolution of opposites and it is within this framework that the true character of Dove's art can be understood. Its profound nature-orientation was Dove's direct legacy from the Romantic tradition, and it is this legacy which determined his highly personal adaptation of vanguard innovations. Dove gave enduring and essential patterns of American thought fresh artistic expression. Later chapters will demonstrate the immediate, local shaping causes which determined more specifically the form and structure of his pictures.

A Biography of the Artist

Concerns central to the Romantic imagination were abundant in Dove's life.[4] Son of a well-to-do brickmaker, Dove was born on August 2, 1880 in Canandaigua, New York and grew up in nearby Geneva. He was introduced to painting as a child by a neighbor, Newton Weatherly—truck farmer, woodsman, and amateur artist—whom Dove warmly acknowledged as a formative influence. Writing of Weatherly to Stieglitz, Dove said, "He was like cloth and vegetables and leaves in the woods. He was the finest soul in my life up to you."[5] Weatherly gave Dove scraps of canvas and paint, the two often went fishing together in the Finger Lakes, and it was to Weatherly that Dove attributed his own affinity with nature. As late as 1935, he dedicated a painting, *Holbrook's Bridge,* to this childhood friend.

In 1903 Dove was graduated from Cornell University with a baccalaureate degree in art. In 1904, he married Florence Dorsey, a Geneva woman six years his senior. He spent the next three years doing commercial illustration (like so many American artists before and after him) for popular magazines such as *Scribner's* and *Century.* The work was lucrative but left him little time for art. The paintings that he did eke out are in a diluted Impressionist manner.

At this time Dove was friendly with John Sloan, Ernest Lawson, and other journalist illustrators who later formed "the Eight." He frequented with them such haunts as Moquin's and Café Francis, but he never joined the others in rendering vignettes of urban life, perceiving little difference between these and his commercial magazine work. In the autumn of 1907 Dove and his wife sailed

for France. Their year-and-a-half stay abroad had a critical and lasting influence on Dove's life.

Not only did the European experience introduce Dove to vanguard aesthetics, but it dramatized for him questions of national identity, of historical necessity and of modernism itself—questions with which he was to concern himself for the rest of his life and whose resolution became the basis of his artistic career. Also, it initiated a process of self-conscious comparison between himself and his European contemporaries. Concerned as Dove was with the necessity for personal, indigenous expression, he remained keenly aware of artistic developments in Europe, mainly through Stieglitz and through reading *Cahiers d'Art.*

In Paris Dove met Max Weber, John Marin, and Alfred Maurer, who was to become a lifelong friend. These men were members of the New Society of American Artists which was formed in Eduard Steichen's studio. It was a counter organization to the well-established Society of American Painters which dominated the exhibitions and won the prizes of the American Art Club in Paris. Dove was not a member of either group but he did exhibit one work in the Salon d'Automne of 1908, a vivid Fauvist still-life called *The Lobster.* Kandinsky participated in the same exhibition, but there is no evidence of any interchange between them.

Upon returning to New York in the spring of 1909, Dove spent a month camping out in the woods near Geneva to recover from what he called his "homesickness," to evaluate what he had learned, and to chart, however tentatively, his future course. The works he did on the heels of this experience in 1910 are six small oils, eight inches by ten inches, on composition board, which he called *Abstractions 1–6* (fig. 3). Demonstrating the audacious conclusions he had formed, these paintings are a watershed between the derivative work of Dove's past and the original expression which distinguished the next thirty-five years of his career. They are, however, an immature effort, lacking a clear and well-realized pictorial idea. The forms are roughly defined, the brushstrokes brusque, the color relations uncertain. The oils were not exhibited during Dove's life and may have been conceived as studies. While they do seem to derive from landscape imagery, they demonstrate a decided effort to be free from representation.

By way of Maurer, Dove was introduced to artist-photographer Stieglitz either late in 1909 or early in 1910 and participated in his first American exhibition in March of 1910 at Stieglitz's Fifth Avenue gallery 291 along with Hartley, Marin, Steichen, and Weber. This was the beginning of Dove's lifelong association with the Stieglitz circle, an amorphous, intensely vital group of writers, painters, and photographers who avidly discussed among themselves the current developments in art and ideas. Also, 291 was the only place in America prior to the Armory Show where European modern art had

been exhibited, so Dove's involvement with this gallery served to reinforce his own awareness.

Dove did not remain in New York City long enough to participate very often in the discussions and Saturday soirées at 291. In 1910 he moved with his wife and newborn son, William, to a farm in Westport, Connecticut where he raised chickens to supplement his income. He could have returned to illustration (as he eventually had to do in the 1920s), but he seems to have understood its real antipathy to the creation of serious art and must have feared that it would dissipate his creative energies. So he turned to egg farming, arduous, but offering a lifestyle more in keeping with the needs of his temperament. It was a clear choice and portentous; he realized implicitly the intimate bearing of environment on character. Though New York was only an hour's train ride away, the distance between himself and the city was of important psychological value. The entire course of his life thereafter—as was the case for all members of the Stieglitz inner circle—was lived away from the city, in the isolated reaches of Maine, on the plains of New Mexico, or in rural New York state.

In so doing, consciously or not, they were following a well-established American tradition, one interestingly traced in Morton and Lucia White's *The Intellectuals Versus the City,* where it is stated that "some of our most talented and influential minds have considered the city the *bête noire* of our national existence," because it destroyed the countryside, sacred as it was, and exacted conditions of conformity.[6] And in our literature, from Hector Crèvecoeur to Herman Melville, Nathaniel Hawthorne, Mark Twain, Theodore Dreiser, Henry Adams, William Faulkner, Ernest Hemingway, F. Scott Fitzgerald, Nathaniel West, et al., the city and its moral equivalent, sophistication, have been traditionally represented as a source of evil which lures one away from the pristine innocence of the land.

Living apart from the city became an established pattern for Dove. He needed to be close to the elements to feel alive; he needed the solitude to feel complete. The assimilation of nature to his inner life was an earnest, spiritual necessity. He once lengthily described a harrowing experience of being out all night in his trawler in a terrific storm (reminiscent of J.M.W. Turner's famous account of being roped to the mast of a ship during a blizzard) and concluded by saying, "I seem to need that sort of thing every now and then."[7] In Romantic thought the solitary encounter with nature is an experience which carries great inner authority. It is a way to transcend the limits of the self and partake in a higher order of reality. It is also a means to preserve a sense of mystery in the world and heighten that cherished condition of inwardness. However Dove was certainly not a lonely, Ryderesque hermit, lost in the throes of self-absorption. After all, he was married, exhibiting in New York, and in frequent communication with Stieglitz; and Westport, Connecticut in those years was

an enlightened community whose inhabitants included such like minds as Van Wyck Brooks, Sherwood Anderson, and Paul Rosenfeld. Still, Dove's choice of place and lifestyle do point to a certain value orientation: ten years on a farm, seven on a houseboat, and the remaining years in rural communities. It is a pattern which had less to do with mere circumstance than is usually assumed.

Dove's first one-man show was held at 291 in February 1912 and then traveled to Chicago with Dove following, where it was shown at Thurber's Gallery. Demonstrating a new level of intellectual rigor and craftsmanship, it consisted of a series of pastels which he called *The Ten Commandments*. In these seminal works he devised what he later referred to in his correspondence with Stieglitz and Duncan Phillips as "the idea." This idea was the concept of nature as a living force, rendered in forms which are organic and in a style which is abstract. It was to be, in varying ways, a guiding principle, providing Dove's oeuvre with a degree of coherence rare in the work of early American modernists. Dove once wrote, "One so seldom gets a good breeder idea. Two or three in a lifetime would be enormous."[8] The remark is telling. It demonstrates how this artist perceived the development of his oeuvre in organic terms and links him with the Romantic reliance on biological metaphors. Even near the end of his life, in 1943, he could write Stieglitz that he was doing new work which was "on the line from the first ones shown at The Place...."[9] The idea therefore is not a static, pictorial formula but a realization which grows in its emotive power as the artist matures. Though he would never have reduced its meaning to literal expression, he does in this way acknowledge the existence of a central orientation in his thought.

The decade after Dove's first one-man show in 1912 was generally fallow. His work was either a restatement of motifs used earlier or without clear direction. Burdened by the responsibility of his farm and family, Dove was artistically unproductive. Letters from Stieglitz from this period often say, "Hope you're finding time to paint," to which Dove would respond, "I know you'd like to hear about some new work...." Approximately ten years elapsed before his art showed any significant growth.

In 1919 Dove ended what had been an unhappy marriage and fell in love with a woman painter who also lived in Westport, Helen Torr Weed, who was known as "Reds." By 1920 they were living together on a houseboat, the *Mona*, in the Harlem River. William Dove recalls that the separation of his father and mother was especially bitter.[10] Dove lost all his possessions (except for Stieglitz's letters and back issues of *Camera Work*), even his paints and easel. Also, he was not permitted to see his son. However, living with Reds was the beginning of a new chapter in his life and eventually a fresh effort in his art. At this point, as after his return from France, he was faced with the task of consolidating his sense of himself and redefining his course. In a revealing comment made to Stieglitz in a letter of 1921, he said, "I am trying to develop an ego, red or purple, I don't know which. You will understand."

By 1924, at the age of forty-four, Dove had entered a second phase of artistic activity which developed from the seminal series of 1912 and led into his mature work. It was a highly experimental period. He began a series of collages, "things" he called them, in which he used a variety of nonart materials with often humorous effect. He became more aware of different painting techniques, used various grounds and binders, and began working with egg and casein tempera. He also ground his own pigments and made his own frames.

Though his life was cramped by poverty which forced him to free-lance as an illustrator (a livelihood he grew to despise), it seems to have been a vital time for him. His diaries reveal that he made frequent trips into New York to visit exhibitions and meet with Stieglitz, and that he was reading widely. Though Stieglitz enjoyed perpetrating the idea of Dove's hermitlike existence, Dove was in easy and frequent access to cultural stimuli. As he remarked to Reds in 1929, after they had moved into a new dwelling, "I am as happy here as I've been anywhere."[11]

In that same year the stock market crashed and the Great Depression began. Dove's work had never sold well. He knew he was appealing to a small audience, as he put it, "those with sensitive instruments,"[12] and as the bread lines began to form, his financial situation worsened. Under the pressure of depressing social realities, many American artists backed off from the internationalism which had characterized earlier phases of modernism and turned to American scene painting. Some, like Dove's close friends, Oscar Bluemner and Alfred Maurer, took their own lives.

Stieglitz's friendship and confidence were critical factors in Dove's own survival as an artist. Not only did Stieglitz act as Dove's dealer all those years, but his faith in the artist never wavered. After a meeting with him once at the gallery, Dove wrote, "I enjoyed sitting there with you for the few moments. Loving to love is so scarce."[13]

Another critical factor in Dove's survival during these hard times was the monthly subsidy of fifty dollars which Duncan Phillips, his most loyal patron, began sending in 1930. Though Dove was indeed grateful to Phillips for the assistance, the relation between the two men was polite but strained.[14] They met only once, in 1936, and Dove cordially refused all invitations to Phillips' gallery in Washington, D.C., sensing that he and the wealthy collector would have little in common.

In July 1933, after his mother's death, Dove sold the *Mona* and moved back to Geneva, New York to straighten out the family finances. It was a long, complicated, trying process. His father's brick factory had gone bankrupt and there were numerous debts. Dove remained in Geneva for five years and despite numerous, nagging distractions, some of his finest work comes from this period, work which is rich in content and stylistically mature. Eventually he began to feel oppressed and stultified by the middle-class atmosphere of the

small town. Also the financial strains were great. When the family properties were sold for back taxes in 1938, he and Reds moved to Centerport, New York, making their home in a small, abandoned post office.

It is in this year that Dove began his bout with disease—pneumonia followed by two heart attacks and the complications of a kidney disorder. He did not stop painting but continued to explore new artistic possibilities—all the while living with the knowledge of his gradual demise. During the last four years of his life he was a semiinvalid. His diaries show his increasing preoccupation with his health. His doctor would come by regularly to check his blood pressure. "Pump okay" he would write after a good report. The physical isolation that was forced upon him was paralleled by important changes in his art. The presence of nature, once his lifeline, becomes increasingly remote; geometric considerations govern his style. The paintings he did in the last few months of his life were done with Reds' assistance. He would tell her which color to use and direct her where to move his hand on the canvas. Dove died on November 22, 1946, four months after Stieglitz.

This is the standard knowledge we have of the artist's life. However, there was another, more private side to the man which has eluded recognition and understanding. As stated earlier, the prevailing view of Dove as an untutored innocent, adverse to "book learning" and the like, was encouraged by his contemporaries and to some extent by Dove himself. He was known and loved for his warmth, his sense of humor, and his utter lack of affectation. As his son has written, "True enough, he was a man of the people in many ways, but he kept his art separate from the people he was closest to in other ways."[15] There was a solid core of privacy in this artist; he would not desecrate his most cherished beliefs by subjecting them to casual conversation.

Believing that "too many thoughts spoil an idea," he did not participate in the heated discussions that went on in the Stieglitz galleries or at Lake George. He once wrote of a conversation he had had with Maurer, "Will tell Stieglitz if I have a chance. If it is discussed in the gallery too much by the intellectuals, it will be called a 'theory' or a 'system'. As Bill says, I wouldn't want my love tossed about."[16] Despite his own garrulousness, Stieglitz felt the same way. He absolutely refused to "interpret" the paintings he showed and once commended a friend for "being without theories." It is a position which conforms with the Romantic "we murder to dissect" and the emphasis upon immediate experience.

Moreover, antiintellectualism is a characteristically American tradition which derives on the one hand from the Puritan mistrust of gratuitous ideas and from the egalitarian spirit on the other.[17] Among intellectuals themselves it is a mask. Dove aligns himself with this tradition in works like *The Bessie of New York*, which has a kind of popular humor, *Goin' Fishin'*, a collage of denim and straw which suggests the vernacular idiom, and the satirical

"portraits" of *The Critic* and *The Intellectual.* Indeed, Dove's antiintellectual persona was so successful that it has long diverted attention from the substantive content of his art. However, Dove cared deeply about ideas. He was not given to theoretical exegesis, nor did he have the facility for it. As if his lifelong commitment to the art of painting were not enough, evidence of his more intellectual side is to be found in the list of reading matter which can be culled from the diaries: Bergson, Spinoza, Plato, Patanjali, Dostoevsky, Rilke, Nietzsche, Havelock Ellis, Bertrand Russell, Aldous Huxley, D. H. Lawrence, Cervantes, Emerson, and Jean Cocteau among others. Dove especially admired James Joyce and Gertrude Stein.

Moreover, his intellectual endeavors reinforced a growing spiritual consciousness. Due to a number of influences, Dove became deeply absorbed in the study of Eastern religions and occult literature when he was in his middle forties. In particular, theosophy made a profound impression on him. In his paintings and letters there are explicit allusions to theosophical ideas drawn from the writings of Madame Helena Blavatsky, P. D. Ouspensky, and their American spokesman, Claude Bragdon. Dove found much in the philosophy of this religion which was congenial to his own Romantic temperament and which enriched the expression of his art.

Dove's life was, on the surface, uneventful and marked by few external events. After his initial trip to Europe, he never again left the vicinity of New York. He was going to apply for a Guggenheim Fellowship after Marsden Hartley had been awarded his, but he wrote to Stieglitz, "The place to find things is in yourself and that is where you are."[18] On another occasion Dove was going to travel to New Mexico with Georgia O'Keeffe but again the plans did not materialize. In a letter he wrote to Elizabeth McCausland in December 1934, he said, "So much happens here when nothing is going on outside—just seeking inside," suggesting that exemplary Romantic condition in which interior existence is as rich and real and immediate as anything in the exterior world.[19] It is in this domain that the Romantic quest is fulfilled and to this end, Dove's covenant with nature was enough.

The Dialectic of Art and Nature

One of the primary artistic problems which painters of Dove's generation inherited from their late nineteenth-century predecessors, the Impressionists and Post-Impressionists, was how to represent this dialectic between art and nature. It was the sine qua non of early modernism and how Dove, Kandinsky, Picasso, Klee, Miró, et al. approached this problem is a critical factor in understanding their identities and accomplishments. The solutions to this problem were several. The artist could obviate the tension between art and nature, as the Symbolist and Symbolist-inspired artists did, by making them

separate, independent, and autonomous; he could emphasize the tension between them as the Cubists did with their visual puns and spatial ambiguities; or he could reconcile the opposition by perceiving art and nature to be based on the same laws, as Dove did.

In a letter of 1913 to Arthur Jerome Eddy, a Chicago collector who bought one of his early pastels, Dove made this seminal statement:

> After having come to the conclusion that there were a few principles existent in all good art from the earliest examples we have, through the masters to the present, I set about it to analyze these principles as they occurred in works of art and in nature. [20]

Consciously or not, what Dove was elucidating is an aesthetic concept which derives directly from the German Romantic nature philosophy which had a formative influence on the development of American culture. [21] According to this belief, expounded in the writings of Goethe, Schelling, the Schlegel brothers, and Schiller, there is but one realm of truth which includes both art and nature. Because they derive from the same source, they share the same laws and the same aim. Both are routes to spiritual understanding. Art is meant to mirror the laws of nature, as nature mirrors the cosmos. By making these correspondences visible and their significance known, the Romantic tradition believed it could effect a more complete understanding of life, even its most mysterious aspects. This is what Dove meant in the remark which precedes this chapter, "Paintings are mirrors, so is nature." The centrality of nature to his life and to his art—its themes, imagery, and forms—makes him heir to this tradition.

In a letter to Stieglitz which mentions the log he kept of natural events, Dove remarked, "I suppose the weather shouldn't be so important to a modern painter," acknowledging with appropriate irony the tension he, like many of his contemporaries, perceived between art and nature. To reconcile this tension Dove employed a typically Romantic convention: the organic analogy. It is this analogy which underlies his choice of imagery as well as his theoretical statements on color, line, form, and space. These are the painter's primary pictorial elements which Dove believed are aspects of nature before they are the instruments of art. To Maurice Denis' famous statement, "It must be recalled that a picture before it is a picture of a battle-horse, nude woman or some anecdote—is essentially a plane surface covered by colors arranged in a certain order," Dove would have responded that before colors, lines, and forms become art, they *are* nature, a part of the living universe. [22]

Although Dove was very private about his art, and never revealed the sources which influenced it, he willingly discussed the organic analogy, even using it as a shield to protect his more personal ideas. Neither a formula nor an aesthetic solution, this analogy was a rudder by which Dove steered his course

through the eddied waters of modernism. It enabled him to maintain his own distinctive identity as an artist while assimilating the diverse vanguard influences to which he was exposed throughout his career.

As it derived from Romantic nature theory, this convention assumes that there is an innate correspondence between organic growth and artistic creation. Like a plant, the work of art is vital. It grows spontaneously from a root and unfolds its form gradually outward. As it grows from its native soil, it will inevitably manifest characteristics which are both contemporaneous and national. Similarly, the artist, instead of following preordained rules, heeds the dictates of his own sensibility and creates without deliberate calculations, as does unconscious life. The artist's work achieves the vitality of nature by embodying those principles which characterize the structure and development of nature. Thus, an understanding of nature's inner function and laws was necessary for artistic creation.

Dove's use of the organic analogy meant that he saw his art as directly analogous to the character and quality of living things. As he continued in his letter to Eddy, "One of these principles which seemed most evident was the choice of the simple motif. This same law held in nature, a few forms and a few colors sufficed for the creation of an object."[23] It was a belief which Dove espoused his whole life. Thirty years later he wrote, "I use one, two, three, four or five colors at a time, very seldom five, usually two or three as we see in a natural object.... Trying to use too many colors would be like trying to live with more than one woman at a time.[24] And to Duncan Phillips in October 1946, a month before Dove died, he wrote, "the essence of what I had found in nature was in the motif choice—two or three colors, two or three forms."[25]

Using nature as a paradigm, Dove limited his palette not only in number but in quality as well. After the Fauvist still-life he did in 1908, he never again employed such vivid, antinaturalistic colors. The hues most characteristic of his work are more like crushed berries and roots, moss and lichens, muted, umber tones. Because his style broke with representational art, his color has been mistakenly compared to that of his European contemporaries, the Fauves and the *Brücke* painters, whose use of color was autonomous and determined by the expressive demands of their art.[26] Though Dove rejected the representation of nature's appearances as the basis of his art, he respected, at least in theory, its underlying laws.

Color was therefore the vehicle by which he conveyed his objective knowledge of nature's laws as well as the subjective impression which these laws made upon his imagination; Dove could not conceive of the world apart from his own felt response. On several occasions he used the phrase "condition of light" to express the meanings which color held for him. On the one hand, the phrase referred to the peculiar combination of hues which defines the purely visual character of an object: "a certain red, a certain blue, a certain

yellow...almost spells mallard drake here under the window or raw sienna, black and willow green the willow tree...."[27] On the other hand, the phrase implied Dove's intuitive apprehension of the world. In a letter he wrote for Samuel Kootz's *Modern American Painters,* Dove said:

> There was a long period of searching for something in color which I then called "a condition of light". It applied to all objects in nature, flowers, trees, people, apples, cows. These all have their certain condition of light which establishes them to the eye, to each other, and to the understanding. To understand that clearly go to nature, or to the Museum of Natural History and see the butterflies. Each has its own orange, blue, black; white, yellow, brown, green and black, all carefully chosen to fit the character of the life going on in that individual entity. After painting objects with those color motives for some time, I began to feel the same idea existing in form....[28]

This statement confirms Dove's basically teleological interpretation of natural process. The artist found meaning and beauty in the structure of nature and saw something purposive in organic phenomena which could be used to validate his art. It is a belief he applied in larger terms as well. As he once said, "I still cannot believe that life is an entire accident."[29]

Like color, line too was conceived in terms of the organic analogy. In a 1913 newspaper article, Hutchins Hapgood related the time Dove came into 291 and told Stieglitz that his line had gone dead and that to make it live again, he had to go back to the object, to nature.[30] During the late 1920s, Dove experimented with the innovations of Klee and Kandinsky and used line autonomously in works based on musical motifs, such as *George Gershwin, "Rhapsody in Blue," Part One* (1927). However, it is only when Dove locates his autonomous line in a natural context, as in *Violet and Green* (1928), that he succeeds in his own distinctive way. Even in his late work, as the motif from nature becomes less apparent and the composition more geometric, lines are never ruler straight. They evoke the felt presence of the artist's hand moving across the surface and convey the decided impression of organic growth.

Extending this analogy one step further, Dove sought to endow his painting with its own intrinsic vitality. "To make it breathe like the rest of nature, it must have a basic rhythm," he wrote.[31] More than a pictorial device, rhythm in Dove's art is meant to evoke nature's metabolism, and it could be achieved in various ways: by the repetition of forms and the intervals of space (*Golden Storm*); by interlocking flat shapes of colors of different weights (*Anonymous*); by chromatically ascending waves which suggest movement beyond the frame (*Snow and Water*); or by repeating analogous shapes (*Summer Orchard*). In Cubist compositions this kind of rhyming was intended to reinforce the structural coherence of the picture surface and imply the autonomous existence of art from life. However, the rhythm and unity of Dove's compositions are evocative of nature and natural process. Thus, his

abstract style was not an effort to "liberate" art from nature, but a way to explore its vitalistic essence.

This aspect of Dove's work is often misunderstood. When the artist remarked, as he did on several occasions, "I should like to make a painting exist in itself" and "remind one of no other thing," he was not espousing a credo of artistic autonomy.[32] Rather, he was again making use of the conventional Romantic analogy of art as an organism, having a life of its own, with no detachable meanings, an entity which contains in itself all that is necessary to the experience of it.[33] Unless his statements are viewed in this context, conclusions may be drawn which do not fit the sense of his words.

In Romantic theory, "art which was like nature" and "nature as autonomous life" were two separate ideas which were frequently compared. For example, Goethe wrote that "A work of art must be treated like a work of nature, a work of nature like a work of art, and the value of each must be developed out of itself and regarded in itself."[34] It is a statement which makes full use of the organic analogy, and for Goethe the emphasis is on the word *like*. It is easy to see how the concept of pictorial autonomy developed from this originally Romantic equivalence and how it could be misapplied to Dove. But Dove made it clear which side he was on in 1927 when he addressed a statement he wrote for an exhibition catalogue to the critics of modernism:

> Why not make things look like nature? Because I do not consider that important and it is my nature to make them this way. To me it is perfectly natural. They exist in themselves, as an object in nature does.[35]

This distinction is a subtle one, but on it depends the critical difference between an art that is referential, however abstract it may be, and an art that is autonomous and self-reflexive. On this point depends the balance of Dove's relationship to the art of the past and to the art of the future.

Much of the confusion which surrounds this aspect of Dove's work (the role of nature and the role of purely formal relationships) prevails for two reasons. First, the paintings themselves (as later chapters will show) equivocate between these poles, and second, Dove, not troubled by semantic consistency, tended to conflate his meanings. For example, in a poem written for an exhibition catalogue in 1925, he said, "Works of art are abstract / They do not lean on other things for meaning / The sea gull is not like the sea / That the mountain looks like a face is accidental."[36] Nature, abstraction, and autonomy are employed here as virtually interchangeable ideas. In the art criticism of the early twentieth century, there is the same conspicuous absence of a clearly defined vocabulary; even today the meanings tend to blur.[37] Dove's paintings are abstractions of nature, or as he put it, "extractions" of what he saw as nature's essence. Though it is not always possible to discern the nature-based

motif, suffused as it is by the imagination, it remains integral to the concept, if not the form, of the composition.

Every writer who has tried to define what it is that is distinctive in Dove's work has mentioned his search for "essence," for that irreducible quality which defines the quiddity of some thing. It is a quest which he identified with modernism itself. In a statement he prepared for the 1914 issue of *Camera Work* devoted to the question, "What is 291?" Dove said, "One means used at '291' has been a process of elimination of the non-essential. This happens to be one of the important principles in modern art." And in a letter of 1927 to Stieglitz, he wrote, "It takes a long time to simplify life down, or up, to one thing, especially when one has to live so many of them in one." To simplify, to reach the underlying essence of things, to reconcile opposites in the knowledge that truth is unified, this was Dove's enduring concern. It is an ambition which proceeds from his innately monistic comprehension of life and one which he consciously identified with the Platonic tradition, again in keeping with his Romantic lineage. In the Dove papers at Yale University, there is with the 1913 letter to Eddy a separate sheet which looks like it might have been an enclosure. It contains this passage from the *Phaedo* which Dove transcribed as follows:

> And do we know the nature of the abstract essence?
> To be sure he said.
> And when did we obtain our knowledge? Did we not see equality of material things such as pieces of wood and stone and gather from them the idea of an equality which is different from them? For you will acknowledge that there is a difference. Or look at the matter another way. Do not the same pieces of wood or stone appear at one time equal and at another time unequal?

This passage recurs in Dove's diary of 1925, and in that same year he was reading the works of Plato which he had checked out of the Huntington Library.

In his art Dove was confronted with the problem of how to give iconographic substance to this ideal conception of reality—with pictorial means which would be aesthetically sufficient and historically valid. Though he was certainly influenced by the specific concerns of his intellectual milieu, he had an innate temperamental affinity for that philosophic tradition which strives to see the underlying connectedness of all things. It is an attitude towards reality which is ahistorical and which explains, on one level, Dove's gravitation towards certain kinds of scientific and religious thought. It also illumines his bold move towards abstract art, for the relation between Platonism and abstraction, as Dove conceived it, is implicit.[38]

Dove understood the concept of artistic autonomy, saw it practiced in the work of his European contemporaries, and wrestled with its possible application to his own painting, especially after 1940. From time to time, he

attempted to replace the organic analogy with the musical analogy which was current in his milieu, but such experiments were short-lived. For Dove, paintings were not self-sufficient exercises in color and form, but "mirrors," reflecting his thoughts on the meaning of existence.

Dove and Symbolism

Dove's ideas have so often been attributed to Symbolist aesthetics that one may wonder why it is necessary to go all the way back to German Romantic nature philosophy to find the roots of the artist's vision.[39] It is indeed true that many of the critical discussions which took place at 291 and within the pages of *Camera Work* were deeply indebted to Symbolism. The writings of Benjamin de Casseres, Marius De Zayas, Sadakichi Hartmann, and Charles Caffin stressed the value of subjective response over literal representation, of imagination over logic, suggestion over analysis; and even after *Camera Work* ceased publication in 1917, the writings of Paul Rosenfeld and Waldo Frank, Stieglitz's close associates, continued to espouse the Symbolist credo. When Dove wrote in the Forum Exhibition catalogue of 1916 that he wished to paint "the reality of the sensation" and on another occasion that there "is too much of the intellectual in art these days," he also was expressing his debt to the movement.[40] However, an understanding of Dove's differences from Symbolism does more to illumine the nature of his achievement and to clarify the meaning of his imagery.

These differences become clear when one compares a paradigmatic Symbolist work, such as Odilon Redon's *Vision* (1879) (fig. 4) and Dove's exemplary *Moon* (1935) (fig. 5). On a purely visual level, the two works share certain common features. Both are imaginary renditions in which a ringed, circular form looms out of a dark and suggestively empty space. Both refute quotidian perception, using the objects of the outer world to establish a pictorial equivalence with the inner world. However, their meanings, their fundamental raisons d'être, are markedly different.

In Redon's lithograph, the floating eyeball has been located within an architectural space defined by two large classical columns and seems to orbit towards the small figures of a man and woman in the lower corner. Like the Surrealist art which it anticipates, the composition contains well-defined imagery in an irrational context to suggest those fugitive moments of being which are most frequently encountered in a dream.

In Dove's painting, a lone tree which thrusts up from a low horizon penetrates the womblike rings of the moon and their implicitly erotic union has been emblazoned on a sky of forest green. The moon's light, painted with short, vibrating brushstrokes, pulses outward from a black center and is so effulgent that it obscures the tree's branches and thereby reduces the landscape to the

geometry of lines and circles. To a large extent the power of this painting depends on its seeming artlessness. It shows all the signs of being a spontaneous vision because of its deliberately unstudied appearance. The green ground has been painted in a rough, hurried way; the colors of the moon's rings blur at times, the outlines waver, and yet such features serve to reinforce the immediacy and urgency of this vision. By simplifying the composition to two elements, Dove has amplified its subjective power. He conveys with this spare motif a moment of heightened intensity in which nature is perceived as a mystic organism, breathing and alive. It is less a picture of a moon than it is an epiphanic vision in which moon and tree, phallus and womb, circles and lines, nature and spirit are mystically fused. It is an apprehension which is characteristically Romantic but made peculiarly Dove's own through the use of his highly personal abstract style. Like so many of Dove's works, *Moon* is a rhapsodic celebration of the life-force, mystical and sexual both, which expresses his nearly pagan joy in the world.

Clearly Symbolism was a useful precedent for Dove's conception of art. Its aesthetics gave him the necessary impetus to rebut the realist style which had had such a stronghold on American painters while its art suggested a means of rendering the world with a greater range of feeling and form. However, Symbolism was literally and figuratively a foreign concept.[41] Originally a French literary phenomenon, it represented the effort to express the intricacies and subtleties of psychological existence; its proper province was the self. In Europe it emerged at a time when intellectuals like Henri Bergson and Sigmund Freud were rending the fabric of external reality to explore its subjective content, and while their ideas had a tremendous impact on American culture, the kind of radical subjectivity which prompted their theories simply did not exist in this country.[42] Even though Dove was conscious of personal extension in his art ("I look at nature, I see myself," and "Everything I do is a self-portrait"), his self was less the object of his quest than it was the residue of his empathic, Romantic identification with nature.

To a Symbolist like Redon, art was a means to objectify the vagaries of subjective experience, and nature was the catalyst for private, imaginative perceptions. To Dove, nature was the alpha and omega of artistic creation. No mere conceit, it was the measure of value and the locus of authority. The image, removed from nature and located in art, was more than a means to anchor an evanescent sensation. Its value was innate.

Not merely the escape into exoticism or the abandonment of disciplined reason as its critics charge, Romanticism was conceived as a solution to man's separateness.[43] It was meant to heal the split, that primal fracture, between mind and nature and restore to life a sense of wholeness. In Romanticism, art is not its own end but is meant to redirect our attention to the world and discover value therein. By means of particular themes, imagery and formal structures, it

aims to suggest a deeper, more *felt* relation to life, to effect a unity of being within and without, to evoke that supreme point at which the manifested world connects with its ineffable source. When Dove wrote in his diary in 1943, "work at that point where abstraction and reality meet," he confirmed his perfect consonance with the goals of this ideological tradition.[44]

As a modernist, Dove was committed to finding new ways of depicting nature, but in so doing, he perpetrated the questions and solutions, forms and intentions characteristic of Romanticism. He wanted his art to revivify our response to the world. To this end he invented a pictorial vocabulary of organic forms, painted numerous cosmogonic landscapes and seascapes, continuously turned to solar and lunar imagery, to themes of growth, sexuality, and primitivism. All represent an effort to see the world as new and enter into what Emerson called "an original relation to the universe."

In 1932, Dove wrote, "I have found that subject matter does not matter. It is all the same."[45] Selecting motifs whose power of evocation far transcends their literal form, he sought to elicit the sensation of nature as a living force. He employed subjects and symbols which are natural, and which could remain valid because they are timeless and universal. Frank Kermode has defined the Romantic image as one which is "radiant as truth," having nothing to do with historical circumstance, which is free of fixed content and in which form and meaning are perfectly coincident.[46] He was describing a genre of poetry, but it could as well have been Dove's art.

2

Science: Abstraction's Rationale

The artist says his work is based on "mathematical laws...."
Harriet Monroe

Science as Exemplum for Art

Because Dove's thinking was rooted in the American Romantic past, his art and theories were profoundly committed to nature. However, during his lifetime, the concept of nature had received bold new definition under the impact of significant scientific discoveries. These discoveries prompted him to find new ways of rendering nature in his art. A close study of Dove's oeuvre reveals that his thematic content and formal structure were keenly informed by scientific theory: his conception of organic form corresponds to a central tradition in biology and his treatment of pictorial space reflects ideas of modern physics and higher mathematics. Though Dove is often characterized as a lyrical nature poet who simply transcribed his feeling for the world, he needed the certainties of science as an underlying rationale for artistic creation. It was not simply a matter of transposing facts from one realm to another. Rather, science gave Dove the raw materials for his imagination to imbue with expressive value. It was a means to establish that necessary correspondence between his inward, personal existence and the objective, universal order of reality.

In the early decades of this century, like today, science held great cultural authority. It was a model of reasoned order and a measure of knowledge. For Dove, it was an indispensable means of understanding the world in any complete way. The bearing of science on Dove's art derives from his profound need for a unified knowledge. Being a modern artist (and the epithet was significant for him) meant being au courant, not only on art but on all significant human endeavors. Needing a new approach to nature, Dove found in science an imaginative stimulus which inspired him to paint not nature's appearances, its surface relations, but the invisible forces which give shape to life. In this sense, his art parallels the efforts of science to penetrate the crust of

observable phenomena and reach the underlying structure of physical reality. Moreover, Dove's attraction to science was in keeping with the fullness of his Romantic sensibility, for biology and physics proceed from the same premise as Romantic philosophy—that nature is a totality, ordered and harmonious in its laws, in which the smallest element is inexorably bound up in the structure of the whole. While a coherent vision of life could not be derived from science alone, it could not be had without it.

Reinforcement for this view was readily available to Dove within the Stieglitz circle. Brother of two doctors, Alfred Stieglitz was keenly interested in science. His library included works by Charles Darwin, Albert Einstein, Bertrand Russell, J. B. S. Haldane, and Sigmund Freud among others, and scientific subjects were frequently discussed in his galleries and at Lake George.[1] Also, the criticism in *Camera Work* often justified what it called "the new art" on the grounds that it was scientific. Though Stieglitz exercised no editorial authority to make the articles he published represent a single point of view, the critics, in analyzing the motives of modernism, often used science as a way to reconcile the new art with the art of the past.[2] From the time that Dove returned from Europe until the time of his first exhibition at 291, numerous articles appeared by such writers as Charles Caffin, Marius De Zayas, and Sadakichi Hartmann which celebrated science as a means to reach the fundamental laws of expression, though the articles were never specific enough to say what aspect of science and what manner of expression.

For the most part, the *Camera Work* critics were writing in response to the exhibitions of modern European art which Stieglitz began exhibiting in 1908. Reviewing a show of Paul Cézanne's watercolors, Caffin argued that the Impressionists had failed "because their compositions were inorganic and unorganized," while Cézanne's contribution to art is "that he has tended to intellectualize it. He has pointed the way for placing it on that basis which alone counts today in any department of human activity—a scientific one." The way Cézanne made art more scientific, according to Caffin, was that he

> established as the principle of form in nature that it is based upon the geometric figures of the sphere, cone and cylinder; not, be it noted, on the circle, triangle and square, for they are the figures of surface geometry. It is also noticeable that he omits the cube, probably because he regarded it as a figure of man's constructing and not of nature's.[3]

Thus Cézanne's greatness for this critic lay in his scientific approach to art, his manifestation of the geometry inherent in nature.

Like Caffin, Marius De Zayas, in reviewing the Pablo Picasso exhibition of 1910, said that it is the geometry of the artist's forms which gives them universal appeal and a scientific foundation. The analogy between science and art is central to this theory. In "The Evolution of Form," De Zayas wrote:

Art in its latest manifestation has opened its door wide to Science; it has ceased to be merely emotional in order to become intellectual.... For a long time Science has striven to explain the law governing artistic phenomena, without being able to come even to an acceptable hypothesis. It was not until art felt the powerful influence of the progress of Science that it awoke and broadened its horizon, calling to its aid the resources which science had accumulated. Possibly this only means the absorption of Art by Science.[4]

In another article, De Zayas characterized modern art as "analytical" because

It wants to know the essence of things and it analyzes them in their phenomena of form, following the method of experimentalism set by science, which consists in determination of the material conditions in which a phenomenon appears. It wants to know the significance of plastic phenomena, and accordingly, it has had to enter into the investigation of the morphological organism of things.[5]

As shall become apparent, Dove's interest in organic form is remarkably parallel to De Zayas' equation of modernism with "the morphological organism of things."

In an article called "Structural Units," which bore even more directly on Dove's formulation of his direction, Sadakichi Hartmann wrote that it has been the purpose of all great artists to reflect "the harmonious proportion and movement of nature" and "some big truth underlying natural appearance."

Geometrical shapes formed the intelligent and austere understructure of all arts.... A rhomb, an isosceles, an ellipse are beautiful in themselves.... All great art expressions are extractions, typifications, symbolizations of general laws and apparitions, composite expressions of such concentration and breadth that they reflect unconsciously our noblest emotions about man and his relation to the world.[6]

Again it is suggested that an artist could endow his paintings with scientific validity by relying upon those archetypal, geometric forms which express the inner substance of nature.

Even outside the pages of *Camera Work* the analogy is frequently established. Hutchins Hapgood, Walter Pach, A. J. Eddy, and Willard Huntington Wright all discussed how modern art, like science, is a manifestation of modern life; and just as science must discover new laws of nature, in order to progress, so must art.[7] In fact, Wright, in his *Modern Painting* (1916), mentions Dove specifically as an example of how modern art is scientific, though he does not say in what way.[8]

Thus, in the criticism contemporaneous with Dove's first serious efforts, science was seen as an exemplum for modern art because of its self-critical research and open-ended exploration of possibilities. Geometry was cited as the means of attaining objectivity and endowing art with timeless, universal appeal. By using these instruments, it was believed, the modern artist could

penetrate the appearance of nature, reach its essential core, and put the new pictorial innovations to a purposeful end.[9]

Stieglitz gave Dove his "first one-man show anywhere" in February 1912. It consisted of ten pastel drawings, approximately eighteen inches by twenty-one inches, titled *The Ten Commandments*. Twenty years later Dove cited the importance of these works to his career and recalled "the joy" which they first gave him. These pastels were a decisive turning point. In them he defined the goal by which he would chart his future course: to manifest the hidden mysteries of nature by penetrating the laws and logic upon which it is based.

In March 1912, the exhibition traveled to Chicago where it was exhibited at Thurber's Gallery and widely reviewed in the Chicago papers. Dove was interviewed by several reporters and his remarks shed light on the intention of these works. In the *Chicago Examiner,* March 15, 1912, Effa Webster wrote:

> We confess instantaneous confusion . . . until Artist Dove paints the evolutions of principles in art as he sees them in nature, his artistic eyes tempered by his mental acceptance of absolute forms in conjunction with planes of light. . . . In several of Dove's paintings grouped on one wall, the geometric forms "sensed in nature" are defined in contrasting and harmonious colors. "I don't like titles for these pictures," Dove said, "because they should tell their own story. You can see that forms repeat themselves in various phases of light and that convolutions of form are results of reflections in nature."[10]

Harriet Monroe, in the *Sunday Chicago Tribune* of March 17, 1912, reported:

> At Thurber's is an advanced young radical of the group who scorns "representation" and deals with circles and polygons. . . . The artist says his work is based on "mathematical laws" . . . taking their motives only remotely from nature. . . . Modern minds he thinks, are reaching out toward an art of pure color and form dissociated from "representation."[11]

It is clear that Dove went to Chicago armed with theory much influenced by the criticism of *Camera Work.* Moreover, in saying that his art was based on "mathematical laws" and geometric forms "sensed in nature," he was expressing an idea which was then being widely discussed by scientists and aestheticians alike and which became a primary orientation in his art and thought for the next thirty-five years. It is the idea that nature is based on mathematical proportions which govern the growth process and determine the structure of organic form.

In 1911 Dove was in need of new ways of depicting nature, ways which were consonant with the demands of modernism. The concept of organic form was a brilliant solution to the challenge he faced. It suggested the means to paint not nature's appearance but the laws behind it, those archetypes which lie beneath the multiplicity. It was an idea which satisfied the criterion of the *Camera Work* critics, representing as it did "some big truth," and it was a subject of intrinsic aesthetic value as well.

What gives organic form its artistic appeal and makes it visually satisfying are in fact the same qualities admired in a work of art.[12] There is some regularity in its structure—the repetitions, intervals, and proportions—and immense diversity within the whole. There are a few underlying forms and a glorious array of patterns, textures, colors, and shapes. Order rules over chaos, law over accident, and yet there is freedom within the law. Whether it be a cornstalk or a crustacean, a bird's wing or a hornet's nest, a lily or a lion's claw, organic form is a diagram of the material and mechanical forces which brought it into being. Its aesthetic appeal can be directly attributed to the mathematical principles upon which those forces are based. This idea represents a central tradition in biology—one which grows directly out of German Romantic nature philosophy.[13]

Early in the nineteenth century, this philosophy instigated a course of scientific research in which the concept of organic form, originally a philosophic and literary concern, was applied to the study of living things. The Romantic nature-philosophers and their progeny were searching for ideal, archetypal forms which they believed underlay the chaos of appearances. Idealistic morphology, as their work was called, was given its initial expression in the botanical analyses of Johann Wolfgang von Goethe, Lorenz Oken, and Carl-Gustave Carus; their enthusiasm inspired similar research outside of Germany in the work of Gregory St. Hilaire and William McLeary. As the concept of organic form was validated by the empirical studies of natural scientists, a more precise definition of its meaning was sought. While the Romantic philosophers held that organic life transcended mathematical expression, it was gradually realized that the archetypal forms which had entranced their imaginations were not "ideal" or "transcendental" as they had thought, but were in fact based upon proportions and principles of mathematical regularity. This research was spurred on by the intense debates which ensued after the publication of Darwin's epochal work in 1859. Also, in the 1880s, there were significant advances made in the construction of the compound microscope and in cellular staining techniques which allowed the inner structure of organic form to be better understood. As a result of these discoveries, biology made spectacular progress. Not only was it the science which attracted the most attention and research, but its prestige was an important stimulus to the vitalistic philosophies of Henri Bergson and Wilhelm Ostwald which, in turn, reinforced the development of an abstract art based on biological principles.

The persisting interest in the geometric properties of organic form culminated in the early decades of the twentieth century and provided the supporting intellectual milieu for Dove's development of an artistic concept. In 1911, the year he began *The Ten Commandments,* D'Arcy Wentworth Thompson, the celebrated biologist, wrote, "There never was a time when men

thought more deeply or labored with greater zeal over the fundamental phenomena of living things."[14] More recently, Sixten Ringbom wrote:

> Actually the idea of a new, inner truth to nature as the basis for a future renaissance of the arts was so widespread during the early decades of this century that it is almost impossible to trace the influences in detail.... The biological argument was widely used to defend the abstract propensities of the new art on the premise that the great achievement of our era is biological thought which has revolutionized art and science.[15]

Nevertheless, several sources contemporaneous with Dove's inception of his pictorial vocabulary should be identified.

One of the first to indicate that the forms introduced to science by morphology and microscopy in the nineteenth century have a broad aesthetic appeal was Ernst Haeckel (1834-1919). Heir of Goethe and Oken, Haeckel was the leading exponent of the belief in archetypal form and chief interpreter of Darwinian theory. In 1905, he published *The Wonders of Life*, which was immediately translated into English. It became immensely popular in this country, giving rise to a vast number of reviews and critiques. In it Haeckel said, "Modern science considers the ultimate aim of all research to be the exact determination of phenomena in measure and number or the reduction of all general knowledge to mathematically formulated laws."[16] Moreover, he contended that the "aesthetic study of [organic] forms provides inexhaustible material for the plastic arts" because the "infinite variety of species...may be reduced to a few...fundamental forms;" these archetypes "lie at the root of the real forms both in nature and in art."[17] The text is written with reference to his *Kunstformen der Natur* (1899-1904), which consists of one hundred color lithographs of plants, insects, molluscs, and vertebrates. The line drawings on the tissue overlays emphasize the symmetry and geometric properties of these organisms.

Another work in this vein is J. Bell Pettigrew's *Design in Nature* (1908), a profusely illustrated text which demonstrates the same idea and goes on to say that the dynamic principles in nature are evident in mechanisms as well— screws, gears, trusses. The work is rife with philosophical conclusions about this relationship.

There were numerous articles, too, which treated this idea.[18] The fruition however of the century-long tradition of morphological research occurred in D'Arcy Thompson's *Growth and Form* (1917). This monumental work identified hundreds of correspondences between mathematical laws and organic forms. Quoting Plato and Pythagoras, Thompson contended that, "The harmony of the world is manifested in Form and Number," and that mathematics is therefore the necessary basis of organic morphology.[19]

While most scientists employed intellectual restraint in drawing metaphysical conclusions from this discovery, others were not so cautious. For

those who shared in the Romantic conviction that art and nature are analogous, it had immediate aesthetic applications. Such art theorists as John Ward Stimson, Theodore Cook, Samuel Colman, Jay Hambidge, and Adolph Best-Maugard contended that proportions which govern organic growth should also be applied to artistic composition. In this way, they said, art could achieve universality and unveil the hidden laws of life. Their work has been largely forgotten today but earlier in the century it had a passionate following. As will be discussed, it bears directly on Dove's art.

Thus, throughout the late nineteenth and early twentieth centuries, there was a pervasive tradition which conjoined art and nature on the principles of mathematical law. The concept of organic form held meaning on several levels at once. Scientific research into its nature was much influenced by philosophic assumptions, and the aesthetic theory which grew up around it relied on scientific documentation. This tradition was immensely popular because it attempted to demonstrate what most people wanted to believe—that nature has a purposive order, that entelechy is a part of life.

Geometric Order, Organic Form

Synthesizing his own deep feeling for nature and his milieu's veneration of scientific research, Dove's early works are expressive evocations of the geometric order which lies behind organic form. This is the common ground of art and nature that, as Dove wrote Eddy in 1913, he "set about to analyze," and it represents the "mathematical laws" on which he told the Chicago reporter his art is based. For Dove these laws were assurance, the means by which he could give his abstract art, still a rare and isolated phenomenon in 1911, substantive meaning and pictorial direction. This, he recognized, was the problem with *Abstractions 1-6,* a problem he proceeded to rectify in *The Ten Commandments.*

Some confusion still surrounds this series.[20] The drawings had no titles when first exhibited in New York and Chicago, and there are more than ten works which conform to the same medium and dimensions. Titles were provided at a later date, and because they refer to phenomena in the external world—horses, sailboats, trees—the drawings have been treated as if they were all abstractions of physical objects. The more probable situation is that the compositions inspired the titles. Moreover, these pastels do not have the homogeneity usually found in a series. They are stylistically diverse, conveying the spirit of research and discovery in which they were done. In the course of creating *The Ten Commandments,* Dove not only assimilated the example of European modernism to which he had recently been exposed, but he also evolved a highly original, pictorial concept. Specifically, this concept can be observed in the dynamics he established between nature, geometry, and art.

Because it is a pervasive aspect of his early pastels, discussion need not be limited by the thorny question of which ones were the original ten.

By definition, organic form is that in which the inner structure is propelled outward by internal force and in which outer form must adapt to the exigencies of the environment. Its visual and intellectual appeal lies in its inherent regularity and manifest variety. Organic form is not merely a static configuration of discrete elements, but a totality which is more than the sum of its parts. It contains a geometric structure based on laws which are constant while evidencing the process of growth and change. While it has always been a well-spring of artistic creation, its application varies widely. Analysis of several of Dove's early works will clarify how he used this idea in his art. In *Team of Horses* (fig. 6) the entire picture surface is filled with solidly colored ovoids (in five colors and varied sizes) which have been superimposed in a shallow space. The sloping surface of the large white ovoid in the lower right receives bold emphasis from the row of brown, saw-toothed shapes which become progressively larger according to a logarithmic curve. Although the title has led some writers to see this composition as an image of horses struggling to go forward in snow, Dove's point of departure was not a scene in nature but rather these geometric forms; the title was applied after the fact in response to a reviewer's comment.[21] Still, the drawing does evoke nature with its muted palette of cream, tan, maroon and blue and with the ovoids which are innately biological in character. The logarithmic curves and thrusting contours invoke the instincts of growth while the overlapping shapes create a naturalistic, recessional space. These dynamic patternings suggest at once nature's latent order and procreative force, both form and formation.

The same approach was used in two other drawings of this time. *Nature Symbolized No. 2* (fig. 7) consists of variations on the spiral motif which have been layered in shades of green on a blue ground to appear as if they recede into infinity. The two which are closest to the picture surface have pie-shaped wedges removed. In the lower left corner three of the spirals' tails thrust up from the frame and become progressively larger moving from left to right, while another cluster of these shapes occurs in the upper right corner, adding to the drawing's formal unity. Again, this composition comprises geometric or geometrized elements which allude to the natural world. The spiral formation is recurrent in Dove's oeuvre. Like the ovoid, it is geometric and organic, and its mathematical proportions can be observed in numerous natural phenomena. The closely valued and limited palette and the formal repetitions endow this work with a high degree of order and coherence, traits which were to Dove artistic goals *and* expressions of natural law. *Sails* (fig. 8) employs an inventive variation of these forms—the spirals' tips which have been truncated to look like blades of grass (or wind-filled sails) and the ovoids, shaded on their ends so that the shape within echoes the shape without. Again, they are layered

to suggest spatial recession but are here positioned on a low horizontal line which inevitably creates a more traditional landscape space.

With this pictorial vocabulary, Dove was attempting to simplify the variety and multiplicity of the visible world and extract what is essential and expressive of life. Consequently, the standard juxtaposition between organic and geometric does not apply. He deliberately conflates the two by geometrizing nature and naturalizing geometry. His geometry does not consist of circles, squares, and triangles, "surface geometry" as Caffin called it, but is uniquely, distinctively biological. Suggesting the procreative energies of organic life, it is a geometry of curves which characterize organic forms.

As an art student at Cornell, Dove took courses in the colleges of architecture and mechanical engineering; with this background he would have been familiar with the elementary analysis of geometric configurations.[22] Geometry texts contemporaneous with his first series are filled with illustrations of the mathematical forms, their evolutes, roulettes, and generating curves, similar to those which appear in Dove's art (fig. 9). In addition, elementary geometry seems to have been a topic with broad popular appeal as well. At the same time that *Camera Work* critics were celebrating its universality, *Scientific American* was publishing a weekly column on the practical construction of geometric configurations.[23]

In *Plant Forms* (fig. 10), Dove achieves an expressive equivocation between organic life and geometry with a similar pictorial vocabulary. He renders the highly stylized plants as thrusting ovoids, again layered in progressively larger sizes, long narrow cylinders which project in all directions, and serrated, radial shapes similar to the spiral tips in *Nature Symbolized No. 2*. The junglelike density and close-up focus help suggest the ongoing struggle among competing organisms for light and space.

In his personal card file (which he began in 1932 as a way of keeping track of his work), Dove wrote the following statement about one of the pastels which was the namesake for the series: "Yellow, green and black, circle and angle motif, arithmetical progression (halved) and circles." Although there is some question as to which drawing the statement describes, it indicates how this artist consciously employed mathematics as an underlying pictorial structure while the effect he achieved in his art is one of burgeoning vitality.[24] Geometric shapes were Dove's point of departure, assuring him of structural order in the realm of abstraction, but he colored and composed them to suggest nature's order as well.

This procedure is also evident in *Golden Storm* (fig. 11), a painting of 1925 which continues the idea of the early pastels. Here the geometric motifs are gracefully distended and compressed into a shallow space. The catenary curves and ellipses, like the arched backs of dolphins, are positioned in a measured, almost musical sequence. Their rhythmic repetition along the upper corners

contradicts the angularity of the canvas and creates a sense of continuous, circular motion. The palette is limited to only two colors—metallic gold and matte blue—and the paint is mottled and reflective like sunlight on water. Again the geometric forms provide the basic vocabulary, but through the judicious selection of color, composition, and perspective, the geometry becomes nature-oriented and serves to evoke the insistent rhythms of the sea. The painting's mechanics become subsumed by the sheer lyrical power of the whole.

It is clear from the inventive shapes, the subtle, closely valued colors, the license with scale and proportion, and the irregular perspectives that Dove did not submit nature to rule or measurement. He employed geometry to evoke its inner order and growth process but his methods as an artist were nonmathematical and unscientific. He sensitively balanced organic structure and geometric form with his own intuitive response.

In the 1916 Forum exhibition catalogue, Dove wrote that he wished to paint "the reality of the sensation" and the reflection "from my inner consciousness." On the broadest level, what he aimed to do was to establish a correspondence between nature—its forms and form-giving laws—and his own sensibility. Because he could not conceive of nature apart from his own lived response to it ("I look at nature I see myself"), his work evokes the resonant interaction between the two and demonstrates the imaginative assimilation of the outer world to his inner life. This is what saves his art, given his passion for "abstract essence" and "mathematical laws," from a bloodless rigidity; this is what gives his style, despite extrinsic influences, its vital, highly personal character.

Besides the marrying of nature and geometry, another way in which Dove employed the organic analogy can be seen in *A Walk Poplars* (fig. 12). If one takes the visual cue provided by the title, the dotted yellow stripe which stretches down the center of the canvas looks at first like a sunlit, tree-lined path which has been tilted forward to became parallel to the picture plane. However, if the title is ignored, the stripe can be seen frontally, in section rather than in plan. Along its surface crudely drawn black arcs partially encircle white nodes which become progressively smaller toward the top as branches do on a tree. Viewed in the context of Dove's other organic abstractions, their graduated size and serpentine positions suggest a lively visualization of the law of phyllotaxis—the logarithmic arrangement of leaves on stems and branches on trees which assures the plant of receiving the optimum amount of light and air. Although this law had been known to botanists for some time (fig. 13), it played an important role in the growing body of literature on organic form because it suggests that nature has a purposive order.[25] Moreover, because it demonstrates the universality of logarithmic growth, as seen in a humble stalk of asparagus or a mighty oak, it provided a geometric basis for the

reconciliation of nature and art. Dove's pastel, however, was not intended to "illustrate" phyllotaxis. His lines and circles are not mathematically positioned and lack the graphic exactitude which would be required to make this idea overt. Still, the phenomenon would have qualified as one of those "fundamental truths underlying nature" which could give his abstract art pictorial direction and thematic content.

The imaginative assimilation of science to art can also be observed in the beautiful *Violet and Green* (fig. 14). Here, an enormous, funnel-shaped cloud fills a storm-colored sky and looms portentously over the sea. Across the surface a spiraling black line weaves back and forth upon itself, suggesting the latent power of this natural force and also the frantic flight of a bird which has become caught in its grip. Reinforcing this analogy, Dove said of this work, "flight of sea gull in tornado."[26] While such superimposed, meandering lines have their pictorial precedents in the art of Klee and Kandinsky, the particular pattern Dove employed is virtually identical to a diagram in Theodore Cook's *Spirals in Nature and Art* which illustrates the spiraling motion of a bird's wing (fig. 15). Characteristically, Dove avoided the measured and mathematical regularity of the drawing so as to endow his painting with vitalistic force, but the correspondence between them suggests the artist's innate affinity with the philosophy and aesthetics of organic expression.

Given this orientation, numerous other examples of the organic analogy become evident in Dove's oeuvre. The asymmetric interstices in *From a Wasp* (fig. 16) suggest the patterns of ventriculation seen on the insect's wings (fig. 17). *Snowstorm* (fig. 18) contains a large, pronged form which manifests the logarithmic proportions and biaxial, radial symmetry seen on some leaves and shells (fig. 19). The coiled spiral in *Cow No. 1* (fig. 20) resembles that of a filery fern (fig. 21). The interlocking forms of *Summer Orchard* (fig. 22) seem remarkably like the logarithmic curves seen in goats' and rams' horns (fig. 23), while *Sunrise II* (fig. 24) suggests the cross-section of a plant containing a lateral root cap, a formation of new growth which can be seen in a plant's interior with the aid of a microscope (fig. 25). However, these compositions were not determined by scientific fact but by artistic and expressive considerations. Thus as with all Dove's work, *Sunrise II* is not intended to illustrate but to suggest. It is not "about" lateral root caps, but it is very much about growth, genesis, and the life-force, one of Dove's most significant and pervasive themes. Just as there is no literal application of nature's mathematical laws, there is no systematic use of the biological paradigm. Because he valued his intuitive response, Dove could not conform to a priori formulas. By avoiding a literal content and allowing his art to be expressively ambiguous, he employed organic form as a springboard for his deeply personal meditations on the meaning of nature.

Considering the myriad possibilities of nature motifs there are, it is important to note which motifs Dove chose, time and again, why he chose them, and how he used them in his art. Implicit within every one of the organic analogies listed above is the suggestion of growth based on mathematic laws. Each form demonstrates the idea of periodic progression governed by proportions which remain constant through all phases of change. Significantly, Dove did not choose forms like a flower or a honeycomb which are static and symmetric, but rather those which are dynamic and asymmetric, those which suggest in one self-contained unit both nature's structure and the process of its formation, law and motion, order and invention. These are the tensions which give organic form its visual appeal and which also provoke the larger questions about life's order and purpose which eventually led Dove into the labyrinthine realm of the occult. For if there is law at work in nature's smallest forms, does it not imply law in the cosmos too? Like many of his Romantic predecessors, he believed that it did.

Dove of course was not the first artist to make use of the lively interest in biology. Art nouveau, which has been characterized as a kind of "biological Romanticism," employed rhythmic linear configurations and emergent spatial relations to convey a sense of instinctual energy; its aim was to celebrate the elemental life-force by formulating a universal language which evoked the origin of things.[27] In this sense, Dove was its heir. Although his pictures do not possess the earlier style's sophisticated grace and urbane elegance, they too represent the attempt to formulate a pictorial vocabulary which could be immediately perceived and intuitively comprehended. In a letter recounting how these first works came about, Dove wrote: "Expressing oneself in a universal language is quite a job."[28] As with art nouveau, the organic expression which characterizes Dove's oeuvre stands in direct historical continuity with the efforts of biologists to demonstrate the form-giving principle of life. However, as an American artist recently stimulated by European modernism, he used a singularly different method.

As Dove began to evolve the concept of organic form, exploring the ways in which nature's logic and laws could be utilized in his art, he was working on a theme paralleled in the work of such contemporaries as Kupka, Kandinsky, Klee, Miró and Arp. However, the significant differences among all these artists' oeuvres demonstrate that the organic analogy was not an artistic solution but a point of departure. While Dove rejected nature's appearances as an historically valid basis for art, he respected what he believed to be its underlying laws and sought to endow his painting with the vitality of living things. Though it is not always possible to discern the nature motif, suffused as it is by the artist's imagination, it remained integral to Dove's art—its form and theory.

The Ovoid and the Spiral

For Dove artistic creation was a process of discovery as much as invention. The principles of his art were deduced from those laws which he understood to be operative in the natural world. He accepted the idea that nature expresses itself in a few universal forms which appear in infinite contexts and which undergo a constant process of change. Correspondingly, in his art he developed a pictorial vocabulary using a limited number of forms intrinsic to nature and natural processes—archetypes—which are the organizing principles behind the immense variety in the visible world.

In one of his fragmentary, personal essays Dove wrote:

> The thing has never been done that I should like to do. It must contain all of nature, built on and enveloped in a precisely pure, mathematical dream, wherein the tone and line and spirit create a form in themselves, as one would multiply, subtract and divide whole conditions of existence, the sum of two or three motives, curves so to speak, representing instincts from all of life.[29]

As previously discussed, Dove used the phrase "two or three motives" from nature to describe his approach to the problem of pictorial form. There are indeed several forms which are significantly recurrent in his oeuvre—the ovoid and its variant, the ellipse as well as the spiral, both flat and conic. From these the artist created his "universal language" intended to evoke the essence of nature in a "precisely pure mathematical dream" with curves "representing instincts from all of life." These "two or three forms," which are mathematical and organic, are used by Dove with infinite variation, in all guises and disguises, throughout his thirty-five year career. This continuity was possible because he never wavered from the underlying idea on which these forms were based: in the structure of organic phenomena can be seen the order of nature and a model for art.

Few forms have as many significant associations as the egg—procreation, fertility, birth—and its appearances in mythologies and the history of art are legion. Admired for its simplicity and economy of structure, it has long been considered a biological, mathematical, and aesthetic paradigm. Moreover, it was a form with which Dove became intimately familiar during his ten years as an egg farmer in Westport, Connecticut. The ovoid's relative, the ellipse, is also a mathematical configuration which is frequently found in nature as a demonstration of force in the formation of shells, for example, or the orbit of planets. These forms, ovoids and ellipses, figure prominently in such works as *Team of Horses, Plant Forms, Golden Storm, Tree and Covered Boat, Out the Window, Two Sisters, Golden Sun, Willows,* and *Frosty Moon.* The spiral too recurs in Dove's oeuvre from first to last: *Nature Symbolized No. 2, Red Sun, I*

Saw a Cross in the Tree, October, Portrait of Alfred Stieglitz, Untitled (both collages), Summer Orchard, Willow Tree, Cow No. 1, Variety, and Frosty Moon. However the significance of the spiral is less commonly known and requires a word of background.

As a result of the biological research of the late nineteenth and early twentieth centuries, a great deal of symbolic lore accumulated around the spiral because it was discovered to be a form pervasive in nature—observable in the nebulae of the galaxies, the horns and claws of animals, plant whorls, and numerous molluscs, most famously in the shell of the chambered nautilus.[30] The spiral was also a subject of mathematical fascination, being the only plane curve which can increase in size without changing shape and the width of whose turns increases at a fixed ratio to its length. When the spiral occurs in nature, as in the nautilus, its incremental progressions are based on logarithmic proportions. In this way, the spiral formation gives dramatic demonstration of natural growth based on enduring mathematical laws. For reasons such as these, the spiral acquired great symbolic meaning. It was an emblem of constancy and change, the inner law of vital force. Today we can hardly comprehend the significance attached to this form, but early in the century it held great promise of being visible evidence of nature's invisible unity. Called the "spira mirabilis," it became the focus of numerous aesthetic theories and even ontologies.[31]

One painting which eloquently summarizes the iconographic import these forms held for Dove is the haunting Long Island (fig. 26) of 1940. Here the ovoid and the spiral are the sole protagonists in an empty, primordial sea, illumined by the single spotlight of a pinhead sun. Rising out of the waves like two lonely megaliths of an earlier age, they endow this painting with mythic power. The exaggerated scale and low horizon are used to evoke the sense of primeval mystery while the somber, shadowed sky introduces a subtly elegiac note.

Clearly, these forms occupied an archetypal status in Dove's imagination, representing what he called "the instincts from all of life" and a "precisely pure mathematical dream." Not only did ovoid and spiral come equipped with the appropriate pedigrees, but they were timeless and universal as well. In their structure, they demonstrate the mathematical laws which give nature an aesthetic order, and they are dynamic forms suggestive of the life process itself. In Dove's art they represent the vocabulary of his "universal language."

Because these forms were not, like traditional symbols, part of a larger frame of reference, their use raises the question of communication. To what extent did Dove develop an iconography which was laden with personal significance and esoteric allusion? Referring in a letter to Stieglitz's having retitled his early works Nature Symbolized, Dove wanted to set the record straight and wrote: "Do not let it bother you as to records, etc. They were

'Abstractions' and as such were much like secrets—that is, there are no such things."[32] They were not based on actual physical objects, he seems to be saying, but on the hidden essence, on a certain understanding of how things mean. The forms he used suggest on a purely visual level the meanings and associations he wished to evoke. Even independent of their specific symbolic import, their feel is clear. In a cultural climate in which the old myths and traditional symbols could no longer sustain themselves, many artists found it necessary to find new ones. Dove's use of the ovoid and the spiral was just such an effort. Though he did not invent them, he chose them from the multiplicity of natural phenomena and provided them with a rich artistic context in which they could live.

Force Lines

The organic analogy inspired not only the iconography of Dove's "universal language" but also suggested a significant means of organizing the pictorial structure. Evidencing the acquired confidence of his maturity, the paintings Dove did between the middle 1920s and 1940 are characterized by a new treatment of form and surface which clearly distinguishes them from what came before and after. In these works Dove employed a highly distinctive device to activate and animate the picture plane: vibratory patterns of line, form, and surface which push the image out in all directions, making the canvas seem rife with motion. With this device Dove sought to express not nature's appearances or surface relations, but those invisible forces which give shape to life.

These vibratory patterns have been variously described in the Dove literature. In 1932 Paul Rosenfeld referred to them as "drunken oscillations." In more recent criticism they have been called "resonances, auras and vibrations," "pulsations of energy," and "a Synchromist or Orphist legacy."[33] Dove himself, in several statements written for exhibition brochures, used the expression "force lines." For example in 1927 he wrote: "I should like to take wind and water and sand as a motif and work with them, but it has to be simplified in most cases to color and force lines and substances.... "[34] Although this expression had been given artistic currency by the Futurists, Dove's meaning and pictorial application are his own.

Though most of Dove's early works are abstract, they still retain such traditional devices as overlapping and diminishing size to create the illusion of spatial recession. In such pictures as *Team of Horses, Plant Forms,* and *A Walk Poplars,* solidly colored shapes are superimposed within a shallow space and locked in place by distinct outlines and edges. Describing how these first works came into being, Dove wrote that it had been his intention to render a nature motif "subjectively, that is, by certain shapes, planes of light or character

lines determined by the meeting of such planes."[35] Thus, his effort was to find an expressive pictorial equivalent for the motif, and "character lines" were those contours which best corresponded to its objective *and* subjective presence.

This stylistic approach characterized most of Dove's work until 1920, but within the next couple of years, his art demonstrated an altogether different mode of pictorial construction, one which resulted in some of his most successful pictures, At the same time, in Dove's writings, the expression "character lines" was replaced by the more allusive "force lines." This change in terminology, in conjunction with important alterations in his treatment of the picture surface, suggests that Dove was working under the influence of new ideas—that his focus had shifted from the perception of nature's exterior forms and planes to that which is interior and invisible.

One of the first paintings to incorporate this shift was *Chinese Music* (fig. 27), an important watershed in the artist's oeuvre. Rather than layering distinctly outlined geometric shapes to establish spatial location, Dove here grouped his shapes on the striated ground and used the device which signals this new phase in the evolution of his style: repeated or radiating shapes which are lightly shaded and progressively scaled to suggest gently expansive movement out towards the frame. Within the course of the next fifteen years, the formal and expressive functions of this device were explored, enriched, and expanded to become a key organizing principle in Dove's art. Although this painting does not possess the facture or dramatic dynamism of Futurism, these formal repetitions are clearly reminiscent of the force lines in the art of Giacomo Balla and Luigi Russolo (fig. 28). Inspired by the chronophotography of Jules-Etienne Marey and the faceted structure of Cubism, these artists rendered objects or space in motion as kinetic signs by means of broken contours and repeated linear configurations, and used their "lines of force" to express the shifting relation between objects of the world and the activity of the mind.[36] Though Dove's vibratory patterns had a different thematic purpose, they also serve to endow his picture plane with structural coherence, enliven it with the suggestion of movement and enrich it with metaphorical association.

Defining, then, an important phase of his stylistic development, the vibratory patterns in Dove's art are as pervasive as they are various in their appearance. They can occur as horizontal undulations which fuse land, sea, and sky into a single entity so that the whole surface heaves in rhythmic unison (*Clouds*, 1927), or they can take the form of concentric rings which reverberate like sound waves from a pulsing center (*Fog Horns*, 1929). They may appear as highly linear calligraphic configurations (*Below the Floodgates*, 1930) or as softly modeled, biomorphic forms (*Dancing*, 1934). They may be used to energize a pictorial field which is essentially empty of objects (*Snow and Water*, 1928) or to activate the image within it (*Goat*, 1935). They may be

compartmentalized within the specific shapes (*Fields of Grain Seen from a Train*, 1930). The device is not only graphic. Carefully weighted color contrasts, applied with slight gradations of value, are also instrumental in achieving the effect of motion on a flat surface. These contrasts can consist of subtle variations of a single hue (*Silver Tanks and Moon*, 1929) or a more dramatic progression from dark to light to dark again (*Alfie's Delight*, 1929). Occasionally Dove used the directional axes of thinly applied brushstrokes, dark on a light ground (*Moon*, 1935), to heighten the sense of expanding space. These vibratory patterns, then, provide a new kind of structure for his art. Whatever their chromatic arrangement, they serve to negate depth and direct the movement within the picture out towards the frame. They make the image appear to expand rather than contract, and they prevent the surface from ever being inert. By abandoning the clearly outlined shapes and receding planes in his early pastels, Dove achieved in this new body of work a quality of charged space and an interaction between form and surface which is directly parallel to modern science's concept of nature as an integrated field of force. The comparison is apt.

Although the expression "force line" was given artistic application by the Futurists, it derived originally from the field of physics where it had first been used by Michael Faraday to describe his concept of the electromagnetic field. [37] Under the influence of German idealistic *natur-philosophie*, Faraday began a series of experiments in 1831 to demonstrate that the various forces of nature were all interconnected. [38] By placing a rotating copper disk between the poles of a large magnet, he proved that an electric current could be obtained in a wire extending from the axis of the disk to its edge. Not being a mathematician, he used the expression "lines of force" to describe the reciprocal relation between electricity and magnetism. By the early decades of this century, the concept of nature's force fields was widely disseminated and commonly discussed in popular journals, and because it led to such dramatic discoveries as radio, X-rays and telegraphy, it had a profound impact on the public's imagination. [39]

Besides the Futurists, other early twentieth-century artists put this scientific discovery to artistic use. In *Concerning the Spiritual in Art* (1912), Kandinsky employed it to justify abstraction and wrote that the concept of matter was being replaced by "the theory of electrons, that is, waves in motion." [40] Fourteen years later in *Point and Line to Plane* (1926), Kandinsky again alluded to it in the section entitled "force from within and force from without," where he discussed the perceived tension and attraction which can exist among compositional elements. [41] Also under the impact of these ideas, Paul Klee devised a variety of abstract signs and linear formations to suggest the invisible field of energy which lies behind visible nature. [42] Also, the Constructivists Naum Gabo and Antoine Pevsner attempted to embody this concept in the structural rhythms and interior spaces of their sculpture. [43]

Closer to home, John Marin imposed an armature of perpendicular and diagonal "force lines" upon the translucent spaces of his art to establish centripetal and centrifugal tensions, and wrote of "the 'pull forces' which play with one another; great masses pulling smaller masses, each subject to the other's power."[44]

The idea of force fields attracted the attention of these diverse artists for several reasons. First, this knowledge demanded a change in the imaginative visualization of nature and posed a direct challenge to the traditional methods of representation. Whereas in classical physics, the propositions reflect the structure of the world given by ordinary perception, this discovery offered a world view which is contrary to direct observation and suggested that what we see is partial and illusory—a mere fraction of what is actually taking place. The disparity between appearance and reality, of abiding interest to artists anyway, was thus given dramatic documentation. Second, this knowledge contradicted Positivist assumptions and confirmed the existence of a nonmaterial order of reality which was charged and unified. Third, it offered a scientific rationale for abstraction as a more accurate and more complete representation of that which is real, albeit invisible, in nature. Thus there are meaningful parallels between the scientific discovery of force fields and modernists' probing critique of appearances, their conviction that appearances are changeful and transitory, and their use of abstraction to represent what is essential, enduring, and invisible. The matter of force fields bears directly on the intellectual context in which Dove was working and, on one level, accounts for the stylistic innovations which occur in his art between 1923 and 1940. Having taken a course in experimental physics while he was a student at Cornell University, he was no doubt aware that the expression "force lines" carried scientific connotations; yet the vibratory patterns which characterize his art held other meanings as well.[45]

In a letter of 1930 to the art critic Samuel Kootz, Dove described the evolution of his style and identified these "force lines" with the patterns of growth which are visible in some forms of organic life. "The line at first followed the edges of the plane . . . later it was used in and through objects and ideas as force lines, growth lines, with its accompanying color condition."[46] Similarly, on another occasion Dove wrote, "The force lines of a tree seem to me to be more important than its monumental bulk," here referring to those concentric rings seen in cross-section which are one of the most pervasive features of organic life, occurring not only in the interior of a tree or even a radish (as Dove noted in his diary), but also on the surfaces of shells (fig. 29), the structure of bones and teeth, mackerel clouds (fig. 30), snow drifts and sand dunes (fig. 31), even in the electrical reflex discharges which monitor metabolic processes.[47] These all manifest the same morphology because they represent the same phenomenon—the residual track in space and through time of the

action of energy on matter repeated in regular succession.[48] Force lines, as they occur in organic or inorganic matter, give evidence of nature's periodic rhythms.

This ultimately is what Dove sought to express—not the product but the process, or in his own Klee-inspired words, "not form but formation."[49] Dove was obviously entranced by the mysterious interaction between matter and energy which lies behind the crust of appearances. Analogous in his mind to artistic creation, these dynamics suggest the forms and spatial structure of his art in a fundamental way, as evident for example in *Sunrise III* (fig. 32). Concentric rings of brown, mauve, green, and blue surround a golden sphere and radiate their energy into the blue-green ground. The waving contours, feathered edges, and thoughtfully weighted colors imbue the picture surface with the suggestion of charged space, while the thin, quivering black line which half encircles the yolklike center acts as a dynamic foil to the otherwise static symmetry. Although the sheer scale of this circular formation has a nearly autonomous presence, the undulating line parallel to the lower margin reads, inevitably, as the horizon and causes these rings to be seen as a sunrise. In this way, they call to mind the kind of solar imagery seen in the work of other American moderns, such as O'Keeffe, Bluemner, and Marin, and invoke the sun's mythic associations with fertility, growth, and the life-force. However, this formation dominates almost the entire picture plane and thereby violates the "correct" or proportional relationship of the sun to the earth. In so doing, it negates the single reading of a sun seen within a landscape space and suggests analogy with a tree's growth rings, thus providing a vision of nature's inner structure as well. By uniting the celestial and terrestrial, the macrocosmic and microcosmic in a single image, these "force lines, growth lines" become a visual metaphor for the whole of nature and imply the underlying connectedness of all things.

Space and Dimension

This device of vibratory, oscillating lines and patterns was, then, a key organizing principle which enriched Dove's art with manifold levels of meaning. By saturating his canvas with vitalistic power, they invoke those invisible forces which form and inform the natural world. Moreover, this device imbues his art with a quality of motion and energy which strikingly corresponds to the new theories of the physical universe. There is evidence that Dove pursued this new stylistic direction in direct response to the contemporaneous discussions centered on physical theory and the nature of space.

In his correspondence from the 1920s and 1930s, the artist frequently used the word *space* to describe his expressive goals. To Dorothy Norman in 1934 he

wrote, "the spacing of ideas in relation to each other in space—that is what I have tried to do in my painting," and to Elizabeth McCausland at about the same time, "Just at present I have come to the conclusion that one must put in space an idea so that those with sensitive instruments can pick it up.... The play or spread or swing of space can only be felt through this kind of consciousness."[50] Referring to the woman who became his second wife in 1929, Dove wrote Stieglitz in 1920, "Reds is working, more 'space', spirit and color in the real sense," and in 1932, "What I have been trying to do is make what would be called an abstraction be self-creation in its own space and not be confined to a flat canvas for its existence."[51] He praised John Marin's art for its "sensation of space" and wrote Duncan Phillips in 1940, "I hope the feeling of space will creep into the coming paintings."[52] Also he commonly used *dimension* as a laudatory term: "Am trying to work slower now so that each bit will have thought and feeling... more dimension."[53] Clearly, when Dove spoke of his work as gaining in space or dimension, he was not referring to its size or the three-dimensional space of the physical world. His meaning was personal, idiosyncratic, and metaphorical. It was, moreover, informed by the heightened significance which these words held in his cultural milieu.

During Dove's lifetime, significant advances had been made in the fields of physics and higher mathematics which prompted widespread discussion on the nature of space.[54] Early in the nineteenth century, the development of *n*-dimensional geometry had raised the possibility of a mathematical space beyond the known three dimensions; in the latter half of the nineteenth century, the non-Euclidean geometries of Karl Friedrich Gauss, Georg Friedrich Riemann, and Nikolai Ivanovich Lobachevsky had demonstrated alternate methods of delineating spatial structure. Consequently, these mathematical discoveries stimulated new interest among physicists and philosophers in the character and dimensionality of physical space.

After Michael Faraday's discovery in 1831 that magnetism and electricity are reciprocal forces, the concept of space as a continuously charged field gradually replaced the Newtonian view of material objects which can be simply located in the emptiness around them. The field concept—in addition to Ernst Mach's research on rotational motion at the turn of the century and Hermann Minkowski's formulation of the time/space continuum in 1908—was ultimately used by Einstein to disprove the existence of absolute, Euclidean space. In his Special and General Theories of Relativity of 1905 and 1916 respectively, Einstein applied this knowledge to the structure of the universe itself. His concept of space was so comprehensive that it altered not only the understanding of physical nature, but as with any discovery of such magnitude, it deeply affected philosophical thought as well. As a result of such discoveries and the dialogue they engendered, the word *space* was loaded with meaning on many levels.[55]

Much of the speculation concerning the nature of space centered on a widely popular concept known as "the fourth dimension."[56] In her enlightening and exhaustive study of this concept, Linda Henderson sets forth the various meanings the phrase held for artists in the early decades of this century. While the idea that space could have more than three dimensions originated with the development of *n*-dimensional and non-Euclidean geometries, the fourth dimension was soon associated with ideas and phenomena outside the realm of mathematics. By 1900 it had an extensive history and had acquired philosophical and mystical meanings as well in the writings of such authors as Charles Howard Hinton, Claude Bragdon, and P. D. Ouspensky. As Henderson demonstrates, this concept had a significant impact on artists in nearly every major modern movement. Because it signified an ideal, invisible level of reality which exists beyond the known, three-dimensional world, it inspired artists to abandon traditional methods of representation and prompted the invention of radical, formal innovations. In the case of Frantisek Kupka, Kasimir Malevich, and Piet Mondrian, the notion of the fourth dimension was a primary stimulus for the development of a fully autonomous art.

Dove shared these concerns. Giving pictorial form to the fourth dimension was a primary artistic ambition, coincident with what he called "the sensation of space." Like his European contemporaries, Dove tried to encompass a higher, ideal level of reality. It is this ambition which underlies the many references to space in his personal writings and which accounts for the dramatic change in the spatial structure of his art in the mid-1920s. However, for Dove, the fourth dimension was not an excuse to repudiate all reference to the physical world. Rather, this concept prompted him to find new ways of depicting nature, ways of endowing it with enhanced import.

The first artistic application of the fourth dimension in America occurred in a *Camera Work* essay of 1910 by the painter Max Weber. Weber's definition set an important precedent for Dove's own thinking on the subject. Weber wrote:

> In plastic art, I believe there is a fourth dimension which may be described as the consciousness of a great and overwhelming sense of space magnitude in all directions at one time, and is brought into existence through the three known measurements. It is not a physical entity or a mathematical hypothesis, nor an optical illusion. It is real, and can be perceived and felt. It exists outside and in the presence of objects and is the space that envelops a tree, a tower, a mountain or any solid; or the intervals between objects or volumes of matter if receptively beheld....
>
> It arouses the imagination and stirs the emotions. It is the immensity of all things. Two objects may be of like measurements, yet not appear to be of the same size, not because of some optical illusion, but because of a greater or lesser perception of this so-called fourth dimension, the dimension of infinity.... The ideal dimension is dependent for its existence

upon the three material dimensions, is created entirely through plastic means. . . . Life and its visions can only be realized and made possible through matter. The ideal is thus embodied in and revealed through the real.[57]

This definition is important in several respects. By establishing a connection between the fourth dimension and visual art, Weber provided modernism—a relatively new phenomenon in America at this time—with valuable, theoretical justification. Moreover, Weber identified the fourth dimension as a realm which can be reached through consciousness, which is dependent on, indeed made possible by, the physical, material world. He described it as existing *in* nature, in the space potency *around* objects, thus implying that pure abstraction is not necessary for the realization of this ideal. When Dove wrote in an exhibition catalogue of 1929, "And as I said before, things can be of the same size and of different sizes at the same time. That is certainly true and covers both vision and feeling," he demonstrated his familiarity with Weber's definition written nearly two decades earlier.[58] As we shall see, it is a familiarity evinced in Dove's paintings as well.

In the years following the publication of this article, the fourth dimension played an important role in the art discussions which took place in New York—in the soirées which Mable Dodge hosted at her Fifth Avenue apartment and in the salon of Walter and Louise Arensberg.[59] Within the Stieglitz circle, it became a popular catchphrase meaning the superlative degree of something.[60] It was used this way in the Dove diaries by Reds to describe her husband's work (and why she preferred it to Cézanne's), while Dove described 291 as "an idea to the *n*th dimension."[61] Also, Dove's diaries show that at one time his library contained information on the subject.[62]

The important role which the fourth dimension played in discussions of his artistic milieu and the heightened import of *space* in intellectual circles had a decisive impact on Dove—provoking analogy in his mind with the picture space of his canvas. The vibratory patterns or force lines which were previously identified with the growth patterns in organic phenomena thus have another level of correspondence. By imbuing the picture surface with the suggestion of energy and motion and by implying more space than is actually depicted, they invoke a higher space, a space of the fourth dimension. The force lines in the art of the Futurists, Marcel Duchamp and Kasimir Malevich, as we have seen, were also used to imply motion on a flat surface, but the motion in their art was inspired by the chronophotography of Jules-Etienne Marey. It is linear and sequential and not in itself sufficient to qualify for the representation of the fourth dimension.[63] Unlike the spatial structure of their art, Dove's force lines suggest motion which is not simply sequential but expansive and progressive as well; the motion proceeds from the center of a form or point in space and moves out towards the edges of the frame. By keeping his imagery flat, these vibratory,

radiating patterns negate depth and avoid the illusion of three-dimensional space, despite the ubiquitous inclusion of a horizon line.

For example, in *Snow and Water* (fig. 33) Dove achieved his "sensation of space" by dramatizing the proportional relationship between small rectangles, mysteriously ascendent in their location on the sea, and the surrounding white void. This seemingly empty expanse has been painted with brushstrokes that fan out towards the frame, thus emphasizing the sense of radiant motion. The composition suggests some extraordinary celestial event in which a blazing curtain of white light has fallen from the black night sky. It intimates that ordinary perception has been replaced with an imaginative kind of vision in which the world assumes a portentous character. This pictorial format must have been of special import to Dove, for he reused it in a 1930 painting, *Snow Thaw* (Phillips Collection).

Although this new method of structuring the picture space corresponds with the discussions on the nature of space which took place in the artist's milieu and invoke comparison with the fourth dimension, Dove was not merely responding to a popular expression nor using it to justify his formal innovations. Rather, he put these innovations in the service of his deeply felt vision of nature, a vision which was informed by the latest scientific research.

By the early 1920s, when Dove first began to alter the spatial structure of his art, the fourth dimension had acquired another meaning. With the popularization of Einstein's theory of relativity, this concept was gradually identified with the time/space continuum of Einstein's physics.[64] In 1919, a British expedition had observed the deflection of light rays during a solar eclipse and this event gave official confirmation to the theory of relativity. Practically overnight Einstein became a celebrity. In 1920 he began a lecture tour of the United States which gave him even greater visibility, and throughout the decade numerous popular expositions of his ideas were published. The role which the fourth dimension played in Einstein's profoundly transformed vision of the universe gave the concept new scientific authority. Dove's efforts to enhance the space potency of his art were informed by a direct knowledge of Einstein's work. Though the expression "force lines" derives originally from Faraday's work of the early nineteenth century, it is with contemporary physics that Dove's art more closely corresponds. With his patterns of vibration and undulation Dove achieved a quality of breadth, an interaction between form and space, which directly corresponds to the new concept of nature as an integrated field of activity.

From a scientific standpoint, the great virtue of the relativity theory is the immense coherence it bestows on natural phenomena. On the simplest level, it states that in order to locate or define an event in the physical world, all of its dimensions must be taken into account. Space and time, matter and energy, are seen as interdependent coordinates which cannot be understood without

reference to each other. Space is not the empty arena in which matter sits but is an extension of matter's field; matter is not inert and unchanging but conceived of as an event or an activity. Each determines the structure of the other and the ancient, metaphysical dualism between them is dissolved. Thus, the physical world is envisioned as a continuous medium of energy manifested as matter or radiation in differing levels of concentration. Other physicists, such as Louis De Broglie and Erwin Schrödinger, added the idea that the energy which makes up the essential fabric of nature is transmitted through the atmosphere by waves which are imperceptible to direct observation.[65] According to them, the most accurate description of physical reality is that of wave motion.

The unique achievement of Dove's art from the late 1920s and 1930s is that a pictorial analogue for the time/space continuum is suggested by his distinctive method of organizing the picture surface. In his best works from this period, no part of the canvas is inert, and each element participates in the field of every other. For example, *Golden Sun* (fig. 34) comprises three large forms representing the sun, the earth, and the sea, rendered here as three undulating self-contained bands. Their size, position, and colors (neutral greys and greens) have been carefully adjusted so as to maximize the impact of the surrounding yellow space which does not recede but becomes coextensive with them. Because the field is painted with the same pulsing strokes as the sun and earth, the forms themselves appear as dynamic concentrations of that which surrounds them. The whole surface seems to radiate energy in different levels of intensity.

It was no doubt through Stieglitz that Dove first came to his appreciation of Einstein. Always an admirer of scientific achievement, Stieglitz had been especially impressed with the significance of the theory of relativity.[66] His library contained copies of Einstein's writings in German and in English, and in conversation he freely applied the concept of relativity to a wide range of philosophical matters.[67] Dove too had a high regard for the scientist, once remarking that Einstein was one of the two people he would most like to have met in his life (the other being Gertrude Stein).[68] Furthermore, Reds' diaries show that on February 5, 1929, she and Dove "went to Brentano's . . . and got explanation of relativity by Bertrand Russell," and that on August 9, 1925, they "had a talk on energy." Among Dove's personal writings, there are several references to Einstein and the rhetoric of physics.[69] Though he often used the kind of similes which occur in scientific textbooks to illustrate a theoretical point, he never transcribed literal, factual explications but adapted scientific data to his own understanding of things and the needs of his art. For example:

> The Einstein thing of the stretched plain [sic] in two dimensions all applies to the one-dimensional idea. It is just as possible with one as with three to reach four. I must go on . . . to mention co-ordinates.

This color condition and form might be expressed by the same co-ordinates. A flower has a motif color, a motif form, a motif smell. . . . In other words, its identity consists of a set of co-ordinates representing all of the senses we so far know.

Painting is the same as writing—from locale to locale in space. Not static planes in space. Not form but formation. To set planes in motion. Einstein. "The greatest form of degeneracy is pathological individualism."

Am wondering in connection with the discussion of the time-space thing of the fourth dimension, of the difference in the substance measurement on the surface of a hen's egg and a china one. Can a line be so pure that the shortest distance is the same to one mind as to another? It would seem that a perfect conception presupposed a norm, that is, the thing in color to whose eye the light is reflected. The one thing that seems so far to me to remain is the condition of existence which can be followed through any further existence by knowing definitely the other existences that have had their influence upon it. We can blow up a rubberband with dynamite and they both continue with their residues which could be traced back or unblown so to speak. That seems to me to be the answer to this so-called infinite thing. If we start with three elements, the combinations are never the same, that is, with time considered, and if we could trace them back, we might come closer to what we call god than we yet have.

The shortest distance between two points is entirely dependent on what's between them. Given three points and the truth becomes abstract. Given four and it becomes nothing. That is apropos of the line.

In passages such as these, Dove is grappling with the new knowledge about physical reality and applying it to his own intuitions. The measurement of a hen's egg alludes to Riemann's geometry of curved surfaces (sometimes called elliptic geometry). The difference between a hen's egg and a china one is that between nature and art. The example of a rubber band blown up and traced back suggests Einstein's conception of an expanding universe in which space is finite and unbounded. "The shortest distance between two points depends entirely on what's between them" refers to non-Euclidean geometry's refutation of Euclid's parallel axiom. Yet because Dove needed to reconcile these ideas with his own spiritual intimations of reality, he could, at the same time, speak of "god," "the distance between one mind and another," and "the condition of existence."

Thus, there are meaningful parallels between the new science and Dove's own thoughts on the meanings of things. The force lines of his art can now be understood as a pictorial analogue of nature's invisible energies. They evoke the view of the physical universe as a charged field and at the same time suggest the periodic rhythms of growth in living things. Derived from scientific fact, they provided the means to bind his art more closely with the essence of life. Biology and physics, then, were not separate but mutually informing influences on Dove's imagination. Moreover, because they suggested a hidden order where invisible forces give shape and structure to life, they provided the rational foundations for Dove's spiritual probings into reality as well.

3

Theosophy: A Spiritual Focus

Suggested Interview

Mention some you like: Cézanne, Picasso, Gertrude Stein, Rousseau, boats, Lao-tzu, Sri Krishna, Savoy cabbage, early morning, storms, my own work.

What do you dislike? Contradictions, dinner parties, organized crowds, Prohibition, suffering interruptions, good and evil.

What do you think of the mystics? Mysticism is like radio and the mind and body are the instruments.

What do you mean by abstraction? Intuition. The struggle of a horse to go up a hill. Bergson's *Introduction to Metaphysics* is very clear on this.

<div align="right">Arthur Dove</div>

Science and Religion

Science for Dove was a necessary touchstone in understanding the natural world—a way of verifying his perceptions and validating his quest—but it was in itself not enough. During his lifetime, science had made spectacular progress in describing the activities of nature, but it had had very little to say about the realm of feeling and value which were intimately involved with Dove's pursuit of reality. Its solutions are, after all, conditional, and there are numerous mysteries which its analytic method fails to penetrate—mysteries to which Dove was most responsive. Given its ontological deficiencies, science alone could do little to answer his deeper questions or reckon with his innately spiritual intimations of the world. Dove had the invincible need to believe in a transcendental reality, and as an artist it was his purpose to give expression to that reality—invisible and interior—which eludes scientific measurement.

The dialogue between science and religion, central to Dove's oeuvre, was of larger cultural concern as well. Between 1920 and 1940, an inordinate number of books were published by such authors as Joseph Needham, Bertrand Russell, and J. B. S. Haldane attempting to formulate a philosophy

which could accommodate them both. In the *Dance of Life* for example, which Dove read in April 1925, Havelock Ellis wrote: "not only is there no opposition between science and mysticism but in their essence and at their outset they are closely related.... When all deduction has been made of the mental and emotional confusions which have obscured men's vision, we cannot fail to conclude that science and mysticism are nearer to each other than some would have us believe."[1] In the autumn of 1930, the British Broadcasting System sponsored a symposium entitled "Science and Religion," and it was a subject discussed even in the contemporary art criticism. For example, in his *Expressionist Art* Sheldon Cheney argued that the innovations of modern painting had been necessitated by the coming together of these two realms.[2]

Several factors can account for this cultural preoccupation. The new physical theories had strikingly demonstrated the inadequacy of narrow materialist views. They had proved the vastness of the unknown and that the division between mind and matter is not so clear after all. Renowned scientists like Sir Oliver Lodge, James Jeans, Camille Flammarion, Thomas Edison, and Sir William Crooke were men with strong spiritualist leanings. Others, like Arthur Eddington and Arthur Holly Compton, believed that the scientific disclosure of nature's unity required religious interpretation. On a more popular level, the 1925 trial of Tennessee teacher John Thomas Scopes put the question directly in the public limelight, provoking heated controversy throughout the country.

For Dove too the choice between science and religion was a false set of alternatives. Like so many of his contemporaries, he understood these two levels of reality to be deeply interdependent. Religion without fact was fatuous and science without value barren. Each was an aspect of that indivisible unity in which he earnestly believed. While Dove never aligned himself with any religious institution, he was greatly absorbed in religious questions. In his diaries, there are frequent references to conversations with friends in which they "talked religion" or debated "the whys of existence."[3] There are random statements like, "I think spirit's the core of life really," "God is the finest thing in you," and "I cannot believe that life is entirely an accident."[4] It is commonly remarked that Dove's art is characterized by a pervasive pantheism—that it demonstrates the sort of transcendental nature worship seen in much American art of the nineteenth century.[5] Indeed, the primal simplicity of Dove's abstract style, the cosmogonic themes and celestial imagery seen throughout his œuvre certainly support this view. However, this quality has not been defined in terms any more specific than the vague expression *pantheism* allows. The decidedly spiritual character of Dove's art—its way of imbuing nature with the suggestion of ultimate value—was not simply the unconscious extension of a Romantic temperament nor a conditioned reflex to American art history. Rather, it was a deliberate, highly conscious effort to give form to the spiritual

feelings he had toward life. What has not been recognized is the source from which these feelings sprang or the specific way in which they inform the structure and the content of his art.

As mentioned earlier, during the last two decades of his career, Dove was very much absorbed in the study of Eastern religions and in particular theosophy, and these sources had a profound impact on the development of his art. Those devices previously discussed in relation to the morphological research of contemporary biology and the inquiries into the nature of physical space have another dimension of meaning which contributes to the manifold richness of his art. It was in theosophy that Dove found the means to reconcile his respect for scientific fact with his need for religious faith.

In recent years, several scholars have demonstrated the importance theosophy held for other pioneers of abstraction, such as Kandinsky, Mondrian, and Malevich, by helping them formulate a vanguard pictorial idiom.[6] Unlike his European contemporaries, Dove's historic move into abstraction neither paralleled nor prompted his turning toward abstraction; his art had been well-established in that direction, due to other influences, since 1910. Nevertheless, theosophy did provide him with justification, a meaningful rationale, at a time when abstract art was very much under fire, and it suggested the imaginative means to express his innately mystical apprehension of the natural world.

Dove's interest in mysticism had important American precedents. Transcendentalism, a philosophy integral to American culture, was deeply indebted to the Vedic scriptures, and this historic tie provided a sympathetic framework for later contact with Eastern thought.[7] As Romain Rolland, the French novelist, wrote in 1930:

> It would be a matter of deep interest to know exactly how far the American spirit had been impregnated directly or indirectly by the infiltration of Hindu thought during the nineteenth century; for there can be no doubt that it has contributed to the strange moral and religious mentality of the modern United States which Europe has so much difficulty in understanding.... It is nevertheless a psychological problem of the first order, intimately connected with the history of our civilization.[8]

Though the link between transcendentalism and theosophy is indirect, the transcendental belief that nature is the outward manifestation of ultimate reality is directly parallel to theosophical doctrine which maintains that the terrestrial and celestial realms are corresponding and continuous. Both grow out of that larger philosophic tradition which attempts to break down the barrier between fact and value and see the underlying connectedness of all things. Moreover, this link had been reinforced by other transformations in American culture as well.

During the late nineteenth and early twentieth centuries, partly in reaction to Positivist thought, a strong interest in mysticism was expressed in the writings of William James, Edward Carpenter, and Richard Maurice Bucke. In fact, Bucke's *Cosmic Consciousness* was widely read by the American avant-garde and provided the foundation for their speculations on the relation of art to a higher reality.[9] However, there are important aspects of American mysticism which should be noted at the outset that distinguish it from its Eastern counterpart.[10] In the writings of the Americans, there is an anticlerical stance, a rejection of institutional allegiances, and an emphasis on locating the source of spiritual authority in themselves. That is, the mystical experience is made out to be self-verifying. It is typically associated with nature instead of sacred scripture or the church and is given a naturalistic interpretation without reference to any religious leader or doctrine. In contrast to that of the East, American mysticism fairly bridles with individualism.

Dove conforms with this native pattern. His occult sources are thoroughly subsumed by the nature contexts he provides, and he early showed his own rejection of institutional authority when he "resigned from the church at the age of twelve."[11] It demonstrates an attitude which has more than a little to do with the independent tack of his art.

On a broader level, Oriental culture as a whole was of great fascination to Americans at this time.[12] Learned societies devoted to the East were established and a large influx of Oriental literature and translations was available. Such works as Percival Lowell's *Soul of the Far East* and Edwin Arnold's *Light of Asia* enjoyed enormous popular success as did the pseudo-Oriental verse of Edward FitzGerald's *The Rubaiyat*. In the realm of criticism, Irving Babbitt and Paul Elmer More attempted to erect a new social ethic based on Buddhistic values while Ernst Fenollosa and Arthur Dow advocated a synthesis of Eastern and Western artistic practices. The teachings of Fenollosa and Dow were an important precedent for the development of modernism in this country, for long before the establishment of 291 they had loudly deplored an art of factual verisimilitude as lacking in spiritual value.[13] Due to their influence, Oriental art was often cited by the supporters of modernism as a stylistic paradigm.[14] Dove was not exposed to the Fenollosa-Dow aesthetics while he was in art school as Weber and O'Keeffe were, but he did own the 1912 edition of Fenollosa's *Epochs of Chinese and Japanese Art*. In his 1913 letter to Arthur Jerome Eddy, Dove praised Chinese art for "its perfect sense of order," and once equated it with modern art's effort to express "the spirit of the thing."[15] Thus, side by side with the better-known traditions of realism and pragmatism, there was, in intellectual circles at least, a fascination with Eastern art and thought. The West, as it became increasingly industrialized, seemed to many to become spiritually impotent. The East represented spiritual consolation on the one hand and an affirmation of higher values on the other.

Dove's interest in the occult is not manifested in his art till the mid-1920s and was immediately inspired by personal experience, but the ground had once again been prepared by criticism in *Camera Work*. Though Stieglitz liked to pretend that his magazine espoused no editorial policy and even published criticism adverse to the exhibitions at 291 to prove it, the essays in *Camera Work* often reveal a critical position which is antimaterialist in its orientation and highly critical of modern life. As early as 1903 excerpts from Maurice Maeterlinck were published, followed by James McNeill Whistler's "Ten O'Clock Lecture," and passages from Henri Bergson's *Creative Evolution* and *Laughter* which celebrate intuition and art for their ability to "reveal a deepseated reality which is veiled to us by ordinary perception."[16] A paragraph from Kandinsky's *Concerning the Spiritual in Art* appeared in July 1912, immediately after its publication in Germany.

Also the regular contributors to *Camera Work*—Benjamin de Casseres, Gellet Burgess, Marius De Zayas, Sadakichi Hartmann—manifested strong Symbolist leanings by suggesting it was the artist's role to find pictorial equivalents for emotional states. In articles such as "The Renaissance of the Irrational," "The Unconscious in Art," and "Essays in Subjective Symbolism," they stressed the extraintellectual, instinctual, and precognitive powers of the mind as indispensable to the creation and experience of art.

Other critics went even further—claiming that the innovation of the modern artist can be attributed to his "psychic" perception. In one article of 1912 which must have impressed (and certainly flattered) Dove for the analogy made between his work and that of Duchamp, Maurice Aisen wrote that the impact of modern art derives from "the awakening sixth sense:" "Whereas the other five senses have concerned themselves with matter, the sixth sense concerns itself with 'spirit.'" Aisen predicted, "Today the psychic is coming to the front...."[17] It is an idea repeated in John Weichsel's "Cosmism or Amorphism," where the modern artist is said to possess "a new mental instrument" which he also calls "a special consciousness" or "the sixth sense," the means by which the "mysterious source of nature is reached."[18] Approximately twenty years later Dove wrote, "This so-called sixth sense is very closely connected with what is being done by the moderns in painting, literature and music. They may not admit it, but it is."[19]

The *Camera Work* essays were important because they set the general tone and direction for American art criticism even after publication ceased in 1917. Inspired by Kandinsky's title, the association between art and "the spiritual" continued to be a concern in the writings of Paul Rosenfeld and Waldo Frank, A. J. Eddy, Albert Barnes, and Sheldon Cheney. In Cheney's *Expressionist Art*, one chapter entitled "Abstraction as Mystic Revelation" states, "The abstract form fixed in a picture is a direct revelation of cosmic

architecture...which carries with it cosmic and spiritual implication."[20] Significantly, the chapter is illustrated with Dove's *Wind and Clouds* (1931).

While there were, then, important precedents and parallels for Dove's interest in mysticism, there were more immediate, more urgently personal reasons for his turning to these sources. In 1920 Dove was forty years old. He faced a critical turning point in his life not unlike that after his return from Europe in 1910. He had recently separated from his first wife, sold his egg farm, and begun a new life living with Reds in a houseboat on Long Island Sound. The pressures he faced were enormous—not only emotional and financial but artistic. His last one-man show had been in 1912 and though he continued to paint, he had not been able to develop or enlarge upon the pictorial ideas first expressed in *The Ten Commandments.* It was at this time that he began a long and close friendship with Stieglitz's niece, Elizabeth Davidson, and her husband Donald, about whom Reds once wrote: "they are the people it is most satisfying to show work to."[21]

The Davidsons were Vedantists, and for over two decades they brought a steady influence of Eastern thought into the Doves' life. They visited the Doves regularly in Huntington and Geneva, and when the Doves went into the city, they stayed en route with the Davidsons at their farm in Monsey, New York. During the 1920s and 1930s, a constant stream of "postals" was exchanged. The Davidsons frequently sent books dealing with Hinduism and as the Dove diaries indicate, the books were read: *The Lectures of Bodhananda, Kali the Mother, Raja Yoga.* On at least two occasions the Davidsons brought Swami Nikhilananda with them on visits to the Doves. One such visit Reds described: "The Swami is very amusing. He talked of snakes and superstitions; finally got around to talking religion and his philosophy."[22] On another occasion Dove met with him privately, and once Reds attended a Vedanta Society meeting.

Donald Davidson's interest in spiritual matters went far beyond the orthodoxy of Vedanta.[23] He was deeply interested in the occult and was believed by those who knew him to have exceptional powers of clairvoyance. He studied astrology and occult numerology and had an extensive library of esoteric literature which included the Kabbalah. Besides the books he sent Dove, there were also exercises in meditation and, throughout the years, monthly horoscopes ("prognostications" they are called in the diaries) which the artist followed with interest. William Dove has said that after his parents separated, his father depended on Davidson's "crystal ball gazing" to learn what was going on in his home.[24] It is possible that the two friends may have also practiced some form of occult ritual, for the diaries contain this mysterious passage from June 28, 1924:

> D. stayed over. Got back to our early Chinese days. Pink slippers, climbing over Swami's chair. Reed flute, fish scale cement, room with sunlight, bench with hole knife.[25]

Thus it seems that at this point in his life Dove had clearly come under the spell of Davidson's occult views. However, the artist engaged in studies of his own as well.

During the years 1924 through 1926, Dove made frequent trips to the Huntington library and checked out works by Plato and Spinoza, on Chinese and Indian religion. On December 15, 1925, Reds wrote "went to Brentano's and bought books by Bergson," and on December 19, 1925, "A. bought more Bergson books." In addition, Dove read Maurice Bucke's *Cosmic Consciousness,* the *Bhagavad Gita,* Lao-tzu, and Patanjali. He greatly admired Ghandi and once remarked, "The Eastern mind seems to make an art of its religion and we either try to make a religion of our art and [sic] failing that, make it utilitarian."[26] Dove's interest in the East was not merely intellectual: he expressed the belief to his son that he had "the soul of a transmigrated Chinaman."[27]

Despite numerous personal difficulties, this was a time in Dove's life of intellectual stimulation and artistic exploration. He frequently made trips into the city to meet with Stieglitz and visit exhibitions. In his art, faced with the challenge of consolidating new ideas, he experimented widely with style and media. He switched from pastel on linen in which he had done most of his earlier work to oil on a variety of grounds—glass, metal, canvas, and oilcloth. In 1924 he began what must have been an exhilarating departure from all his previous work—the assemblages—which constitute a distinct phase in his career (to be discussed in chapter 5). These coincide with a small group of paintings in which he took an important step forward. In such works as *Moon and Sea No. II, Waterfall, Sea Gull Motif,* and *The Wave,* Dove, inspired by the religious and philosophic ideas with which he had recently been absorbed, aimed to see things large. When Elizabeth Davidson described one of them as "a profound philosophic experiment," his reply was, "Just that."[28]

Reduced to their primal elements, these seascapes represent nature in the original purity and simplicity which preceded human existence. They recall that moment in Genesis when the Creator looked on His work and saw that it was good. Such thoughts were not far from Dove's mind. In 1924 he described a sunrise he painted with the phrase, "As it was in the beginning."[29] If these paintings are compared with Dove's earlier efforts it becomes quickly apparent that there has been a decided switch in perspective, one which is pictorial as well as philosophical. In the pastels of 1911 through 1920, for example, *Sails, Yachting, Plant Forms,* or *A Walk Poplars,* a small fragment of nature has been examined closely and enlarged to reveal the harmonies and rhythmic proportions in organic form. In the seascapes Dove shifts his view from the microcosm to the macrocosm. He adopts a God's-eye view of the world and renders nature as a philosophic abstraction, devoid of detail and the particularities of place.

For example, *Moon and Sea No. II* (fig. 35) carries with it the full weight of the Romantic tradition.[30] Nature is reduced to its most primal elements and rendered in a highly stylized way so as to endow the composition with symbolic import. The moon is positioned in the exact center of the top margin and cropped by the frame so that only a golden semicircle remains. Its white beam fans across a midnight blue sky and activates the waves below. To emphasize this correspondence between the celestial and terrestrial realms, the orientation of the canvas is vertical. The static symmetry and frontal perspective have been employed to suggest the immutable order which lies behind the flux of appearances. Further, a distinctly cosmogonic quality is suggested by the formality and by the empty horizon which seems to continue without interruption forever. Nature is shown in all its immensity and without a past.

Similarly in *The Wave* (fig. 36), a fragment of nature has been presented without any surrounding context and all references to time or place have been eliminated. There are no clues to indicate how far we stand from the subject. The composition is radically simplified, consisting only of the undulating hills and the sea. It is tilted on the diagonal, making it unclear whether the vastness of space has been viewed from above, with the reeling perspective of a bird in flight, or if it has been flattened and tilted forward. By adopting this vantage point, Dove was able to introduce a sense of space and surging motion unlike anything in his earlier pastels. This effect is greatly enhanced by the new, more fluid use of line. Though it still has a representational function, it is unattached to things and moves across the surface with an autonomous freedom. This is also the case in *Waterfall*. Isolated from any naturalistic context, forms flow across the surface, less like water than molten lava, and they are no longer contained by outline.

Despite the almost naive simplicity of these paintings, the direction Dove pursued in them is important to his later stylistic development; the themes of primal purity and mythic import are ones with which his imagination remained consistently preoccupied. For all the sensuous immediacy of his paint, nature is rendered as an impersonal force whose laws and meanings far transcend human life. Thus, the paintings of 1924 through 1926 represent a transitional phase in which Dove consciously began to redefine his artistic purpose—or as he put it, "grow a new set of feelings."[31] He was overtly interested in giving freer rein to his intuition, to the emotional wellsprings of his creativity. His friendship with Davidson, his immersion in idealistic philosophy, and his own deepening maturity all contributed to the enlarged vision of these works—the greater freedom of form and space.

It is against this background that the paintings of the artist's later career must be understood. Although Dove and Davidson had their spiritual affinities, as their long and close relationship testifies, they also had their significant differences. Theosophy was one of these.

Davidson's daughter, Sue Lowe, recalls that her father had been annoyed with Dove's attraction to theosophy, believing the artist had fallen prey to a cultural fad; and William Dove remembers that theosophy had been a topic of conversation between his father and Reds.[32] Dove himself was generally secretive about this interest. Although his paintings contain specific analogies with theosophical concepts and there are echoes of the occult in his unpublished writings, there is no explicit discussion of the subject. The records of the New York Theosophical Society do not indicate that Dove was ever a member, but he may at one point have been considering joining. Typical of his cryptic, slapdash style, a diary entry of August 5, 1924, reads : "Letter from home. Worried about Gilbert's antiques. Theosophical Society?" There is also one direct allusion to theosophy in a fragmentary essay Dove wrote:

> The moderns have gotten into a receipted formula, in reality built on the old religions or so-called secrets of the masters—now well-known.[33]

This was theosophy's boast—that it held within its teachings the secrets of those who are the most spiritually advanced, "the masters," which are at long last being shared with mankind. The statement reveals how closely theosophy and modernism were identified in the artist's mind.

Because Davidson disapproved of theosophy, Dove's introduction to it must have come through other sources. There are several possibilities. In *Concerning the Spiritual in Art* (a copy of which Dove owned), Kandinsky praised highly the work of Madame Blavatsky and the Theosophical Society (TS) as "a tremendous spiritual movement."[34] Within the New York art world at this time, Katherine Dreier, who founded the vanguard Société Anonyme, was greatly interested in occultism as were Hilla Rebay, founder of The New Museum of Non-Objective Art, and Walter Arensberg, whose apartment on W. 67th St. was an important meeting place for artists in the 1910s.[35] Several writers admired by or involved with the Stieglitz circle were, in varying degrees, interested in the subject, such as Hart Crane, D. H. Lawrence, Aldous Huxley, Jean Toomer, and Waldo Frank.[36] Max Weber and Marsden Hartley, Dove's painter colleagues at 291, were both deeply influenced by mystical thought.[37] Most likely, however, Dove's introduction to theosophy came directly through Stieglitz's friendship with Claude Bragdon.

As described in his autobiography *More Lives than One,* Bragdon was an architect, actor, painter, and the author of several texts on theosophy and higher space.[38] He helped to establish the Genesee Lodge of the Theosophical Society in Rochester, New York and served as the translator of P.D. Ouspensky's *Tertium Organum* in 1922. Bragdon was a frequent visitor to An American Place, Stieglitz's Madison Avenue gallery, and he became an outspoken proponent of abstract art at a time when most critics in this country

were condemning it.[39] Since 1924, he, O'Keeffe, and Stieglitz had all lived in New York's Shelton Hotel, and they often breakfasted together.[40] Dove could have easily met with them on such occasions because he sometimes took an early train into the city to "breakfast with Stieglitz."[41]

In any case, by 1920, theosophy was very much in the air. Founded in New York in 1875 by Helena Blavatsky and Colonel Henry Steele Olcott, the TS was established at a propitious moment—just as the fascination with spiritualism was beginning to wane. It took root as quickly as it did because it was part of a larger revolt going on in this country against the authority of the Protestant churches.[42] Its teachings represent a curious mixture of Hermeticism, Platonism, and Hinduism which Madame Blavatsky claimed to have learned by mental transference from "the masters" in a Tibetan monastery.

Essentially theosophy teaches that there is one truth which was given to mankind in the beginning of civilization. Though it has been obscured by centuries of religious schisms, it has been kept alive in the continuous tradition of esoteric literature. In its doctrines theosophy pictures a universe which is fundamentally composed of consciousness, ruled by correspondences and which is susceptible to sympathetic influences. A central premise of its teachings is the Hermetic identification between the microcosm and the macrocosm.

Because it posed an alternative to the materialist and mechanistic view of Western culture, theosophy had great appeal to those disenchanted with official religions. It offered a comprehensive philosophy which claimed to be the unifying element behind all human activity—art, science, industry, and religion. Moreover, it was consolingly optimistic. By using the controversial theory of evolution for its own ends, theosophy promised that life is immortal and not only evolves but progresses in an upwardly moving spiral. Given the progressive thrust of American society in those years, it was a timely doctrine.

But in what way and for what reason was Dove attracted to the fantastic claims of occult lore? What are the nature and extent of his involvement with the movement? How did he integrate its teachings with other aspects of his life and how did it affect his art?

In general an interest in the occult represents a protest against the dilution of what is sacred and ineffable in order to make it accessible to the general populace. It can also be a way to assuage a sense of personal isolation by cultivating an attachment to a larger order. For Dove it offered a means to project onto life a coherence and value which the contemporary culture could not provide. Given his Romantic temperament, his sequestered lifestyle, his early rejection of organized religion, and his need to believe in a trancendental reality, he was naturally susceptible to the promise and particular slant of theosophical thought. It fulfilled his craving for religious belief by providing

some form of spiritual focus. Most importantly, it did not contradict his respect for scientific knowledge.

An important aspect of theosophy (and a source of its intellectual appeal) is that it promotes and encourages the study of science, believing that one day physical science will catch up with what occult science has been saying for centuries. In fact, Madame Blavatsky predicted that at some point in the twentieth century her books would replace scientific texts in the schools. The first volume of her *Isis Unveiled* is devoted to the ways in which discoveries like electricity, radium, and X-rays confirm the existence of an immaterial and invisible order of reality whose effects can nevertheless be felt. The relative longevity of the TS as compared to other religious cults can be ascribed to the way it adapted itself to progressive alterations in the current knowledge. As the more orthodox faiths were buckling under the assault of the theories of evolution and relativity, theosophy cleverly assimilated these into its philosophy, taking what was congenial and rejecting what was not. By giving a religious interpretation to scientific discoveries, theosophy was always in conformance with facts.

For the purposes of this discussion, it is especially important to note the particular character which the TS had assumed in America by the 1920s—that decade when Dove's work first manifests a relationship to its teachings. By this time much of the secrecy and closed rites associated with the movement at its beginnings had been eliminated, and in some circles it had even become intellectually fashionable. In 1928 it reached the height of its popularity when TS membership peaked at about 45,000.[43]

Theosophy gained much of its popularity from the fact that it was closely parallel to the work being done in the field of psychic research.[44] Though theosophy and psychic research had their fundamental differences and required different kinds of commitment, they had enough in common to have an overlapping appeal. Growing out of the nineteenth century's fascination with spiritualism, psychic research was an attempt to verify by objective, empirical standards the existence of an immaterial reality. From the outbreak of World War I until well into the 1930s, psychic research had a large audience which included a cross-section of the American public. It was attractive to the scientific and lay communities alike, and there was an enormous groundswell of interest in psychic events. Séances were a popular pastime, mediums flourished, and many instances of automatic writing, spirit photography, and levitation were reported. During the 1920s *Scientific American* published a regular column by Malcolm Bird called "Our Psychic Investigations" and in January 1923 offered a prize of $2500 to the first person who could produce "an objective psychic manifestation of a physical character."

Because theosophy's teachings were supposedly open to empirical demonstration, they were frequently identified with the activities of psychic

research. Both theosophy and psychic research sought to expand the limits of the natural world and redefine the rational. Both made claims on invisible reality by demonstrating the affinity between mind and matter. Both called their findings "scientific" (though the psychic researchers were clearly the more scrupulous). In the eyes of many people, both represented an acceptable solution to the debate currently being waged between science and religion.[45]

Dove's attraction to theosophy had a lot to do with its association in the 1920s with psychic research. Though he had the need for spiritual faith, he also had the skepticism of one conditioned by modern science. He had no interest in white magic or any of the more lunatic claims of occultism. In fact he eventually became exasperated with his friend Davidson's "voodoo," though they remained close friends until the artist's death.[46] While theosophy and psychic research had their arcane aspects, to Dove they represented the efforts of science to come to terms with religious insight.

Dove's interest in psychic research was no doubt inspired by Davidson initially, but as William Dove puts it, "Father believed that he had certain powers."[47] The artist's letters to Stieglitz are filled with references to telepathic occurrences. Dove once wrote him, "You have a very strong sending outfit."[48] His diaries record a conversation with friends on the subject of "mental telepathy," and his essays often contain the vocabulary and rhetoric of psychic research—the mind is called "an instrument" or a "crystal" and mysticism is "mental radio"—the title of Upton Sinclair's 1930 book on extrasensory perception. Most significantly, Dove associated the investigation of an invisible reality directly with the efforts of modern artists:

> The human being is probably born with a far finer radio outfit than he ever invents for himself afterward. More people who have this gift are appearing every day. This so-called sixth sense is very closely connected with what is being done by the moderns in painting, literature and music. They may not admit it but it is.[49]

In his mind theosophy, psychic research, Eastern religion, scientific discovery, and modern art were efforts in the same direction: they all represented imaginative insight into the essential reality.

> Modern instruments are finally getting around to what those fine old gentlemen of the East could do a thousand years ago.

> The Chinese knew all this so well. The student was put at the top of the scale and the merchant and soldier at the bottom. No wonder their ideas seem wrong to us with our Western minds. Their most sensitive individuals could do things a thousand years ago that our modern world is all stirred up inventing instruments to do. We think it remarkable to hear what is now happening at a distance with our ear phones clamped to our heads, and many of these fine old individuals in the eastern countries thought nothing of doing the same thing in the present, past or future. They seem to have eliminated time.[50]

To Dove *modern* was less a temporal designation than a qualitative one. It could mean a return to the wisdom of the past or represent the latest scientific discoveries. As the occultists claimed, science was simply finding the mechanical means to perform what clairvoyants have always been able to do: conquer time and space. A painting Dove did in 1929, *Telegraph Pole* (fig. 37), gives expression to this idea.

Because it required the invisible field of force to overcome finite, physical limitations, telegraphy, or "the wireless," as it was called, was commonly used by theosophists and psychic researchers as an analogy for mental telepathy. For example, in *Man Visible and Invisible,* the British theosophist C. W. Leadbeater wrote:

> We have here (in the thought process) a kind of system of telegraphy between the physical plane and the soul; and it is important to realize that this telegraph line has intermediate sensations. It is not only from the physical plane that impressions can be received . . . but it is also quite capable of receiving impressions from the surrounding matter of its own plane.[51]

In Dove's painting, the telegraph pole is seen close-up so that its four ends meet the edges of the frame on all sides. The angular geometry, rare in his oeuvre of organic forms, contrasts with the rotund hills seen echoing in the distance. The horizon, included even in Dove's most abstract compositions, is drawn on a diagonal which contributes to the sense of dynamic motion. Though ordinary perception tells us that a telegraph pole is an inert column of dead wood, Dove suggested its hidden energy by covering its exterior with sprightly yellow leaves, thus demonstrating the eternal disparity between what seems and what is. The telegraph pole assumes a fantastic, spectral quality in this composition by being pushed close to the surface while looming over the distant hills. Another American artist, Charles Burchfield, used this subject with similar intent. Also influenced by theosophy, Burchfield did a large watercolor called *The Singing Telegraph* (1917-52) in which a long line of poles and quivering wires recedes into a highly animated landscape.[52]

Corresponding to theosophy's use of the visible to affirm the invisible, *Telegraph Pole* is a good example of how Dove could integrate scientific fact with his mystical perception of the world. The relation between his art and theosophy is however much more fundamental. As it shall become apparent, the themes, imagery and pictorial structure which characterize his work during the last two decades of his life all have their analogies in the occult.

Form and Light

In Dove's writings there are numerous examples of how his thought and artistic theory were informed by a knowledge of the occult. In 1930 for instance, one of the many occasions when the artist was asked to explicate his art, Dove wrote:

There was a long period of searching for something in color which I then called "a condition of light." It applied to all objects in nature, flowers, trees, people, apples, cows. These all have their certain condition of light which establishes them to the eye, to each other, to the understanding. . . .

After painting objects with those color motives for some time I began to feel the same idea existing in form. This had evidently been known by the Greeks, as in going over conic sections again with this in mind, I found that they were called "Maenechmian Triads". Maenechmus was an early Greek sculptor, and invented these triads. This choice of motive of course took the painting away from representation in the ordinary sense.[53]

Ostensibly this statement, in a letter to Samuel Kootz, describes how *The Ten Commandments* came into being two decades earlier, but it reveals more about what Dove was thinking at the time it was written.

Also in 1930, Dove made another seminal statement in a letter to Stieglitz which he called, not without some irony, "Pencil Notes Written on a Boat":

I have come to the conclusion that there is one form and one color. That simplifies to the point of elimination, theory, which might be called conscience. The form is the cone. From it we get the conic sections, the spiral, the circle and the straight line. Whirl the circle and get the sphere. The cylinder is just a circle moving in one direction. The cube of course comes from the straight line section of the cone.

A laboratory where forms could be passed through each other under many conditions might yield interesting observations.

The color is white light. The over balance of one color or the insufficiency of another will bring all of the most subtle "conditions of light".

I doubt if the instrument known as the human eye is sensitive enough to see pure white light. There are so many millions of whites that the slightest feeling of any kind in the human instrument would color it. The same is true of form.

White light and space are perhaps more analogous than pinning it to a form through which one might imagine objects—ourselves for instance. One can never quite grasp that.

How often it happens that one seems not to be present when seeing most clearly. It is possible to die without pain with sufficient concentration, without inconvenience or conscience— regret. When in pass[ing] through the point of nothing, one knows it not. In reality when another thing goes through that point but one knows nothing of that point in ourselves. There is nothing to know. Wisdom ceases!

Dear Stieglitz, I know you will smile._____Dove[54]

A few days later Stieglitz responded, "No, I didn't smile. Didn't even wonder."

These two statements of 1930 are directly analogous in their discussion of light and form, but their difference in style—one written for publication and one made in confidence—indicates how Dove would deliberately conceal his ideas in a kind of protective doubletalk. For example, instead of telling why conic sections are important he deflects our attention by discussing their

inventor. The statements are significant because in his cryptic way Dove deals with the painter's primary tools—form, space and light—and endows them with personal meaning which directly parallels occult theories.

Dove's statement that the cone is "the one form" is remarkably analogous to what Bragdon had to say about archetypes in 1928 in *The New Image*:

> Could we form a true conception of an archetype in accordance with the word's deeper signification we should have gone far towards resolving that mystery of phenomenality. An archetype of anything is that which is essential to it, that which makes it what it is—without which it could have no existence. It is the form of all forms; itself invariable, it is the cause and source of every variation. These inhere within it in the same sense in which the circle, ellipse, parabola and hyperbola inhere within the cone: they are every one "conic sections" and the cone may be the archetype of them all.[55]

As previously discussed, the concept of archetypes was most important to the morphological research which dominated biological thought in the late nineteenth and early twentieth centuries. It also played an important role in that genre of aesthetic theory which advocated organic form and its harmonic proportions as the basis of art. For the scientists and aestheticians alike the logarithmic spiral was particularly significant as a form in which the secrets of the cosmos could be divined. Bragdon was quite familiar with this body of thought, and as it shall become clear, so was Dove.

Because the concept of archetype implies a teleological world view, one in which everything works according to a purposive scheme, theosophy adapted it to support its own esoteric philosophy. Madame Blavatsky rightly credited Goethe with the original expression, and like the occult tradition which preceded her, she believed that "nature geometrizes universally in all her manifestations."[56] Moreover, Blavatsky regarded specific geometric forms like the swastika, the cross, the circle, and the ovoid as symbols of cosmic truths. Putting these ideas to artistic use, Claude Bragdon wrote often of archetypes. He believed that geometric forms like the ovoid and the spiral as well as "the Platonic solids" are the archetypes of nature which should be used as the basis of art to "unveil the hidden spirituality of life;" for "the language of form is the symbolical expression of world order."[57]

In Dove's mind, the cone was "the one form" because it could generate other geometric entities. It represented the abstract essence he was searching for, the irreducible foundation of all visual phenomena, and yet it would be as hard to find many cones in his oeuvre as it would be in Cézanne's. Deeply indebted to Plato's conception of reality, theosophy distinguished between noumena and phenomena, the archetypal and the manifested. The cone may be "the one form" but the spiral is the form by which it is manifested in nature. In mathematical language they are evolutes. If the spiral is projected into space and made volumetric, it becomes a cone. Said inversely, the cone which has

been flattened becomes a spiral. Dove was entranced by these geometrical relations because they provided him with the coherence he wanted his abstractions to possess.

The previous chapter discussed the biological heritage of the spiral and how it was seen to symbolize nature's hidden order. This form held other meanings as well. In particular, the conic spiral, an upwardly gyrating configuration, became an important intellectual conceit used to envision time and temporal development.[58] Cyclical theories were widely prevalent in the late nineteenth and early twentieth centuries because they signified the change from a static to a dynamic world view. Darwin, Marx, Spengler, Hegel, Toynbee, and Spencer all used a concept of cyclical development to explain change. Even the mythical "gyres" of William Butler Yeats can be understood in this light. In a letter to Stieglitz of August 1925, Dove too employed the image in this way: "The future seems to be gone through by a spiral spring from the past. The tension of that spring is the important thing."

Because of its evolutionary implications, the spiral also held theosophical import. In *The Secret Doctrine* Madame Blavatsky described "the law of vortical movement" as one of the oldest principles of occultism: "This tracing of spiral lines refers to the evolution of man's as well as nature's principles, an evolution which takes place gradually ... as does everything else in nature."[59] Moreover, spirals constitute "the first link between the ever unconditioned and the manifested," and are generated by what Blavatsky called "Fohat," that electric, vital power of the universe.[60] Claude Bragdon used the conic spiral as the frontispiece to his *Primer of Higher Space* as an emblem of the fourth dimension (fig. 38) and in his theosophically oriented text, *A Method of Creative Design,* Adolph Best-Maugard discussed the spiral as one of the seven archetypal forms which give expression "to the occult and undiscovered forces of the universe."[61] This design manual (fig. 39), which refers the reader to Bragdon's works, was one which Dove gave to his son in 1930 to help him with his own art.[62]

In the diaries, specific mention is made of the spiral: "Did two watercolors composed in the conic manner (spiral)"; "Worked on 'spiral line' "; "Laid in small spiral painting" and "1 w.c. built on spiral formation."[63] These comments suggest that the form is somehow implicit in the structure of the composition, but the spiral—in all its variety—could also be an explicit, iconographic element as in *The Park* and *Just Painting* (fig. 40) (where it is identical to Best-Maugard's illustration), *Red Sun, Willow Tree, Through a Frosty Moon,* and *Long Island.* A cone and spiraling lines are also the basic components of *Violet and Green,* where they have been located within a landscape context.

The other form, discussed in the preceding chapter, which Dove invested with archetypal status is the egg. As the cone is to the spiral, the circle is to the egg. In *The Secret Doctrine,* Madame Blavatsky wrote of the circle as the

"symbol of infinity and eternity, the mystic essence of the universe"; in its natural or manifested form it occurs as the egg, symbolizing the "promise and potency of the universe."[64] Ovoids abound in Dove's early pastels, inspired no doubt by his other career as an egg farmer, and they acquire iconographic import when used as a primary motif in such later works as *Golden Sun, Willow Tree, Through a Frosty Moon,* and *Long Island.* Rich in associative value, eggs and spirals are the phenomena of nature's archetypes. They are, at once, fact and symbol, organic and occult, interdependent aspects of one reality, and it is their poetic use which gives Dove's imagery its expressive resonance. In the early pastels, the geometric forms are distinctly biological in character, and sharply outlined, as if constructed with a ruler and compass. In the later works, the geometry is still organic, but more loosely drawn and dense with symbolic potential.

In the second part of the artist's statement to Stieglitz, another occult concept is suggested in terms of aesthetic theory: "The color is white light. There are so many millions of whites that the slightest feeling of any kind in the human instrument would color it." Though the analogy with Chevreul's optics is clear, Dove's meaning goes beyond the physical properties of light and color. Infinite, indivisible, and eternal, light and space, the most immaterial aspects of nature, have long been associated with spiritual concerns and are fundamental to mystical thought. In *Key to Theosophy* Blavatsky refers to theosophical truth as a pure ray of white light.[65] Bragdon too wrote of "the white light of the life-force" and "the white light which is god."[66] Whatever the simile, white light is analogous to archetypal form, the pure, unconditioned reality. It is so pure in fact that the "human instrument" cannot see it. When manifested, it becomes "colored by feelings of the slightest kind," and is then what Dove called in his letter to Kootz "the condition of light." Dove spoke of it on other occasions as well:

> I've always had the feeling that the condition of light was directly related to the line motif in form and color and all the other senses...the color condition is closely related to the principle in line upon which that object's growth is built.

> A condition of existence is important. Every object in nature has it—got to have—can't get away from it. Leaves, trees, animals, all have it, a condition of light. A certain condition of red, green and violet. They cut the color cone with their own individual curve.[67]

That is, everything in nature has its own identity—a condition of light, color, and form—which results from its archetype and the growth process as well. Because this condition of light or existence can be "altered by the slightest feeling of any kind," it is an idea directly analogous to what theosophists call aura—those cloudlike ovoids of colored light which encompass all living things.[68] Auras are emanations of the life-force generated by emotion or

consciousness and are altered in color and form as they respond to thought vibrations in the surrounding atmosphere. For theosophists auras exist on "the astral plane" of reality; they can only be seen by those with clairvoyant powers of perception. Annie Besant's *Thought-Forms* and C. W. Leadbeater's *Man Visible and Invisible* offer the most complete discussion of this theosophical concept. These were works which Dove knew well.

Occult religions are based on the belief in a hidden order of reality. What is distinctive about theosophy is that this reality was believed to be accessible through the intuition. It could be observed *and* represented. It was not just metaphor but *fact*. Theosophy's emphasis on the visualization of a supernal realm understandably attracted artists. To followers of theosophy, it must have seemed terribly auspicious that psychic researchers were beginning in 1920 to investigate this phenomenon which clairvoyants had detailed two decades earlier.[69]

Though Dove never mentioned auras, his use of "white light" and "the condition of light" corresponds to theosophical discussions of the same idea. There is, however, an important difference. Dove wished to discover the hidden laws and forces of nature and was interested in how these inform not "the astral realm" but the physical world we experience. He adapted these well-known theosophical concepts to his own ideas and experience with nature. In this way the vitalistic attitude towards organic form first expressed in his early works is, by 1930, integrated with a new spiritual content.

Besides the statements to Stieglitz and Kootz, other of Dove's writings contain echoes of occult ideas. For example, in a letter to Elizabeth McCausland, Dove said, "Just now I have come to the conclusion that one must ... project into space an idea so that those with sensitive instruments can pick it up."[70] This statement corresponds to a passage in *Thought-Forms* where Besant discusses it as the painter's role to "put in space" his mental image.[71] In one of his fragmentary essays, Dove also wrote:

> These later ones are absolute bits of reality put together with a certain concentration on a definite spirit expressed in their content. They bring to that expression the things that cling to it as people are forced to take themselves wherever they go. By concentration we mean nothing fixed—rather letting it go through you. When absolutely concentrated on a certain psychic sensation, we get everything around us that is in the same condition of existence.
>
> That is, if the crystal of our sensibility is clear enough to reflect what comes to it without coloration from itself, if that crystal is colored (we will say by some physical conflict, for instance showing red) everything coming through to us is colored and affected by that quality of red. It may even neutralize opposite qualities. Those first instincts are the ones that drive us with the most force.[72]

Referring to the mind as an instrument or crystal alludes to the theosophical concept of a receptive consciousness which can receive messages—thought

waves—from the mental body. The description of concentration is reminiscent of Eastern meditation practices. The statement that the mind can be colored by conflict "showing red" is analogous to Besant's description of how emotion can affect the aura: "red of all shades, from lurid brick red to brilliant scarlet indicates anger."[73] By calling his pictures "absolute bits of reality," he refers to experience unmediated by intellectual observation, which has always been the mystic's quest. Thus, Dove assimilated occult ideas directly into his artistic theory. These ideas did not provide him with artistic solutions, but they did offer a meaningful idealism on which to base his art.

Vibration

Besides form and light, the other element of nature (and art) which Dove endowed with mystical import was space, and space was of paramount importance to this artist. It was a primary pictorial tool and a medium of ideas. Moreover, the various ways in which Dove structured the space of his art distinguish the major stylistic shifts in his oeuvre and are an important indicator of his broader intellectual concerns. In the previous chapter, his treatment of pictorial space was discussed in relation to the contemporary interest in force fields and Einstein's physics; the vibratory patterns which characterize his mature art were discussed as an expression of nature's invisible energies. Given Dove's innately monistic orientation towards life and his belief in unified truth, this device also carries occult connotations.

According to theosophy, the whole universe is a continuous medium of energy manifested as vibrations which organize themselves as mind and matter. These vibrations account for all forms in the natural world and are a defining characteristic of the transcendental realm as well. Ultimately they signify a cosmic principle whose effects on all life are pervasive. Drawn from esoteric Indian teachings, this concept of a vibrating cosmos was of central importance in occult thought because it represented a physical link between the macrocosm and microcosm and provided the unitary basis by which all dualisms could be dissolved.

This belief is one example of how theosophy appeared to be in perfect accord with the contemporary physics which contended that the essential reality of nature consists of waves in motion. As Annie Besant wrote in *Thought-Power:*

> There is one key word, vibration, which is becoming more and more the keynote of western science, as it has been that of the east. Motion is the root of all. Life is motion. Consciousness is motion. And that motion affecting matter is vibration.... So again in physical nature, we mark off different ranges of vibration by different names, calling one set light, another heat, another electricity, another sound, and so on, and yet all are of the same nature, all are modes of motion in ether, though they differ in rates of velocity and in the character of the waves.[74]

Thus to a theosophist, it is not only physical but also psychic phenomena—thoughts and feelings—which manifest themselves as radiating vibrations. Charles Leadbeater discussed these vibrations as making up the appearance of the aura which surrounds living things (fig. 41). To demonstrate that this precept can be empirically verified, Leadbeater gave as illustrations E. F. F. Chladni's sound plates and the "vibration figures" of F. Bligh Bond which record the impress of supersensible phenomena on matter.[75] Also he provided illustrations of how these vibrations affect the human aura on the astral plane. Bragdon discussed this concept not as a feature of the astral plane but as a final principle of organic nature: "Since all things are waxing and waning... radiation rediscovers and reaffirms, even in the utmost complexity, that essential and fundamental unity from which complexity was wrought."[76]

For Dove the concept of a vibrating cosmos was an important stylistic influence. By suggesting the means to envision the invisible energies of nature, it provided the meeting ground for a scientific and a mystical view of reality. The vibration patterns in his art thus represent a pictorial device which gave symbolic form to Dove's uniquely dialectical vision of the world.

A comparison of one of his early pastels, *Team of Horses* (fig. 6), for example, and a later painting, *Summer Orchard* (fig. 22), demonstrates how these vibrations of form and surface altered the expressive quality of his work. In the pastel, saw-toothed curves and ovoids are densely layered so that there is no sense of surrounding space. The shapes are distinctly drawn, each color solidly applied within a given boundary, and motion is suggested by their progressive curves. The visual complexity of nature is reduced to "a few forms, a few colors" to suggest its inherent order and procreative energy.

Summer Orchard was based on the same thematic idea, but the forms are softer, more sensuous. They are fluid and continuous, making it hard to discern where one begins and another ends. Though both pictures are organic in character, the earlier work is more like a diagram of biological life, the latter an evocation. The central grey form suggest the contours of a ram's horn which curls around on the left to create the unmistakable outline of the spiral. The fluid transition between closely valued colors—apple green, pear yellow, and pearl grey—and the discrete brushstrokes make the forms appear to be gently breathing. Their rhythmic curves bring to the surface a fluidity of movement and a high degree of pictorial unity. By eliminating the clear division between figure and ground seen in the pastel, Dove dramatized his own empathic response and effaced the separation between subject and object. It is as if he could himself feel the inner pulse of living things.

The early pastels are frequently cited in the literature of modern art for their historical priority, but what makes Dove's later paintings like *Summer Orchard* so resonant is that they evoke not only the rhythms of organic form, but the mysteries of the life-force, not only the known but the unknown.

Though there is in Dove's oeuvre a remarkable continuity of formal and thematic concerns, in his later work, as a result of specific stylistic innovations, the forms radiate transcendent import.

In *Rise of the Full Moon* (M.37.11) the vibrating patterns which characterize every passage of the surface are divided into separate zones— green, beige, blue turning to black. These vibrations surround a pale yellow moon riding on the waves which its power generates. Its radiant energy is suggested by the concentric rings of grey and blue, but also by the fine, uncoiling line which follows roughly the contours of the color zones and even crosses over the moon's surface. In the context of occult philosophy, it is suggestive of "Fohat," the cosmic electricity whose influence is felt on the earthly plane as "a magnetic and active force." Madame Blavatsky notwithstanding, the spiraling line and the vibrating gradations of color all suggest motion and energy, and in conjunction with the moon, a clearly numinous body, they render nature as an animate presence.

Dove used the surface vibrations with great graphic and expressive variety. In *Holbrook's Bridge, Northwest* (fig. 42), vertical, horizontal, radial, and perpendicular vibrations have been layered in successively larger sizes, endowing the composition with a sense of expansive motion. They spiral outward from a green rectangle into the shallow picture space and at the same time create a diagonal axis which extends from the lower left to the upper right. In this way the composition is remarkably analogous to the principles of Jay Hambidge's "dynamic symmetry."

This curious design philosophy was well known to Dove and his contemporaries, such as Maurer, Weber, and Bellows, who all practiced it in one form or another.[77] It epitomizes the century-long romance with the concept of numerical correspondences between nature and art. Hambidge carried the enthusiastic philosophizing about the spiral one step further by demonstrating how its "mystical proportions" can be changed from a curvilinear configuration to a rectilinear one, thus becoming directly applicable to the canvas's format (fig. 43). He also recommended using a diagonal axis to make the composition dynamic, like nature, and to approximate the laws of natural growth.

As an artist who championed intuition, Dove is not likely to have applied the mathematical ratios which Hambidge advised. To submit art to this kind of formula would kill its spirit, and it was ultimately its spirit, not the law, which he sought to express. Like Blake, whom he greatly admired, Dove distinguished between "mathematic form" and "living form." Still, there is a striking similarity between Hambidge's diagrams (fig. 44) published in his short-lived magazine, *The Diagonal*, and *Holbrook's Bridge, Northwest*. Moreover, the rhythmic repetition of shapes which spiral out from the center implies progression from point to line to plane, a dimensional movement into

higher space. Thus Dove transformed Hambidge's simplistic design concepts into an image of visual power and mysterious presence.

It may be argued that the art philosophies of T. A. Cook, Samuel Colman, Adolph Best-Maugard, Jay Hambidge, and Claude Bragdon are not in themselves significant and that, as Dove instinctively knew, to follow their advice would inevitably lead to dull painting. However, these authors do represent a very real need in the intellectual community earlier in this century for unified knowledge, that is, a holistic conception of art and nature which had the rigor of science and the verity of mathematics. Interestingly, it was never questioned by any of them whether nature is the best basis for art or whether there might be others. It was confidently assumed that art had the power to manifest this knowledge. Though they were not all theosophists, their teleological world view was one which Dove found useful because it articulated his own mystic faith in the unity of life.

The Fourth Dimension

Vibrations, radiations, undulations were the means Dove used to make his pictures alive with motion and emotion, to make them "breathe like the rest of nature." Vibrations strengthen the formal aspect of his art by introducing a high degree of pictorial unity and at the same time enlarge the thematic content to accommodate a scientific and mystical view of reality. By emphasizing the abstractness of his compositions, they move the image one step further from representation and nearer to revelation.

These vibratory patterns were, then, one means Dove used to achieve what he called "the sensation of space," and as we have seen, in Dove's complex understanding of space, the fourth dimension played an important role. Widely discussed in his cultural milieu, not only was this concept important in the realm of higher mathematics and physics, but it held philosophical and mystical associations as well. Though the fourth dimension was originally dismissed by Madame Blavatsky (who died before it received scientific confirmation), it later acquired occult import in the writings of other theosophists.

In America the most eloquent spokesman on the mystical meanings of higher space was Claude Bragdon, for whom the mathematical construction of the fourth dimension was empirical proof of an unseen, spiritual reality. Because his ideas often parallel Dove's, it is necessary to summarize them briefly.

In the works that he wrote between 1910 and 1930, Bragdon defined the fourth dimension with an increasingly broad range of reference. In his 1913 *Primer of Higher Space* he defined the concept in strictly geometric terms. In his 1916 *Four-Dimensional Vistas* he extended his definition to include a wide

variety of phenomena, both natural and psychic. He freely applied the ideas of Plato, Boehme, Swedenborg, Bergson, and the Hermetic texts and gave examples, such as organic growth, which demonstrate temporal, progressive change. By 1925, when Bragdon wrote *Old Lamps for New,* his belief in the fourth dimension had been corroborated by the important role it played in Einstein's physics. He expropriated the scientific application of his concept to suggest how modern science, in perfect agreement with the occult, refutes a materialist view of reality. To encompass these various applications, Bragdon, like Weber, viewed the fourth dimension as a designation of consciousness, a way for the mind to transcend the limits of mundane vision and comprehend infinity:

> The idea of hyperdimensionality provides the mind with a conception by means of which it is enabled to establish so clear and definite a relation between the perceived part of the world and the transcendental. . . . By the application of these analogies to our human predicament, we are enabled to glimpse a world-order which resolves all paradoxes and reconciles all contradictions, relating in a logical and unbroken sequence, the visible to the invisible, the real to the ideal, time to eternity, the self to the Self, the moth to the star.[78]

A crucial aspect of this definition is that for Bragdon, as for Weber, the fourth dimension is conceived as a way of seeing in which nature and spirit *coexist.*

The problem Dove faced, then, as a painter was how to employ fourth-dimensional "seeing" in his art, how to unveil the ideal in the real, and endow the physical world with transcendental value. It was a problem which had been faced by an earlier generation of American artists, but whereas his predecessors in the Hudson River School had used storm-ravaged trees and sublime vistas to this end, Dove relied on the animation of pictorial space. The vibratory patterns which characterized his oeuvre for over fifteen years invoke the idea of higher space, a space which continues beyond the margins of the frame, and they endow his depiction of the world with portentous import. But Dove's realization of the fourth dimension was iconographic as well.

In *Moon* (fig. 5) the lunar rings—grey, white, black, and blue—pulse outward from a black center and are surrounded by a sky of green, thinly applied over a white ground, which radiates around the moon and charges the surface with ambient motion. In view of this treatment of the picture surface, the painting becomes a vivid demonstration of Weber's definition of the fourth dimension: "the space that envelops a tree, a tower, a mountain or any solid; the intervals between objects." The dramatic emptiness of the ground takes on heightened meaning. The radiating rings and expansive surface give the canvas an undeniable sense of movement into infinity. The low horizon, the relative contrast between figure and ground, and the directional brushstrokes all contribute to the enlarged sense of space.

Similarly, in *Golden Sun* (fig. 34), the sun, earth, and sea, not anchored to the frame at any point, seem to float within the immensity of the universe, and the brilliant yellow ground which surrounds them carries connotations of infinity. Its charged radiance is emphasized by the light overpainting of black, applied in a radial pattern to keep the solidly colored ground from being inert. Also, because the pictorial elements are few in number and large in relation to the frame, the painting appears to possess imposing dimensions, even though it is only ten inches by fourteen inches. It achieves "the sensation of space, "but clearly this is a higher space which contains the sun, the earth, and its waters all at once. It too suggests what Weber called "the dimension of infinity," "the immensity of all things."

Still another definition of the fourth dimension which appears to have been a potent stimulus to Dove's imagination occurs in an important essay in P. D. Ouspensky's 1931 *New Model of the Universe*. Contending that there is no difference between physical and psychical reality, the Russian mystic, like Bragdon and Weber, located this transcendental order within the natural world, and believed that organic growth is one of its most comprehensible forms: "Leafless trees in winter or early spring often present very complicated and extraordinarily interesting diagrams of the fourth dimension. We pass them without noticing because we think that a tree exists in three-dimensional space."[79] To demonstrate his point, Ouspensky provided an illustration of a solitary leafless tree (fig. 45), an image which had been a favored symbol of artists working in the Romantic tradition from Friedrich to Van Gogh and Mondrian.[80] Both visible and invisible, the tree is solidly rooted in the ground while its branches, becoming gradually smaller, reach heavenwards.

Dove gave artistic expression to this idea in *Electric Peach Orchard* (fig. 46). Rather than dramatizing the "empty" ground around the pictorial elements to augment the space potency of his art as he did in *Golden Sun, Moon,* and *Snow and Water,* Dove here filled the canvas with those horizontal undulations so familiar in his oeuvre and upon these superimposed a layer of squirming black trees. Whereas Ouspensky's illustration is little more than a conventional drawing which in no way communicates expressive content, Dove's painting is replete with the suggestion of an animate world. The undulating ground of blue, green, and white keeps the space flat but moving, while the bare, silhouetted trees provide a vertical counterpoint. Their finely drawn branches are stretched out like live wires to invoke the bond between the visible and the invisible, and floating amongst these are small, amorphous forms, like concentrated residues of energy. In the title as well, Dove alluded to Ouspensky's theory that electricity evidences the fourth dimension because it is physical proof of an unseen world and its positive and negative valences symbolize the occult reconciliation of opposing forces.[81]

As the link between physics and metaphysics, the fourth dimension provided Dove with the means to reconcile scientific knowledge with spiritual insight, fact with value. Whereas it prompted his contemporaries Mondrian, Malevich, and van Doesburg to transcend the physical world and formulate a nonobjective pictorial idiom, it inspired Dove, in the tradition of his American forebears, to suggest the supernatural in the natural, the ideal in the real. For all Dove's attraction to Sri Krishna and Lao-tzu, his was a mysticism tempered by native pragmatism. It was not rarefied and otherworldly but grounded in his love of nature.

Synaesthesia

The mystical content in Dove's art is so thoroughly assimilated by the nature motifs and his abstract pictorial vocabulary that it cannot always be isolated as a discrete element in his paintings. This is especially apparent in those works where he employed the concept of synaesthesia—the analogy between one art form or the faculty of its perception and another. Though synaesthesia is the logical consequence of the theosophical world view, it was hardly original to it. It has a long tradition in occultism, evidencing as it does the Hermetic identification among all things. Acknowledged by the mystical tradition of the Renaissance, synaesthesia was revived in the eighteenth century by Swedenborg and Boehme and became an integral part of Romanticism. Within this tradition the experience suggested that the universe is a storehouse of correspondences and analogies, horizontal and vertical, and it was believed that it is the role of the artist to perceive these as a way of tapping the root from which all life springs. In 1857, synaesthesia was given one of its most influential artistic expressions by Baudelaire. In his sonnet "Correspondences," the data of the various senses—colors, scents, sounds, and textures—are poetically analogized, expressing his belief that everything in the natural world as well as the spiritual is reciprocal because it is all derived from "the universal analogy."[82] As one historian has put it, "the theory of correspondences enabled the aestheticians of the nineteenth century to revive as if they were new things, doctrines commonplace in 1600."[83]

Synaesthesia, especially "colored audition," became a characteristic preoccupation of the Symbolists and received musical, poetic, and artistic expression throughout the nineteenth and early twentieth centuries—ranging from Wagner's *gesamtkunstwerk* to the sound and light machines of Rimington, Taylor, and Wilson, Scriabin's color-coded scores, and Whistler's "symphonies." In America there were the Synchromist paintings of Morgan Russell and Stanton MacDonald-Wright and the jazz-inspired compositions of Stuart Davis. Thus, while synaesthesia has its roots in occultism, it had in the

early decades of this century a popular and artistic currency quite apart from the occult.[84]

In theosophy it goes well beyond the interart analogy and becomes a part of that larger correspondence pervasive in the world. It is not merely a physical experience but a metaphysical one in which the arbitrary, illusory distinctions between mind and matter, self and world, sight and sound are magically dissolved. To Madame Blavatsky "sounds and colors are all spiritual numbers...radiations of the Unity, the central, spiritual sun."[85] In *Thought-Forms* Annie Besant illustrated how music generates configurations of colored forms which characterize the emotional content of the work.[86] Some theosophists devised elaborate charts correlating the colors with musical keys, attempting the literal transcription of one faculty into another. Bragdon too was interested in the idea of a "color organ" and wrote about the mystical correspondence between sound and light in several of his books and articles.[87]

Being more interested in how "the condition of light" or colors appear on the wings of a butterfly, as he wrote S. Kootz, Dove had no use for theosophy's literal-minded color symbolism.[88] Moreover, a formal analysis of the relation between the two arts is not likely to have interested him. Beyond the important precedent of Kandinsky and Klee, Dove's interest in synaesthesia derived from an imperious need to see behind physical experience, to reach its metaphysical root. The real purpose for the music and art analogy was to illumine the point of correspondence underlying them both.

There are frequent allusions to the analogy in his writings. Once, comparing Bach to Marin and Klee, Dove wrote: "they seem to be held at just the point where all the arts become identical."[89] In a May 27, 1928 letter to Stieglitz, he described some new work: "Two of the large paintings I feel have the sensation of sound in them, as though some primitive had hit a tree with a club." On March 5, 1929 he wrote, "It is nearer to music, not the music of the ear, just the music of the eyes. It should necessitate no effort to understand."[90] What Dove admired in music was the immediacy with which it could affect emotion. He wished his art to be just that instinctual, to give what he called "the first flash of feeling." Striving to reach that point, to express the mysterious, subjective equivalence between sight and sound, he often listened to records while he worked—everything from birdcalls and Whitman's poetry to Stravinsky and Louis Armstrong.

Several paintings in Dove's oeuvre establish the synaesthetic analogy by their titles: *Music* (1913), *Sentimental Music* (1917), *Swing Music* (1937), and *Primitive Music* (1944). In 1927 and 1928 he did six pictures devoted to the theme, some of which were collages: *Rhapsody in Blue Part One* and *Part Two*, *Rhythm Rag*, *Improvisation*, *I'll Build a Stairway to Paradise*, *Orange Grove in California*, *Irving Berlin*. About these Dove wrote in an Intimate Gallery catalogue of 1927, "the music things were done to speed up the line to the pace

at which we live today," but their real purpose seems to have been to emulate the art of Kandinsky. They are not paintings in which Dove grapples with the problem himself of giving visual form to sound. His approach is largely borrowed.

It is not until he did *Fog Horns* (fig. 47) that Dove dealt with the synaesthetic analogy in an original way. Instead of analogizing his painting to music, he used as his motif a sound associated with nature and his life by the sea. The result is one of his most hypnotic and visually arresting pictures. Because it derived from experience instead of a theoretical or artistic precedent, the painting is convincing in a way his earlier efforts are not.

Even though the composition consists solely of abstract geometric elements, it reads unequivocally as a nature image. The pictorial structure has been radically simplified into circles and lines, gently undulating and widened into planes of solid colors. Concentric rings of greyish purple, violet, and mauve hover mysteriously above a rolling sea like messages washing in from distant shores. In color and shape they are an affective pictorial equivalent to the plaintive moans of river traffic. However, Dove's goal was not simply to make color audible or sound visible but to evoke their underlying affinity.

In *The Secret Doctrine* Madame Blavatsky wrote that the union of the circle and line symbolizes life, the divine union between the eternal and the earthly.[91] Numerous paintings in Dove's oeuvre employ these geometric elements in various contexts: for example, *Graphite and Blue, Sunset I, II,* and *III, Moon, Out the Window,* and *Willow Sisters*. Whether or not they carried specific meaning for him, circles and lines are geometric elements which could be more easily integrated into a naturalistic yet abstract pictorial context—as in *Fog Horns*, where they becomes waves of water and sound. Rendered imaginatively, these simple means acquire enormous expressive power. Their melancholy hues and wavering contours dramatize the ephemerality of a never to be repeated moment—a moment of unified being in which all the senses come together. In this way synaesthesia represents an experience in which it is possible, however briefly, to transcend a prosaic reality in which relations are tidily compartmentalized. Like the fourth dimension, it offers an escape from fixed feelings and finite limitations through imaginative perception. Without any hint of contrivance, this painting conjoins sight and sound, form and feeling, line and circle, sense and nature into an imaginative whole.

Ten years later Dove did a similar work, *Thunder Shower* (fig. 48), which has the same thematic content, but in which subtle stylistic changes introduce a new level of complexity. In *Fog Horns* the sound waves are represented as discrete shapes. Though the space has been flattened by the use of monochromatic undulations, the modulation of color and the distinct horizon differentiate near and far. In *Thunder Shower,* jagged, concentric shapes explode outward, filling the entire space with their tremors while a bolt of

lightning splits it in half. It is as if the whole world has been subsumed and rent asunder in one deafening crash. Space is no longer the arena in which things happen but is identical with the image of sound activity. The reverberations of colored shapes are integral with the picture surface, thus suggesting the interdependence of time and space. The composition is remarkably analogous to C.W. Leadbeater's account of the same synaesthetic experience:

> Every sound in nature has its effect and in some cases the effects are of the most remarkable character. The majestic roll of a thunderstorm creates usually a vast flowing band of color while the deepening crash of thunder calls into temporary existence an arrangement of irregular radiations from a center suggestive of an exploding bomb; or sometimes a huge irregular sphere with great spikes projecting in all directions.[92]

The similarity between this passage and Dove's painting could well be coincidence, based on some innate relation between sound and shape, a shared human response. But even if Leadbeater's account was a stimulus to the artist's imagination, its descriptive content has been thoroughly assimilated into the pictorial composition. The painting succeeds not by reference to anything outside of itself but through its sheer abstract power.

Textual Precedents

Still, the fact remains that there are a considerable number of paintings in Dove's oeuvre which correspond to a textual precedent. For example, *Distraction* (fig. 49) is a curious compilation of references. Rendered in the style of Kandinsky's works of 1910 through 1914, the painting represents the Symbolist effort to find pictorial equivalents for emotional states under the more specific influence of occultism. The composition consists of abstract signs which have been expropriated from theosophic texts and located within a decidedly naturalistic space. In the center a deep pink cloud surrounds an elliptical sun on top of which lies a band of vibrating horizontal lines. It is a configuration which parallels another passage in Leadbeater's *Man Visible and Invisible* describing how certain emotions appear to clairvoyants:

> In the astral body of the average man there is always a certain amount of scarlet which shows the capacity of anger, the possibility of being irritated, and each outburst of rage adds something to this and predisposes the matter of the entire vehicle to respond somewhat more readily than before to these very undesirable vibrations. . . .

> The effect of fear upon the astral body is very striking. A sudden shock of terror will in an instant suffuse the entire body with a curious livid grey mist, while horizontal lines of the same hue appear but vibrate with such violence as to be hardly recognizable.[93]

To the right in *Distraction* is a rainbow, and beneath it are three crescent shapes which explode into space. They are identical to those illustrating the emotion "sudden fright" in Besant and Leadbeater's *Thought-Forms* (fig. 50). However, Dove did not use them specifically or literally but to suggest a generalized emotional content within the context of nature. On the far left, balanced against the rays and crescents, are three squarish brushstrokes which appear to be an almost incidental inclusion except that they are found in two other works of the same time. In *Alfie's Delight* (M.29.1) they are contrasted to the diagonally receding crescendo of spheres, while in *Just Painting* (fig. 40) they are juxtaposed to the spiral and placed within an irregular, glowing form, like a massive molten rock. In one of the many cosmogonic myths recounted in *The Secret Doctrine*, Madame Blavatsky described how the elements are formed from grains of raw cosmic matter "which coalesce and receive new spawn—in fiery dots, triangles and cubes which ripen... detach themselves and assume spheroidal form."[94] Given Dove's penchant for elemental themes and primal landscapes, the passage is a suggestive analogy for the repeated use of these marks. Like chards of matter, they evoke—along with the spiral, receding spheres, and emergent space—a sense of process and genesis, or as Dove wrote, "not form but formation."

Sunset (fig. 51) is one of the many examples of solar imagery which was a poetic fixation in this artist's oeuvre. The sun, comprising concentric bands of expansive, alternating color, appears between the cleft of two enormous boulders, while below, three darker orbs are crowding upon it as if drawn in by some magnetic force. One of these is attached to a treelike column which rises out of the earth and thereby connects the celestial and terrestrial realms. Although the eccentric conjunction of abstract shapes confounds a literal reading, the composition is illumined by another passage in *The Secret Doctrine* which describes the creation of the material universe:

> The Central Sun causes Fohat [cosmic electricity] to collect primordial dust in the form of balls, to impel them to move in converging lines and finally to approach each other and aggregate.[95]

Because of its bold simplicity, the composition is not "literary" in any way, although the textual source does provide it with an enlarged frame of reference, a means to imbue landscape with a cosmic dimension.

Cross in the Tree (fig. 52) alludes to theosophy's mythic symbolism in another way. It is anomalous work, one of the few Dove ever did in which the symbols intrude on the naturalistic aspect. Madame Blavatsky described the cross as an ancient symbol whose history predates its Christian usage. By joining vertical and horizontal elements, it too, like circles and lines or wind

and water, stands for the reconciliation of opposites: god and earth, male and female, sun and moon. It is a complete expression of universal forces. Elaborating on this idea, she wrote, "The Cross and the Tree are identical and synonymous in symbolism."[96] Both represent the same life-force which directs growth, "the ever mysterious, the ever unknown." One is conceptual, derived from the imagination, the other is organic. Their conjunction, marvelously improbable except in the context of myth, suggests the two poles between which we continuously move—mind and nature. In Dove's painting, the childlike candor of the drawing acts as an effective foil to the ponderous meanings of cross and tree. Even more auspiciously, in the watercolor (fig. 53), the cross is superimposed on a flower and spiral. This peculiar combination of images—cross, flower, spiral—forces the viewer to consider different levels of symbolism—the natural and the eternal, the organic and the occult. Integrated into one composition, the images become virtually interchangeable.

Of all the paintings Dove did which correspond to occult literature, *Golden Sun* (fig. 34) is perhaps the most stunning. It is stylistically indebted to the vivid free color of the Fauves and the free-floating forms of Miró, and its thematic content is once again parallel to a passage in *The Secret Doctrine* describing how the earth was born:

> "Darkness" radiates light, and light drops one solitary ray into the waters, into the mother deep. The ray shoots thorough the virgin-egg; the ray causes the eternal egg to thrill, and drop the non-eternal (periodical) germ, which condenses into the world egg.
>
> The Ray of the "ever Darkness" becomes as it is emitted, a ray of effulgent light or life, and flashes into the "Germ"—the point in the Mundane Egg represented by Matter in its abstract sense.[97]

Dove's painting has a dramatic simplicity clearly missing from the text. Although it is small, he has endowed the composition with a monumentality appropriate to its theme by maximizing the impact of form in space. The sun with its ray of "ever Darkness," actually three, fine, ruler-straight, pen and ink lines, penetrates the large egg. To Madame Blavatsky the ovoid, a variant of the circle, was a significant geometric form. Identified as the world-egg of Hindu mythology, it was directly related to themes of rebirth and evolution. Here it floats upon the primal waters and invokes a wealth of associations.

As previously discussed, *Long Island* (fig. 26) contains the archetypal egg and spiral, also replete with occult significance. In the watercolor sketch for this painting (fig. 54), the mystical correspondence between the terrestrial and celestial realms is suggested by the triangulated lines which connect these mammoth forms to the sun. Dove frequently used the expression "sun drawing water" or "sun drawing water from the sea." It is the title of a painting done in 1933 (Phillips Collection), it occurs in a 1925 poem published in the Intimate

Gallery exhibition brochure, and it turns up intermittently in the diaries. The idea of a magnetic attraction between heaven and earth appealed mightily to Dove's imagination and was given pictorial form not only in *Long Island* but in other works, such as *Golden Sun, Rising Tide,* and *Through a Frosty Moon.* It is an idea important to occultism as presented in that section of *The Secret Doctrine* called sun force/earth force:

> Thus we have an important scientific corroboration for one of our fundamental dogmas—namely that (a) the Sun is the storehouse of Vital Force, which *is* the Noumenon of Electricity; and that (b) it is from its mysterious, never-to-be fathomed depth, that issue those life currents which thrill through Space, as through the organisms of every living thing on Earth.[98]

Correspondingly, the sun/earth connection is integral to Romantic thought as well. In a conversation Dove once had with Maurer, Johann Eckermann's *Conversations with Goethe* was mentioned, a poetical dialogue which contains this metaphorical description of nature:

> I think of the earth and the atmosphere as a great living being always engaged in inspiration and respiration. If she draws in her breath, then she draws the atmosphere to her, so that coming near her surfaces, it is condensed to clouds and rain . . . she expires her breath again and the watery vapors are pushed up and so dissipated in the higher atmosphere, that not only the sun can pass through them, but the eternal darkness of infinite space seems a fresh blue.[99]

Whatever the immediate source of inspiration for Dove's art, it is clear that his vision of nature is rooted in an ideological tradition which is at once Romantic and occult.

Because his sources are so thoroughly subsumed by the landscape imagery, establishing connections and relationships becomes a methodological problem in discussing his art, as is the case with other modernists. In some examples the relation seems quite clear, as in *Sunset* or *Golden Sun.* In others it is more covert. Such is the case with *Wind and Clouds* (fig. 55). Diagonal, horizontal, and circular lines scallop the hills, whip across the sky, and wave across the sea, integrating nature's elements into a dynamic whole so that each element participates in the others. While it is always possible to read Dove's paintings solely as nature-based abstractions, it is interesting to note in this context that wind moving across the sea is a Kabbalistic symbol for heavenly union—wind and water being the male and female principles of the universe whose interaction suggests the coming together of opposites.[100] It is a symbol which Madame Blavatsky incorporated into her version of cosmogenesis. Though Dove's painting has its parallel in these sources, it also transcends them through the sheer vitality of his line which reinforces the strongly empirical

thrust of his art. As in *Goat, Moon,* and others, he presents a vision of nature as a living force and conveys his own keen sense of what the world is about.

Willow Tree (fig. 56) is one final example of how Dove's use of organic form corresponds with theosophic imagery. The ovoid which dominates this composition is here lying on its side and is so large that it fills the entire frame. Inside it a snake or serpentine form is coiled to conform to the egg shape.[101] Madame Blavatsky wrote thus of egg and serpent:

> "The Mundane Egg" is found in every world theogony where it is largely associated with the serpent symbol; the latter being everywhere in philosophy as in religious symbolism, an emblem of eternity, infinitude, regeneration and rejuvenation as well as wisdom.

She continued:

> ... the simile of an egg also expresses the fact taught in Occultism that the primordial form of everything manifested is spheroidal ... a serpent swallowing its tail. To realize the meaning however the sphere must be thought of as seen from the center.[102]

In the painting the serpent does not create the egg shape by swallowing its tail (too well-worn a symbol for Dove) but is contrasted to a light ground so as to create the configuration of a spiral. As in *Long Island,* the two archetypal forms which Dove favored are conjoined in a single image.

Although these passages are remarkably parallel to *Willow Tree,* it is not their lofty symbolism which makes the painting effective but Dove's highly imaginative and strikingly original rendering. The ground line is retained so that the connection with nature is ever present, but the overwhelming relation of form to space negates the sense of an object seen in a field. By removing the image from the traditional perspective of figure and ground, he endows it with such bold immediacy that any sense of "illustration" is completely negated.

Madame Blavatsky's prose has never been admired for its lucidity. It is dense and convoluted, full of referents and vague abstractions which accumulate as she jumps from one myth to another. It hardly lends itself to being seen, yet Dove's work gives it living form. Since other artists had read the same material and responded in an altogether different style, it is worth considering the uniqueness of Dove's approach.

It must be recalled that before he was ever a free painter, he had a highly successful career as a commercial illustrator. Though he detested this work and often spoke disparagingly of it, he depended on it to supplement his meager income from painting. Working for magazines like *Scribner's, Century,* and *Judge,* Dove would illustrate vignettes from the reams of short stories they published in those days by selecting some pithy passage and drawing it in a caricaturelike style. This thirty-year experience predisposed him to envision

written text. It was a practical bent, a peculiar visual talent which he had to adapt to the standards of serious art. Other Americans, like "the Eight," had been illustrators-turned-artists, but what distinguishes Dove's work is that he transformed a narrative style to make pictures which affect the viewer with their abstract power. He did this by developing a pictorial vocabulary and stylistic devices which were detached from history and could evoke the timeless center of things.

Sexual Imagery

Though many of the theoretical, thematic, and formal aspects of Dove's art have their analogy in occultism, it is important to emphasize that he was not painting to "illustrate" theosophical truths. He strove to give visual expression to his own innately mystical apprehension of the world. He rejected in theosophy what did not suit his temperament (like the theory of anthropogenesis) and adapted what he did use to his own needs and the needs of his art. Its philosophy was often the springboard for his own meditations on the meaning of nature and was therefore sublimated in the pantheism of his art.

At the same time that Dove was deeply involved with occultism, he did several paintings which are richly informed with a specifically sexual content. For example in 1935, the year he created *Moon,* he also did *Goat* (fig. 57), an exemplary Romantic image whose illustrious relatives include Eugène Delacroix's stallions and Franz Marc's deer.[103] No small intimate animal study, this painting is nearly three feet across, and the figure of the goat fills almost the entire space. Unlike Marc's gentle creatures whose forms commingle with those of the landscape, suggesting their mystic harmony with the world, Dove's animal is isolated from a natural setting. It is eyeless and drawn in the remote, profile view like an emblem on a coin. Appropriate to its symbolic content, the goat is rendered as an icon. Reinforcing this quality, its head is silhouetted against a sky blue circle which calls to mind the halos behind the heads of medieval saints.

At first the picture seems to be a confusing mass of unrelated forms in which the figure and ground are strangely equivocal. The horizon line on which the goat stands curves up toward the right, where it becomes distinct from the picture surface, and narrows to a rounded point just below the jaw. The goat's horn, boldly drawn against the blue halo, continues this curved trajectory along its back and hind leg. Hollowed out within the body is an irregular white shape which reads as the "negative" or X-ray of the torso, and in its center is a small, circular form, tan like the goat's fur, with a white dot in the center. This contrast of positive and negative elements, each containing something of the other, is reminiscent of the yin-yang symbol of interlocking opposites; and the chalky highlight along the goat's silhouette and within its interior calls to mind

the way primitive artists used white paint to suggest the animate nature of their ritualistic objects.

Within this rich interplay of form and surface, dark and light colors, positive and negative space, the erect phallus of the goat is not immediately apparent; it is completely integrated within the formal structure of the composition and rhymes with other curvilinear forms. But once this is observed, the canvas seems charged with potency. With this curious two-dimensional, iconic rendering, Dove has dematerialized the goat as a physical creature into an emblem of the life-force. He has transformed the most prosaic of subjects into a living symbol.

While there really is no need to account for the sexual content of specific paintings, so implicit is it in the vitalism of Dove's art, several factors in his cultural environment parallel and reinforce its presence. Historically, sex had been a problematic subject for American artists, as their flagrant neglect of the nude testifies. However, within the rebellious milieu of *Camera Work* and 291, the expression of instinct had from the beginning been celebrated as a means of achieving an authentic identity. The philosophy of the Symbolists and Bergson had certainly been a reinforcing factor in this development, as were Freud's ideas, which had an immense impact on American culture during the 1920s and 1930s.[104] Moreover, Stieglitz's library contained the complete edition of Havelock Ellis, in addition to some Freud and some Kraft-Ebbing;[105] and Freudian themes are predominant in the work[106] of Sherwood Anderson and Waldo Frank, both of whom Dove knew well. Also, despite her adamant denials, O'Keeffe's flower paintings are fraught with sexual implications. When this fact was pointed out by the art critics of the day, Dove wrote to Stieglitz in a letter of December 5, 1930, "The bursting of a phallic symbol into white light may be the thing we all need." The remark is no doubt a reference to O'Keeffe's *Jack-in-the-Pulpit* series of that year, but it also foreshadows instances of his own art, such as *Moon* and *Goat,* which are virtually a pictorialization of that metaphor.

This intellectual environment provided the foundations for Dove's development. Like his colleagues, he admired the writings of Bergson, D. H. Lawrence, and Ellis, and among his personal writings there are pointed allusions to Freudian theory. While such interests were widespread in this country by the mid-1920s, among intellectuals at least, there was a period of gestation before sexual imagery appeared in Dove's art. Then, in 1935, it appears full-blown. Never literal, it is, like other thematic ideas, integrated within the context of nature and implicit within the pictorial structure.

Dove's *Sunrise* series of 1937 continues the priapic imagery seen in *Goat* and *Moon.* Painted in wax emulsion to enhance their luminosity, the solar rings emanate from a light-filled center and progress through alternately darker and lighter hues till the whole surface is covered with their pulsing

radiance. In each case the rings are situated above a low, nearly incidental, but always present horizon to reinforce the idea of a temporal (and implicitly narrative) progression, invoking a wealth of associations.

The *Sunrise* series has been aptly called "a descriptive sequence in impregnation."[107] In *Sunrise I* (M.36.14) the concentric circles of the sun—orange in the center, progressing to white, tan, and blue—acquire specifically sexual connotations, becoming womblike, with the addition of a blue-tipped phallic form and a long-tailed spermatozoon which float freely above them. *Sunrise II* (fig. 24) (discussed earlier for its similarity to botanical illustrations of lateral root caps) suggests the fusion of phallus and womb which results in the emergence of new life as another nucleus and ring begin to form on the right. In *Sunrise III* (fig. 32), the solar rings have become the fertilized ovum, while in *Sunrise IV* (M.37.13) they are again juxtaposed to the now smaller phallic form.

As a characteristically Romantic image, intense, visionary suns can be found in the work of Van Gogh, Munch, Blake, and Friedrich, where they are used as a cosmic ultimate to drive home mystical truth. As an image of divination, a fertilizing force in nature, an agent of growth, the sun in Dove's series is rendered with expanding circles to invoke a sense of wholeness and eternity. In this way it is reminiscent of mandalas, those images of meditation used in Eastern religions with which Dove was no doubt familiar. Juxtaposed to the phallic forms and spermatozoa, the solar image becomes womblike as well. Thus, this simple geometric configuration is transformed into a resonant symbol of the life-force. Multiple layers and correspondences come together in these resplendent works, at once sexual and celestial, biological and mystical. Without being illustrative in any one way, they are evocative in many ways.

The *Sunrise* series is a notable example of how Dove adapted diverse artistic precedents to his own ends. The radiating rings which provide the fundamental structure for these paintings are a configuration which he employed in diverse pictorial contexts, though most often as solar and lunar imagery. Robert Delaunay had used this configuration as an isolated motif in his *Suns, Moons,* and *Discs* of 1912-13, but while formal similarities with Delaunay's art exist Dove's pictures are quite different in character. Less concerned than Delaunay with optical harmonies, Dove used a narrower range of low-keyed colors that gives his series its deeply pensive effect. A more likely inspiration were the sun and moon paintings which Oscar Bluemner exhibited at the Intimate Gallery in 1928.

The sexual implication in Dove's art is the logical consequence of his own history of thought—his entrancement with organic form, themes of genesis and growth, even his attraction to the occult. Within the theosophy of Blavatsky, Bragdon, and Ouspensky there was no war between the spirit and the flesh; sex was regarded as the living form of divine union and was, like all else, endowed

with transcendental value. This view paralleled a larger tendency in American culture at that time which one critic has called "carnal mysticism."[108] The phrase refers to the idea that ecstatic sexual experience can bring one to the limits of the material world, and while it was certainly not a new idea, it received fresh impact under the influence of Freudian thought.

Dove's mysticism was not life-denying but yea-saying, expansive. It was a mysticism innately tied to his physical experience of the world. By the late 1930s, he was at the height of his creative powers. In addition to the artistic precedents and cultural stimuli, the confidence which he felt in himself as a painter, his own power of expression, also contributed to the developed vision and rich, syncretic character of this series.

Theosophy as Instrument

Like most Romantics, Dove believed in the gnostic function of art. The problem he faced as a painter was how to charge pictorial form with ineffable content, how to envision the invisible, how to make the interior reality known. He had to discover the means which would give the elusive spiritual force palpable form and would endow his art with the power of revelation and illumination without recourse to a priori thought. Theosophy was useful to him as an instrument, not an end. No more or less *true* than any other mythic structure, it was a symbolic convenience which provided him with the spiritual focus he craved. It was a supreme fiction by which nature could be celebrated as something sacred. It was a way to reinvest the world with wonder.

To this end Dove used vibrating surface patterns, synaesthetic themes, celestial and cosmogonic imagery, archetypal organic forms, symbols of vitality and regeneration, expansive surfaces and complex spatial structures. His highly personal style of painting was a necessary function of his ultimate purpose as an artist: to restore our knowledge of that eternal correspondence between the visible and the invisible and make it *felt*.

4

The Late Paintings

... bonds are a good investment financially and higher mathematics is mentally.

Arthur Dove

Giving significant form to a mystical conception of reality was an artistic challenge which occupied Dove's imagination during the last two decades of his life. However, after 1940, his means changed. His late works demonstrate a fundamental transformation in style which, nevertheless, represents the continuing evolution of his thought. In Dove's earlier work, where he adapted the concepts of natural science to the needs of his art, geometry was a subtle influence on form; it was an implicit function of the organic expression with which he was concerned. In the work he did between 1940 and his death in 1946, it acquired an eminently ideal significance. The geometry of the late paintings was no longer that "sensed in nature," it was imposed upon nature. As Dove continued to visualize space in new ways, it was specifically the more abstract science of projective geometry which informed the structural and expressive character of his art. It provided the kind of universal, objective certitudes he needed as the ground of abstraction and a new way to suggest the mystical concept of higher space. Not just the refutation of his past, more organic way of working, these late paintings represent a prodigious culmination of the ideas with which Dove had been concerned his whole life. That is, they manifest the same philosophical vision with new pictorial means.

In place of the expansive, vibrating surface patterns which made his art "breathe like the rest of nature," the late works are characterized by a clarity of geometric form which is distinct in Dove's oeuvre. They possess a boldness of design and a static iconic power. There are fewer overt references to nature, and there is a greater reliance on autonomous, pictorial means. Shapes are dramatically simplified, solidly colored and clearly distinct from the ground. The previous reliance on asymmetric curves and logarithmic proportions, so suggestive of growth and biological energy, is replaced by hard-edged circles, triangles, and rectangles. There is a new quality of stoic strength and

philosophical detachment—a contraction of emotional power, a tightening of the reins, as he braced himself against the inevitable deterioration of his health.

By 1941 Dove was virtually an invalid, having suffered two strokes and contracted a kidney disease. It is poignant to read the diaries from these years—the impatience with handwriting, the obsession with medical reports. One entry reads, "JB [his doctor] says I'll never walk again," yet not much later Dove could write, "Am learning so many new things." Despite his failing health, these last few years of his life were artistically vital and astonishingly productive. He consciously explored new avenues of expression and developed a distinct late style.

The new degree of abstraction in these works is not only a response to illness and age. Dove's detachment from nature is a deliberate step to realize new ideas, and once again, it is his treatment of space—its depth, intervals, and relations with form and shape—which gives expression to these ideas. Dove was surely conscious of what they were; in a letter of June 1942, he advised Stieglitz that a few of the paintings he was sending to the gallery "should be saved for their research value." Although these late works become further removed from the space and experience of the physical world, they still possess spatial qualities—tensions, equivocations, sequences—but of a different kind than seen before in his art. Moreover Dove's method of pictorial construction continues his effort to suggest the fourth dimension on a two-dimensional surface.

In the catalogue for his annual exhibition at An American Place in 1940 Dove wrote:

> As I see from one point in space to another, from the top of the tree to the top of the sun, from right or left, or up or down, these are drawn as any line around a thing to give the colored stuff of it, to weave the whole into a sequence of formations rather than to form an arrangement of facts.

Though couched in references to nature, the statement describes a motion from one point to another connected by a line to express a particular space and the positional relations within it. This is the subject of projective geometry—a branch of higher mathematics concerned with the properties of space and the representation of its higher dimensions.[1] Unlike plane and solid geometry, it has nothing to do with measurement, congruence, or proportionality. Projective geometry had its origins in questions of perspective and how things are seen. It grew out of studying the space of the physical world but is also logically independent of it. Though it is based on the extension of Euclid's theorems, it is used to construct models of non-Euclidean geometry and prove that they are consistent. It therefore played an important role in the discussions on the nature of space which occurred earlier in the century and was often

employed as a tool for the depiction of four-dimensional figures of a mathematical and a mystical nature.

Claude Bragdon alluded to projective geometry in 1915 in his *Projective Ornament* and again in 1925 in *Old Lamps for New*. At a time when most American art critics were beginning to reject the avant-garde on behalf of more conservative styles, Bragdon advised that the art form of the future should be "preferably abstract and mathematical, because if other than that, if tinctured by materiality and reminiscent of the things of the three-dimensional world, the imagination would be weighted down by memory and association. . . ."[2] Specifically, he advised that non-Euclidean geometries be used as the basis for art because they are free from the limitations of the physical world:

> The problem then becomes how to project into three-dimensional space the figures of a space which transcends it by a dimension. It seems impossible but there is a perfectly workable method, for in the projection of solids on a plane—illustrated by the science of perspective—have we not triumphed over that very difficulty by representing in a two-dimensional plane a figure of a dimension greater by one? Four-dimensional figures can be projected into three-dimensional space by analogous methods, and if desired, these can in turn be projected into a space of two dimensions. How then can they be rendered? The answer is that they are known *to the mind* and this being so, can be developed and projected, without the aid of memory or imagination, by a purely intellectual and mechanical process. These figures are of extraordinary beauty and variety, susceptible of infinite simplification, elaboration, combinations and developments if dealt with skillfully by a trained aesthetic sense.[3]

What Bragdon is working up to here is a justification of the geometric abstraction of his own work which he called "projective ornament." Though he makes no mention of projective geometry per se, the suggestion is implicit in his discussion.

As mentioned above, Dove made frequent references in his diaries and letters to *space,* beginning as early as 1924. He also used *mathematics* as a term of value: "The workmanship is certainly better than anything yet. Almost 'mathematics'. Am finding something quite clear." "A perfect thing in mathematical beauty of color."[4] However, the diary entries from 1941 through 1944 (the last year he kept a diary) contain specific allusions to these new mathematical concepts, often accompanied by the enthusiasm of discovery:

> Tried again working the 2, 3, 4 points. Gives dimension. Think we have something here.
>
> Wrote Stieglitz: Am working more from space outward instead of the eye back which is a relic. Comes more from space than from drawing.
>
> Did brilliant wax em. [emulsion] on four points.
>
> Best to go on as if nothing has happened. Often find that it hasn't when you think you have discovered something.

Trying to make planes as I saw them in lines.

Did the best thing yet in three dimensions.[5]

These remarks are analogous to geometric theorems which describe the construction of higher dimensional space by the mapping of points, lines, and planes onto each other through perspective projection. When Dove said that he "did the best thing yet in three dimensions," he meant that three points were used on a flat surface to achieve the illusion of space. As an elementary knowledge of geometry tells us, three dimensions are necessary to locate a point in space, only two to locate a point on a flat surface. As his paintings demonstrate, Dove's effort here was to use a two-dimensional surface to imply a three-dimensional space without resorting to mass or volume. His goal was accomplished by the superimposition and juxtaposition of solidly colored planes—opaque and transparent—carefully weighted in value to advance or recede. Sometimes the effect is quite pronounced (*Through a Frosty Moon, Parabola, Rising Tide*), at other times more diffuse (*Anonymous, On the Bank*), but it is a constant modality of the late works.

By working with lines and planes on a flat surface Dove was in effect using a two-dimensional surface to create a space of a higher dimension. On the most elementary level, this is what artists have been doing since the Renaissance. However, Dove was not attempting to simulate the space of the physical world. He purposefully used geometric (or geometrized) elements and geometric (or perspectival) projection as his tools in achieving a space which is not naturalistic but *optical* and *imaginary* in every respect.

As he often took scientific information and adapted it to his own ends, he frequently used mathematical terminology to express personal ideas. For example, in a statement written for an exhibition pamphlet at the Intimate Gallery in 1927, he said, "As the point moves it becomes a line, as the line moves it becomes a solid, as the solid moves it becomes life, as life moves it becomes the present."[6] This remark, written just one year after the publication of Kandinsky's *Point and Line to Plane,* is an expression of the spatial progression of geometric entities towards the fourth dimension in time. In the same statement Dove also described the opposite, the devolution of space: "The line is the result of reducing dimension from the solid to the plane and then to the point." The geometric principle from which he is working is that a two-dimensional space is the cross-section of a three-dimensional space and so forth. Said inversely, a four-dimensional space is the projection of a three-dimensional space, which is the projection of a two-dimensional space and so forth. Alluding to the same concept, Dove once wrote, "Enjoyment is easily distinguished from enthusiasm. Enthusiasm is flat, and enjoyment is round, one is a projection of the other."[7] In geometry, projection and rotation are the two means by which mathematical entities acquire higher dimensions, as he

knew: "From the cone we get the conic sections, the spiral, the circle and the straight line. Whirl the circle and we get the sphere. . . . "[8]

Dove's interest in these matters, especially the generative properties of geometric elements, derived from his need to provide his abstractions with a coherent ground, conceptual as well as structural. As a consistent feature of his thought for almost thirty-five years it explains how he understood his late work, stylistically distinct as it is, to be the logical culmination of what came before. As he wrote Stieglitz on December 14, 1943, "The last one here is something quite new and on line with the first ones shown at The Place. It is just a small addition to the general idea but has possibilities to go on with indefinitely." With projective geometry as a springboard to creation, Dove continued to explore the expressive possibilities of space, but the space in these works has nothing to do with nature and the things in nature. It is a mathematical construct intended to challenge the viewer's spatial intuitions. Even though references to landscape remain, it is this new knowledge which informs their expressive character.

With Klee providing the pictorial precedents (see chapter 5), Dove did not use projective geometry in a mathematically exact way. He capitalized upon the idea, not the method, of seeing into space with a larger perspective than ordinary perception allows. He understood mathematics to be the closest analogue to abstract essence, the purest expression of universal ideals, but, like most Romantics, he could not submit his art to the exacting, rational discipline of numerical formulas. While he did use geometric concepts as a stimulus in dealing with the problem of pictorial space, the geometry was only a point of departure, not an aesthetic solution. Because there are no diagrams or the like among Dove's papers to indicate how he might have applied mathematics to art, and given his Romantic temperament, it can be safely assumed that he continued to place intuition above theory, feeling above formula. However, in his diaries from this period he did mention having used "overlay paper" and having "worked with the triangle stuff," both of which would have aided him in achieving the transparency and perspective of projective space.[9] Because his mathematical concepts are thoroughly transformed by his imagination and governed by the more important demands of pictorial organization, it is not possible to establish a strict correspondence between specific concepts and individual paintings. Nevertheless, the relationship between this body of thought and certain late works, evidenced in the new treatment of space, helps to elucidate their essentially ideational character.

One of the first examples in his oeuvre of this new approach is *Through a Frosty Moon* (fig. 58). Familiar forms like the ellipse, the spiral, and saw-toothed curves are combined here with ones more amorphous and freely drawn. No longer anchored by a ground line or by the force of gravity, forms fluctuate in and out, back and forth, as if floating in space. Because their edges

are cropped by the frame, the relation of part to whole is further obscured. It is no longer the mundane world being envisioned where time and space are logically continuous, but a non-Euclidean space where the old limitations no longer apply.

If this painting is compared to two others done the year before, the innovations become more apparent. In *Willows* (fig. 59) the irregular elliptical forms, suggestive of seeds and growth, are burgeoning with an inner energy, molding themselves around each other and the flat white center. They are large, few in number, and though modeled with thinly applied black strokes, they hug the surface like microscopic organisms seen under glass. They seem to be expanding from a black, wormlike line, giving the composition breadth without depth—a characteristic of Dove's work of the preceding decade. In *Long Island* (fig. 26) the two archetypal megaliths have been placed within a traditional landscape context in which scale, not space, is the novel feature.

In contrast, *Through a Frosty Moon* has a spatial complexity which marks the beginning of a new phase of his career. Distinctly colored planes are superimposed—light on dark grounds and vice versa—to achieve "the sensation of space," as Dove put it, "without monumental bulk," that is, depth without mass or volume. It is the space *around* as well as between these flat shapes that he seeks to describe, but because they are overlapping, contiguous, and cropped, it is impossible to read their distances clearly. By relying on the transparency of color and the layering of curvilinear planes, Dove is able to evoke more space than he actually depicts.

The same devices are employed in *No Feather Pillow* (fig. 60) but to a different end. Here, eccentric shapes, hurtling against one another like strange planetary bodies engaged in galactic warfare, occupy a space which is decidedly atmospheric. Again, their positional relations, not only the intervals between but around, are a distinctive feature of this space, enabling it to suggest the vast distances of the universe itself. The rays of light streaming in from the left, the bruiselike colors, the wavering and ragged edges, all contribute to the effect.

In *Parabola* (fig. 61) all references to nature are eliminated. Dove chose one of the conics as his motif, specifically for the spatial relations which its surface generates. The parabola is a plane curve often used in projective geometry to specify points in space and demonstrate the correspondence of curved spaces (fig. 62). As a section or a projection, it can be used to study hyperspace. In *A Geometry of Four Dimensions,* Henry Parker Manning stated:

A [four dimensional] figure can be accurately determined by its projections. . . . Much can also be learned by studying its sections. A section of a four dimensional figure is that part which lies in a three dimensional space.

One way to study a figure is to let it pass across our space, giving us a continuously varying section as if time were the fourth dimension. Another way is to let it turn, or our section of it, so that the direction of our view changes. It is along these lines, if at all, that we are to acquire a perception of hyperspace and its figures. [10]

The parabolic shapes in *Parabola* seem to do just that. Occupying different levels within the picture surface, they provide different views of the same geometrical entity and thereby demonstrate spatial correspondences.

In two paintings of 1944, *Rising Tide* and *Low Tide,* Dove returned to the cosmic landscape imagery which is a recurrent motif in his oeuvre. If these works are seen against such previous examples as *Moon and Sea No. II* (fig. 35) and *Golden Sun* (fig. 34), it is evident to what degree nature has been subordinated to the geometry. In *Rising Tide* (fig. 63), undulating bands of color weave over and under each other in self-contained, circular patterns, creating an intricate, optical space which teases the eye and mind to comprehend. Devoid of details and the particularities of place, the painting takes on a detached, cosmic perspective by allowing us to see the moon, the earth, and its waters all at once. By dividing the curvilinear planes into distinct zones of color, carefully alternating passages of light and dark, it achieves the illusion of continuous motion. It is obviously less a landscape than a subtle evocation of nature's mysterious invisible force—seen here in the swelling rhythms of the sea and the tide-making powers of the moon. That all-embracing unity of things is the suggestive content of this work, and geometry was the means of realizing it.

When this painting is considered in the context of Dove's contemporaneous diary entries quoted above, its provocative composition calls to mind the illustrations which Riemann devised to map the manifolds of curved space (fig. 64). Though these illustrations were first published in 1854, this knowledge became especially important in discussions on the nature of physical space when Einstein conceived of the universe as a spherical structure. The compositional idea upon which *Rising Tide* is based is parallel to an illustration of topological, or knotted, space (fig. 65) in Bertrand Russell's 1927 exposition of the theory of relativity, *Analysis of Matter,* which Dove possibly owned. [11] Riemann's and Russell's are mechanical diagrams which illustrate overlapping, spatial relationships. Dove's painting suggests the same sort of mapping with its undulating bands and interpenetrating shapes. However, the discontinuity of these bands violates the bland logic of an exact geometry and makes the spatial reading highly equivocal. The translucent glazing of colors introduces the sense of light and atmosphere. The circular shapes, connoting the celestial and terrestrial bodies whose curved surfaces are in fact measured with the aid of projective geometry, imbue the painting with the quality of a cosmic meditation. It has the sort of god's-eye perspective Dove sought in the 1924-26

seascapes, but here it is achieved with a considerably greater degree of pictorial sophistication.

Another kind of spatial equivocation occurs in *Low Tide* (fig. 66). Carefully scaled, interlocking triangles and the meandering lines of the riverbed are used to suggest spatial recession, but depth is checked. While the lower half of the painting is dark and veers towards a vanishing point, the upper half is dominated by a harlequinlike pattern of moonlit triangles which remain insistently forward, creating an inevitable tension between near and far, top and bottom. It is a familiar modernist device, but the deliberate coincidence here between geometry and landscape, the distinctive balance between the two, marks this work as characteristically Dove's. The theorems of projective geometry are most usually illustrated with diagrams of connected triangles which describe colineal positions seen in perspective (fig. 67). When the artist wrote in his diary the same year that he did *Low Tide,* "worked with triangle stuff," he may have been alluding to his own experiments with such spatial construction.

In *That Red One* (fig. 68), Dove tackled the problem of space by dividing the surface into a rhythmic sequence of shapes which are superimposed and contiguous. It is a boldly designed work in which the layering of circles, stripes, and truncated trapezoids represents, in effect, the movement from point to line to plane, a dimensional procession. By juxtaposing the blue and yellow U-shaped bands, a tunnel effect is implied, and then again denied by the imposing black ring which blocks the interior. At first glance, the composition is apparently symmetrical. Careful looking reveals numerous irregularities which add life and feeling: an "extra" triangle appears on the lower left; the green circle is not truly centered on the black; the blue band is much wider on the right; the shapes lack smooth edges; the red stripes are shadowed while the other areas are solidly painted. Even the flourish of his signature, boldly conspicuous in the lower center, is a foil to the seeming geometry.

Similarly in *Rooftops* (M.43.14), comprising rectangles superimposed and arranged on a diagonal axis, Dove keeps the painting from being diagrammatic by violating the sense of measurement and balance in subtle ways. The rectangles are not integral with the ground but float above it in measured cadences. They are not symmetrically placed, nor do the corners conform to a straight line. In addition, the off-key, muted colors, gestural surface, and wavering edges personalize the geometry and introduce a curiously pensive mood.

Even a painting which is unquestionably flat, like *Formation I* (fig. 69), raises the question of space. Irregular, solidly colored shapes are here coextensive with the surface and imply an aerial perspective. Alternating as lines and planes, they seem to originate from points outside the frame and suggest the composition is part of a larger whole. It is as if the painting were a

literal description of a phrase in Dove's notes—"spreading the line out as if with a trowel."[12]

Thus inspired by mathematical concepts and configurations, Dove experimented in these late paintings with various solutions to the problem of representing space. Struggling with the issue of artistic autonomy, he explored those peculiar modernist tensions between surface and depth, lines and planes, abstraction and representation, geometric form and personal expression. What his paintings and writings confirm is that he pursued the geometry of space to satisfy both pictorial and philosophic needs. In those paintings which retain references to landscape, projective geometry enabled him to give expression to nature's immensity; in works whose compositions are autonomous, it engendered sensitive dialogue among the pictorial elements. Either way it was a means to a larger end, a way to challenge our perception and provoke the contemplation of space itself as an abstract ideal.

To Dove, projective geometry or the projection of geometric entities suggested the structural means by which he could achieve the "sensation of space" without "monumental bulk" and at the same time embody an idealist vision of reality. In his late works, he rendered higher space as a process of observing relations so as to leave behind the materiality of nature and open up the mind's eye.

But what bearing does this idealistic content have on the expressive capacity of Dove's pictures? How does it affect them as art? The late works show the same obsession with celestial imagery seen throughout his work of the 1920s and 1930s, and are "based on mathematical laws," as he said of the 1911-12 pastels. Thus they are remarkably continuous with his previous oeuvre. However, the emphatic but subtle use of geometric relationships introduces an impersonal, almost imperial tone, and enlarges their content with a new associative power. By bringing these original solutions to bear on the problem of pictorial space, Dove was able to evoke a conception of the world which is physical and mystical, inspired by higher mathematics yet richly expressive.

Because science had given him the knowledge that nature is essentially mathematical in character, geometry was not just an intellectual exercise for Dove. It was nature's law. Though he delimited his references to nature and subordinated the physical world to his imaginary constructs, space was much more to him than a pictorial component: it was fraught with implications of a higher reality. It was this understanding which accounts for the expressive equivocations of his late work—the way it moves between the poles of nature and art. Moreover, the stylistic direction he pursued was the necessary consequence of his emotional perspective, a means to accommodate personal temperament. Not just a function of age or illness, the distilled power of his late style was an accomplishment, one consciously cultivated. As he wrote in his diary on August 20, 1942, "Work at the point where abstraction and reality

meet." To this end higher mathematics was "a good investment." Like the abstract essence of Plato or the efforts of physicists to comprehend the universe in a single equation, it was a way to hold the world in mind.

5

Nativism and Modernism

Discover, invent a usable past....
Van Wyck Brooks

...the past is not great enough.
Arthur Dove

The Influence of Europe

When Dove launched his career as an artist by going to Europe in the spring of
1907, he was following a well-established tradition. Ever since John Singleton
Copley left this country to join the studio of Benjamin West, the threat of
provincialism had hung over the American artist like Damocles' sword, and
going abroad—be it to London, Rome, Dusseldorf, or Paris—had been for
large numbers of painters and writers necessary and symbolic: a means to
escape the limitations of cultural life in America and to discover new artistic
possibilities. Steadily fertilized by foreign ideas and styles, American art
became a distinctive fusion of national and international experiences—the
product of a double consciousness. Dove's art is no exception.

The situation which prompted his departure was not really much different
from that encountered by his eighteenth- and nineteenth-century predecessors.
In America there was no prevailing tradition which could facilitate the
development of his own style, no vanguard activity to challenge his thought, no
community of artists with whom he could identify. Artists still occupied a
marginal position in society and could rarely live off what they sold. As Max
Weber later said about this time, "No one can have any idea how barren
America was."[1]

By contrast, the charge of Paris must have been very great. The Académie
Ranson where Maurice Denis and Paul Sérusier were teaching had been
established in 1907, and large numbers of Americans were still enrolling at the
Académie Julian. In the aftermath of the 1905 Salon d'Automne, Fauvism had

become an established fact to be assimilated by progressive painters. The Cézanne retrospective at the Grand Palais was being widely discussed, as were Bergson's lectures at the Sorbonne.

Dove did not write much of his stay abroad, but it was, as his paintings reveal, a galvanizing experience. By introducing him to the ideas and ideals of the avant-garde, it gave him the necessary impetus to overcome his provincial past and escape from the grip of illustration. Most significantly, the experience posed for him the question of how to integrate the principles of vanguard art without losing his personal and national identity, or said differently, how to be modern and American at the same time.

Because of the dialogue which American artists have historically had with European art, it has often been said that they "ape a French manner" (to use William Carlos Williams' phrase) by copying a style without understanding its reason for being. To some extent this has been true. The absence of a cumulative culture made style a problematic issue for American artists, all too easily solved by importing one. From the beginning, Dove had a strong sense of his own personality and a steadfast commitment to his own vision; for this reason he never became a minor current in the mainstream of European movements. Although his native heritage did have its limitations, it provided him with a philosophical orientation towards the world, certain inherited views, which served him in good stead. Nevertheless, as was the case with his predecessors, it was in the realm of style that European art was most useful, teaching him to explore as well as strengthen the aesthetic capacities of his own art. The dialectical interaction between European styles and nativist values which is peculiar to American art history as a whole helps to explain Dove's complex response to modernism. It determined the course of his career, and it is implicit in the very structure of his art.

There are many instances in this artist's oeuvre when his paintings or intentions are directly parallel to those of his European contemporaries— either because he was concerned with the same questions or because he consciously adopted their means. However, unlike those American artists who used foreign art in a way that was shallow or passive, Dove approached it not as an end, but as a means to enlarge his own vision. His eye roamed freely over modernism's past and present and used whatever suited his own purposes.

The 1908 painting which survives from Dove's sojourn in France, *The Lobster* (M.08.1), is a work which shows his willingness to experiment and a creative receptiveness to new ideas. It is a still-life which combines Cézanne's solid structure with a Fauvist palette. A conventional tableau of objects—fruit, a pitcher, and the lobster—are arranged on a shallow table top (its cloth has the same massive folds seen in Cézanne's still-lifes) against a busy, floral wallpaper. The chromatic intensity which Dove achieved with deeply saturated colors— reds, oranges, cobalt blue—and the bold patterns replace the wan

Impressionism which he practiced before he went abroad. When this painting was exhibited at the Salon d'Automne, it brought Dove his first taste of success. Upon his return to New York in the autumn of 1909, it gained him entrance into the Stieglitz coterie and was exhibited again in a 1910 show called "Ten American Painters."

At 291 Dove found a milieu which further reinforced the lessons he had learned abroad and which strengthened his commitment to vanguard art. Moreover, this milieu gave him the theoretical foundation necessary to articulate his yet unformed values. In 1908 Stieglitz initiated a series of exhibitions of modern European art which represents a significant milestone in the cultural history of this country. These shows, which included the work of Rodin, Matisse, Cézanne, Picasso, and Rousseau as well as primitive art and children's drawings, were part of that larger climate of international awareness which characterized the New York art world prior to America's involvement in World War I. The ideas of Bergson, Freud, and Marx were just beginning to make themselves felt, and all the arts were absorbing stimuli from abroad. It was a time of rich intellectual ferment and ebullient confidence, and this atmosphere generated an enormous amount of cultural activity. There was an optimistic faith that America had at last "come of age" and was experiencing a rebirth in the arts. As the editor James Oppenheim of *The Seven Arts* wrote in 1916: "It is our faith and the faith of many that we are living in the first days of a renascent period, a time which means for America the coming of that national self-consciousness which is the beginning of greatness."[2]

The first series which Dove exhibited at 291 in 1912, *The Ten Commandments,* provides important insight into how he was to adapt the principles of vanguard art to his own ends. In the course of doing it, he not only evolved a concept of organic form, but also assimilated the diverse stimuli of Symbolism, Fauvism, and Cubism. The dynamics established in these early drawings between natural fact and abstract form endure throughout his oeuvre.

Because of their linear freedom, *Cow,* for example, and *Based on Leaf Forms and Spaces* are akin to Symbolist art of the late nineteenth century yet lacking its hermetic and dreamlike quality. In the latter (fig. 70), loosely drawn forms are vertically arranged in interlocking patterns, alternating light and dark. Their edges are cropped by the frame, conveying the impression that the composition is a small part of a larger whole. In their implied movements, the fluid forms acquire the semblance of vitalistic energy, and suggest the idea that nature is not just a collection of forms but a living force. They are sufficiently vague and undifferentiated so as not to recall specific leaves and plants, yet the curvilinear structure and asymmetric interstices are strongly evocative of organic life which is in a state of growth or change, responding to the stimuli of the environment. In his 1913 letter to A. J. Eddy, Dove described this pastel as

"a choice of three colors, red, yellow and green, and three forms selected from trees and the spaces between them that to me were expressive of the thing which I felt."[3] In keeping with the Symbolist tradition, Dove rendered nature through the veil of personal emotion, while still observing what he perceived as nature's law: "a few forms, a few colors."

This particular adaptation of a European aesthetic to his own nativist values can also be observed in other pastels which are more geometric in character. For example, in *Nature Symbolized No. 1* (fig. 71), circular, triangular, and narrow rectangular planes are superimposed in a shallow space, outlined in charcoal and solidly colored in blue, brown, and cream. They are lightly shaded, not to imply volume but to vary the quality of light. Though this composition comprises geometric elements and references to nature are eliminated, the layering of small shapes on larger ones creates a traditional sense of perspectival space which prompted an early reviewer to see the composition as "a suggestion of roof and factory chimneys."[4] In its use of geometric planes, this pastel shows a marked similarity to Picasso's Cubist works of 1908-9 which were exhibited at 291 from March 28 to April 5, 1911. However, when compared to a Picasso of this era, for example *Factory at Horta de Ebro* (fig. 72), it becomes clear how Dove adapted the Spaniard's innovations to his own ends. In Picasso's painting, the building is represented as broadly faceted, geometrized forms; the *passage* from one plane to another is obscured by shadow or left incomplete. By fragmenting the objects in nature, Picasso eschewed perspectival continuity and achieved the Cubist simultaneity between surface and depth which is crucial to the painting's perceptual ambiguities.

Beginning with planes instead of volumes, Dove avoided these spatial tensions and complexities. Because his shapes have closure, their relation to the surface is always clear. Color is confined within its boundaries, and the shading has none of the ambiguity of Cubist *passage*. Although Dove's pastel is more abstract, i.e., comprising pictorial elements which are autonomous and nonreferential, the concept on which it is based is much less radical than Picasso's for it does not violate the laws of perspective or the integrity of form. When Dove wrote that "a few forms"—here circular, triangular, and rectangular—and "a few colors"—brown, cream, and tan—"sufficed for the creation of an object," he knew what he was about. Whereas Picasso used geometry to exploit the tension between art and nature (a tension which becomes increasingly pronounced in his later Cubist works), Dove, though inspired by Cubist faceting, adhered to the organic analogy and used geometry as the meeting ground between art and nature. He adapted a rough semblance of Cubist structure without its underlying tension between the natural and pictorial, not because he misunderstood Cubism, but because it contradicted his own belief in nature as the ground of art. This same approach can be

observed in *Nature Symbolized No. 2, Sails,* and *Team of Horses*—geometric shapes in a limited palette are superimposed within a shallow space. By applying what he took to be nature's law to autonomous forms, Dove reconciled modernist innovation with his own nativist values. This quality became a defining characteristic of his art, one which continued to distinguish it from that of his European contemporaries.

Although Dove had no knowledge of Kandinsky's art in 1911, the parallel between Dove's early pastels and Kandinsky's contemporaneous works is frequently cited in the Dove literature because both artists turned to abstraction at approximately the same historical moment. However, the comparison is more significant for the differences it reveals than for the similarities. It has the same implications as that between Copley and Gainsborough, Kensett and Courbet, or Homer and Monet. What becomes immediately clear is the American artist's penchant for line, the insistent need to define, delineate, and demarcate.

For example, in Kandinsky's *Improvisation 23* (fig. 73), also of 1911, lightly modeled, irregular explosions of pure color and isolated, linear configurations float freely in an undefined but atmospheric space. Color assumes form without the aid of line, and line functions as an autonomous element, trailing across the surface like an unwinding ribbon, and giving the painting an exhilarating sense of freedom. By contrast, the composition of Dove's pastels is much more studied. Instead of exploiting the atmospheric possibilities of the pastel medium, he contained his colors within distinct geometric shapes. He was, in effect, diagramming his pictorial idea, trying to anchor the elusive potential of an abstract idiom in the certainty of geometry. At this point in their careers, Kandinsky was forty-five years old and a mature artist; Dove, at thirty-one, was a novice just beginning to explore the new knowledge which modernism was.

Dove's particularly graphic solution to the challenge of abstract art is one with ample precedents in American art. If his pastels are now juxtaposed to such a quintessentially American art as an early limner portrait (fig. 74), the nativist component of his early style becomes even more apparent. In the eighteenth-century painting, the figure of the woman has been drawn against a shallow space, and each shape is like a paper cutout, pasted in its proper place without modeling, tone, or atmosphere. Though Dove was working in a vastly different set of circumstances, the roots of his indigenous vision can be found here. He shared a pictorial sensibility with his American ancestor which endured right beside all the other influences which came to bear upon him.

To appreciate the boldness of Dove's achievement in these early pastels, it must be recalled that there were no precedents in American art for such work, that they were done two years after he returned from Europe, one year before the Armory Show, and that they are remarkably different from anything his

contemporaries were doing at the same time. While the European art he saw abroad and at 291 introduced him to fresh stylistic possibilities, the styles were adapted to accommodate his own nature-based content and linear bias.

Americanism

One year after *The Ten Commandments* were exhibited at 291, the largest and most important exhibition of modern art to be held in America opened at the Sixty-Ninth Regiment Armory on February 15, 1913. Preceded by one of the greatest publicity campaigns in the history of art, the Armory Show was attended by one hundred thousand people in New York alone and made a dramatic impact on the American public. It included over twelve hundred works of modern painting and sculpture, one-third of which were foreign. Because so little modern art had been seen in this country prior to the exhibition, it forced the American public to recognize modernism as a new phenomenon in the arts. It brought the issue of abstraction and the existence of an avant-garde squarely to the public's attention and suggested that art was progressive and advancing, just like the sciences and industry.[5] Though it seems to have had little impact on the artists themselves, it dramatized the relative state of the arts at home and abroad and prompted much critical debate on the identity of American art.[6] Dove did not participate in the Armory Show and he was already established in a modern idiom by 1913, but he could not remain unaffected by the heightened national awareness which ensued.

Just a year later John White Alexander, president of the National Academy of Design, wrote an essay entitled, "Is Our Art American?"[7] The question was certainly not new. It had been pondered by earlier generations of artists, but after the Armory Show it became a central preoccupation. Because this exhibition had dramatized the issue of cultural identity, one of its major consequences was to create a dramatic shift in consciousness. The marked internationalism which had characterized the New York art world before 1913 was gradually supplanted by a pronounced emphasis on Americanism.[8]

One example of this changing consciousness was The Forum Exhibition of Modern American Painters which was held in 1916 and organized by Henri, Stieglitz, and others. Because the European artists had received so much attention and publicity as a result of the Armory Show, this later exhibition was intended to call the public's attention to the best work of American modernists.[9] It contained one hundred ninety-three paintings by seventeen artists, including several by Dove, and no foreign art.

Other indices of the rising tide of nationalism are found in the writings of the cultural critics who made fervent appeals for the development of a great national culture.[10] Their writings are often Utopian in tone and based on the belief that America had an important role to play in world culture. For

example, Randolph Bourne envisioned the creation of a "Trans-National America" which gained its strength from the retention of national differences. Van Wyck Brooks argued that America had at last "come of age" and that our artists should define for themselves "a usable past" instead of looking abroad for inspiration. In particular, Paul Rosenfeld and Waldo Frank gave lofty, grandiloquent expression to this new consciousness.[11] Because they were closely involved with Stieglitz and represent an extension of his basic philosophy, they help to illumine the influence which he had upon the artists he represented.

In the belief that Americans had cut themselves off from their own lifeblood, these writers urged artists to look to their own history, make contact with their own land, and cultivate a sense of place. They contended that the way to achieve this great native expression, this sense of national identity, was to establish an elemental relation with the native soil and the objects of one's immediate environment. By staying close to nature, it was believed one could live instinctually, grow spiritually, and avoid a life that was secondhand. Their discussions did not remain in the realm of theory. As Van Wyck Brooks described the 1920s, everyone who could was moving to the country in this search for self-definition, "in search of 'roots'.... No word was more constantly on their lips unless it was native soil or earth."[12] There was really nothing new in this idea. Americans have always accepted the mythic possibilities of their land, but in 1920, it was an affirmation as well as a reaction against the international focus which had characterized American culture before the war.

These authors attempted to awaken the American artist to the advantages of his own situation in a still new country and guide him into a less humble relationship with Europe, but their writings are marked by a strange inconsistency.[13] While they recognized the need for an independent art, they were by nature cosmopolitan in their outlook and continued to appreciate the achievements of European culture. This inconsistency, or perhaps equivocation, is characteristic of Dove's own thought as well. As his writings and art demonstrate, his feelings towards both Europe and America are not without some ambivalence. On the one hand, he knew that his own past, i.e., American art history, was "not great enough"; he recognized that the isolationist view of American critics could only lead to an art that was small-minded and that the process of exchange was healthy. As he once remarked in a conversation with the artist Alfred Maurer:

> The American painter is supposed to paint as though he had never seen another painting.... The French come and go freely through the history of art, back and forth, from the early stone cutters to their own hieroglyphic-like work, everywhere along the road, taking what stimulates, adding, discarding, absorbing. How can one do otherwise?[14]

On the other hand, he resented the cultural supremacy of Europe and always having to work in the shadow of the French, remarking once that "France has become a religion in art."[15]

Thus, by the end of World War I, the situation for modern art in this country began to change in dramatic ways.[16] What had begun as an appeal for America's cultural independence evolved into a dogmatic chauvinism in which political boundaries became artistic ones. Modern (i.e., abstract) art was considered by many critics to be un-American because it was basically a foreign import. Many of the galleries devoted to the exhibition of it went out of business, as did several vanguard publications, *Camera Work* being chief amongst them. Also, the discussion groups which had provided an important network of support and exchange gradually disbanded. Stieglitz's 291 closed its doors in 1917, and Mabel Dodge's soirées ended that same year when she moved to Taos. In the early 1920s, the Walter Arensbergs, whose apartment on West 67th Street had provided a meeting ground for vanguard artists and literati, moved to California.

The most obvious consequence of this great outcry for an American art untainted by foreign influence was the surge of regionalist and social realist art which was produced during the 1920s and 1930s. The pressures created by the depression had raised the question of how art could establish a meaningful relationship to life, and for many the answer was found, as had so often been the case before, in local subject matter and not in style.

The situation for Dove was made all the more difficult. Buyers were scarce, and his position in the art world became all the more isolated. On the whole, he and his fellow artists in the Stieglitz circle remained aloof from the pressures for an art which addressed itself to economic and social realities. However, even within this group, a change of emphasis can be observed. Stieglitz, who had been an easy target for the chauvinist critics, never again exhibited foreign art, choosing to dedicate himself to the survival of a few Americans. He later maintained that his early exhibitions of modern European art at 291 had been a necessary stimulant for the development of an independent American art: "In the years before the war, I was constantly thinking of America. What was '291' but a thinking of America?"[17] When he reopened his gallery in 1925, he specified in an exhibition brochure that "The Intimate Gallery is dedicated primarily to an Idea and is an American Room. It is used more particularly for the intimate study of seven Americans. . . . "[18] This focus became even more pronounced when he titled his next gallery which opened in 1929 An American Place. However, Stieglitz never became isolationist in his views. He remained involved with vanguard activities and continued to maintain his high-minded vision of what American art could be.

Except for Hartley, the Stieglitz artists remained in America after the war, painting nativist themes, cultivating a life with the soil and a sense of place.

Marin painted the New York skyline and the Maine coast. O'Keeffe alternated between Abiquiu and Lake George. Hartley went to Taos and eventually settled in Maine. Dove never left the vicinity of New York. In their attachments to place, these artists too were regionalists of a sort, but they used locale as a means, not an end, attempting to grasp the meaning of America in modernist terms. [19]

Dove was not immune to this rising current of nationalism, but he refused to lower his standards. Because his experience with European art came at a formative moment in his life, he understood that the creation of a great national art was more complex than a depiction of the American scene. As he wrote:

> When a man paints the El, a 1740 house or a miner's shack, he is likely to be called by his critics American. These things may be in America but it's what's in the artist that counts. What do we call "American" outside of painting? Inventiveness, restlessness, speed and change. Well then, a painter may put all these qualities in a still-life or an abstraction, and be going more native than another who sits quietly copying a skyscraper.... [20]

For Dove there was no choice between being modern or American: he had to be both. Taking a broader perspective than his critics and most of his contemporaries, he asked questions which ultimately transcend nationality. What makes art effective and affecting? What makes it historically significant? What makes it survive? By cultivating a style of expression which could be adequate to his idealism and true to what he called "the new feeling," and by pondering those values which are enduring and immune from cultural relativism, he knew that the issue of nationalism in art would take care of itself. As his diaries indicate, he maintained a lively interest in all vanguard activities. He continued to attend exhibitions, read *Cahiers d'Art*—often translating into English articles on painters he wanted to keep for future reference—and also read the little magazines, like *transition,* to keep abreast of literary developments as well. It was this open-minded approach which enabled him to respond to the art of his European contemporaries and of those within the Stieglitz circle while pursuing his own solution to the challenge of modernism.

Dove and O'Keeffe

The personal relationships among the 291 artists—Hartley, Marin, O'Keeffe, and Dove—had a significance more symbolic than real. They rarely saw each other, but through the sheer force of Stieglitz's personality, not to mention the staggering quantity of letters he wrote, they continued to see themselves as a group. This belief in their common historical role, dramatized by their opposition to the mania for American scene painting, gave them a sense of collective solidarity. Dove drew great strength from his association with this

group and probably could not have endured without it, for it helped assuage the isolation he felt as an artist in America. However, his periodic visits into the city became less and less frequent as he got older, and after Maurer died, Dove's closest friends, outside of Stieglitz of course, were not artists.

From the remarks made in his correspondence and diaries, Dove admired Marin greatly and Hartley less so, but it was with O'Keeffe that he felt the greatest affinities. The only painting Dove hung in his houseboat was an O'Keeffe, and she in turn owned several of his (and still does). On rare occasions they would write or O'Keeffe would visit at the Doves' homes in Geneva and Centerport, but the highest form of communication took place in their art. In both their oeuvres there are examples of exchanges and borrowings of individual motifs, whole compositions, and pictorial techniques.

For example, the composition of Dove's 1929 *Silver Tanks and Moon* (fig. 75) is the inverse of O'Keeffe's 1926 *City Night* (fig. 76), in which the looming black silhouettes of two skyscrapers converge on a wedge of purple sky. They are seen from below with the reeling perspective of someone standing in the midst of a city block looking up. Between them is a very small moon which is just beginning its nocturnal ascent. O'Keeffe imposed a lucid clarity upon the city scene and radically simplified it of extraneous detail so that only broad sheaths of solid color with hard, clean edges remain.

In Dove's painting the silver tanks are similarly imposing, permitting only a narrow expanse of sky to remain visible between them, but the tiny moon has been placed high in the sky overhead. Instead of O'Keeffe's sharp, clear color contrasts and glasslike surfaces, Dove's palette is monochromatic, a single shade of silvery blue, which has been applied with gently pulsing strokes. The compositional format is analogous to O'Keeffe's, but the subject matter, which was atypical for Dove, is like the industrial landscapes of the Precisionists.

Other examples of correspondences and parallels between these two artists abound. Dove's 1935 *Cross and Weathervane*, with its objects afloat on an undefined space, is remarkably akin to O'Keeffe's 1923 *From the Flagpole*.[21] The same saw-toothed curves he used in *Team of Horses* in 1911 occur in her *Orange and Red Streak* in 1919. O'Keeffe's 1944 series *Black Place* is reminiscent of Dove's 1938 *Thunder Shower*, in which massive, jagged formations are divided down the center by a lightninglike white line. The waves and hills rendered as slightly shaded undulating lines in Dove's *The Wave* and *Moon and Sea No. II*, both of 1926, occur in her *Black Cross New Mexico* of 1929. In turn, several of O'Keeffe's early watercolors show interesting formal similarities with his later works: her 1917 *Evening Star* with his 1937 *Sunset* series; her 1917 *Light Coming in on the Plains* with his 1937 *Golden Sun*. Working in the same milieu, Dove and O'Keeffe shared many of the same values and artistic ideals. Rooted in the Romantic tradition, they both developed a nature-based imagery which could be vitalistic or visionary.

However, they were ultimately of different temperaments. Because Dove had gone to Europe early in his career and she had not, he was more open to artistic exploration and assimilated a broad range of pictorial and intellectual concepts which had a direct bearing on the character and content of his art.

European and Folk Inspirations

Even as the critics were making appeals for "a great native expression" untainted by foreign influence, Dove continued to look abroad for inspiration. Sometimes it even came to him. In the decade following *The Ten Commandments* he did a group of works which show the decided influence of Dada, in particular, the art of Francis Picabia. Picabia arrived in New York in 1913 for the opening of the Armory Show and overnight became a celebrity. Not only were his paintings amongst the most notorious in the exhibition, but his theories were widely discussed by the press. *Camera Work* published enthusiastic essays on him and on machinist aesthetics, and shortly after the Armory Show closed, Stieglitz honored him with a one-man show.

According to an early newspaper account, Dove first met Picabia at 291 one day in 1913 as Stieglitz was hanging the latter's work. Dove was surprised to see that it paralleled his own, which Stieglitz then brought out to show Picabia. "Recognition followed as quickly as though two persons born with strawberry marks upon their arms had suddenly discovered the fact."[22] No doubt entranced by the coincidental similarities, Dove seems to have deliberately emulated the Frenchman's interpretation of Cubism in a pastel of 1913, *Pagan Philosophy* (fig. 77).

Even though he was already familiar with Cubist faceting, the influence of Picabia rather than Picasso is evident in Dove's flatter, more curvilinear treatment of form. *Pagan Philosophy* is a studied attempt to incorporate the formal tensions which were notably absent from *The Ten Commandments*. The closure of forms, which had distinguished Dove's earlier use of the Cubist idiom, was replaced by the *passage* device to achieve fluid, albeit ambiguous surface transitions. The forms are not referential but they still suggest pipes, gears, and cogs, and their visual rhythms suggest the staccato movements of machinery. The most telling change is in the new structure of space. Rather than layering flat shapes in such a way as to suggest spatial recession, Dove arranged the forms, now open and continuous, in interlocking patterns which defy clear spatial relations.

When Picabia returned to New York in 1915 and then again in 1917, he and Duchamp were already fanning the fires of Dada. Their combined influence in America was considerable, affecting the careers of Man Ray, John Covert, Joseph Stella, Morton Schamberg, Charles Demuth, and (to a lesser extent) Charles Sheeler. With their machine aesthetics, they awakened these

American artists to the distinctions and peculiarities of the American environment. Dove also responded to this new stimulus in his milieu with three paintings of 1921-22: *The Gear, The Lantern,* and *The Mowing Machine.*[23] However, his very choice of objects and style reveal how truly foreign Dada aesthetics was to his own purposes as an artist; for to Dove, *épater le bourgeois* was not a motivating ambition. In comparison with the mechanomorphic ironies of Duchamp and Picabia his subjects are rendered with an embarrassing literalism. The machinery is that of the farm, not the factory, and it looks handcrafted rather than measured and precise, but the personal significance of this approach can be understood when the paintings are viewed in another light—as a response to the critics' appeal for an indigenous art based on the artist's relation to his own locale and the objects of his immediate environment.

Dada's appearance on the New York art scene occurred at a fortuitous moment for Dove—a time when his career was marked with uncertainty and indecision—and it proved to be an important stimulus, awakening him to new possibilities of artistic creation. Although his own response to machine aesthetics was somewhat lackluster, the assemblages which followed are amongst his freshest and most inventive works. By adapting the example of Dada into a vehicle for the expression of his own personality, he achieved in these assemblages an art form which was modern and American at once.

Begun in 1924, Dove's assemblages are whimsical arrangements of objects found on the beach or in a hardware store. They fall roughly into two categories—"portraits" and nature studies. Because they have been treated elsewhere, a couple of examples will suffice to illumine how this nativist/vanguard dialectic is operative in this new body of work.[24]

In *Huntington Harbor II* (fig. 78), horizontal undulations have been painted on a piece of metal to represent clouds, horizon, sea, and shore. Scraps of natural materials—canvas, sandpaper, strips of balsa wood—and sand have been positioned on these painted lines to represent a ship at sea and the vertical rhythm of the piers along the shore. Unlike Picasso's constructions in which ordinary objects are radically dislocated from their usual contexts or surprisingly juxtaposed, Dove's materials have undergone no radical transposition of meaning: canvas stands for a sail, wood for the piers, and sand for the beach. Through the process of judicious selection and placement, these materials acquire a sign-function, but as in the machine paintings, there is a literalism in the artist's use of them.

In *The Intellectual* (M.25.7), a magnifying glass, a chicken bone, a bit of moss, and a pocket scale are vertically arranged on a piece of striped chiffon. Again by association they endow the composition with figurative and metaphorical qualities. The objects do not lose their denotative meaning but acquire connotative value in this thematic context. With seeming

effortlessness, they satirize those who weigh and measure, scrutinize and analyze, rather than respond to life directly.

For these works Dove had ample precedents. The first vanguard use of the collage medium was made by Picasso and Braque in 1913, and in 1921, the Merz constructions of Kurt Schwitters had been exhibited at the Société Anonyme. Object portraits, not necessarily collages, had been done by Marius De Zayas, Charles Demuth, and Picabia (whose *Ici, c'est ici Stieglitz* directly inspired Dove's collage portrait of the photographer). Also, as a result of the growing concern for an indigenous art, there developed in the early 1920s a strong interest in America's folk past. In 1924 the artist Henry Schnackenberg was invited to exhibit his collection of primitives at the Whitney Studio Club; and in 1926 there was a similar exhibition at Isabel Carleton Wilde's gallery.[25] For those interested in finding the roots and origins of the American experience, folk art represented a viable means.

Parallel, then, to both American and European precedents, Dove's assemblages have, nevertheless, a distinctive flavor. They lack the sophisticated ironies of Picabia and Duchamp and the aesthetic ambiguities of Picasso and Braque. The radical assumptions and attitudes towards art which the European artists introduced in their work are not operative here, and unlike the Surrealist constructions they are not meant to juxtapose two different levels of reality. While Dove's assemblages show the same disregard for "fine" materials as Schwitters', they do not employ the detritus of urban life, and their humor is not barbed with social criticism. Like that of the folk artist who arranged domestic and natural materials within a tableau, Dove's approach is gentle and ingenuous. The materials employed are not intended to baffle or shock, but bemuse. The artist establishes a comfortable rapport with the viewer, as in a neighborly conversation over the back fence. Though the assemblages have been compared frequently to the novels of Mark Twain, the comparison remains useful: it points out the delight Dove took in the commonplace and how he was able to put the vernacular to artistic use.

The abstract style of Dove's paintings demonstrates his recognition that the creation of an American art must go beyond subject matter to a new range of formal values, yet the assemblages are a characteristically American response to vanguard innovation in their affinities with the traditional genres of portraiture and landscape. Moreover, because of their commonplace materials, they afforded Dove an ideal way to assume the antiintellectual persona which was so popular among the Stieglitz coterie. By incorporating these various levels of association, they underscore the originality of Dove's response to the complex artistic situation in which he lived. They represent his solution to the problem of creating an indigenous art that utilized vanguard aesthetics and was at the same time a true expression of his own personality.

Besides the assemblages, some other works which possess a frankly nativist character are those done in the early 1940s, which employ the designs and motifs of American Indian art. Like folk art, Indian art represented a way to establish roots and work from "the usable past." Important precedents for Dove's interest in the Indian are to be found in a series of seven paintings which Marsden Hartley did on this theme in 1913. Hartley also wrote an essay in 1919 called "Red Man Ceremonials: An American Plea for American Esthetics," in which he argued that Indian art was a means by which Americans could establish an aesthetic consciousness of their own: "The Red Man is the one truly indigenous religionist and esthete of America. . . . He has the calm of our native earth. It is from the earth all things arise."[26] Numerous American artists and writers began flocking to the southwest early in the century, Hartley, Marin, and O'Keeffe amongst them; and growing out of this western consciousness, an enormous exhibition of American Indian art was organized by John Sloan in 1930 and traveled around the country. The Indian then had great symbolic value in Dove's milieu as the original American who lived instinctually and in harmony with the earth. Whereas the French, as Dove once noted, had to go all the way to the Congo to find their primitives, America had its very own.

Although Dove's interest in Indian motifs has been observed, it has never been explained in the context of his oeuvre.[27] Curiously, these motifs do not appear in his art until 1941, long after his colleagues had manifested their interest in the West. However, it was not until Dove's style was already undergoing a radical transformation—away from organic and biomorphic form to planar, hard-edged shapes—that the geometric character of Indian design became amenable to his own purposes.

Dove's diary records that in July of 1940 he "ordered rug illustrations" from L. L. Bean and "got new rug and Navaho blanket." By 1941, Indian motifs began to appear in such paintings as *Square on the Pond, The Inn, Primitive Music,* and *The Brothers. Square on the Pond* (fig. 79) contains the ripples and triangulation seen in pottery, rugs, and basketry, and has the same flat space which has been divided into horizontal zones. Also, the colors are vivid—blue, purple, yellow, chartreuse, and tan—and are balanced by a predominant use of black. However, unlike the free use of geometric elements on an open field as seen in the Indian arts, Dove's technique was to transpose these motifs, as he did so many others, into a landscape context. The ripples become the sea and shore, the zigzag formation the mountains. In this way, Indian design helped Dove create a modern art which had its roots in America's own history. It enabled him to use the past while responding to the present.

Dove and Kandinsky

On the whole, Dove was more significantly influenced by his European contemporaries. Besides the temporal coincidence between Dove's and Kandinsky's first abstractions, there are other ways in which the two warrant comparison. Both artists came to abstract painting under the influence of Symbolist aesthetics. Both militated against a materialist view of life and consequently turned to theosophy. Nevertheless, because of their national origins, they arrived at remarkably different conclusions about the end of art and its relation to life.

Although Dove had been aware all along of Kandinsky's stature as a painter and theorist, it was not until 1927-28 in a series of pictures whose titles, for the most part, refer to music that the influence of Kandinsky's art on Dove's can be seen. Significantly, the likeness is not to Kandinsky's hard-edged contemporary works, done during his years at the Bauhaus, but rather to those of freer form which date from 1910 through 1914. Dove may have been prompted to experiment with Kandinsky's style at this point because the two artists had exhibited together the year before at the Société Anonyme, or it may have been the fact that Kandinsky had written at length about the musical analogy which at this point began to interest Dove.

The real lesson which Kandinsky held for Dove can be seen in the American artist's new, autonomous use of line in such works as *George Gershwin, "Rhapsody in Blue," Part One* (fig. 80), *I'll Build a Stairway to Paradise,* and *Orange Grove in California, Irving Berlin.* However, whereas Kandinsky strove for a pictorial balance among his colored forms and the superimposed black lines, Dove used color to fill the interstices within his linear configurations so that lines and ground are not nearly so equivalent. In *Distraction* (fig. 49) and *Colored Drawing, Canvas* (M.29.3), Kandinskyesque motifs are placed within a naturalistic space. While this may at first suggest the American's clichéd misapprehension of the reason behind vanguard innovation, it is also true that Dove's priorities were different. This distinction is also evident in the way these two artists responded to the influence of occultism.

Whether or not Dove was aware of Kandinsky's involvement with theosophy is a provocative question. Dove owned a copy of *Concerning the Spiritual in Art,* in which the TS is praised as "a great spiritual movement," and he had had ample opportunity to see Kandinsky's art in the exhibitions of the Société Anonyme, where he might have observed the graphic symbols of *Thought-Forms* (fig. 81).[28] Moreover, Dove's statement that "the moderns have gotten into a receipted formula, in reality built on the old religions or so-called secrets of the masters" makes one wonder which moderns he had in

mind. However, even if Dove had identified Kandinsky with theosophy, the two artists responded to this philosophy in fundamentally different ways.

Dove's interest in the occult is not manifested in his art until the mid-1920s whereas it was an important factor in Kandinsky's move towards abstraction.[29] The allusions to the occult in Dove's writings correspond closely to the ideas of Claude Bragdon, who was close in spirit to the Eastern religions on which theosophy was originally founded. Kandinsky's knowledge came through the work of Rudolf Steiner. Steiner had rejected theosophy's Orientalism and substituted a Christian interpretation of Madame Blavatsky which entailed the fundamental opposition between the material and spiritual worlds.[30] This difference in the orientation of their sources led to important differences in the artists' work and theories.

To Kandinsky, form was matter and had to be overcome for the spiritual in art to be manifested. Thus, he pushed his imagery to the brink of abstraction from 1910 through 1914, the years of theosophy's most direct influence, and gradually abandoned referential form altogether. For Dove, materialism was a social condition, not a physical fact. The physical world was the visible manifestation of the spiritual; the two were not in conflict as they were for Kandinsky because they were conceived to be gradations of the same substance. From this premise, Dove did not need to eliminate references to nature to reveal its spiritual essence. In this way he reinterprets the tradition of nineteenth-century landscape under the influence of occult thought. His American heritage and immediate intellectual context caused him to work in a direction parallel to yet innately different from Kandinsky's.

This difference is most evident in how these two painters resolved the opposition between nature and art. For Dove, who employed the organic analogy for most of his life, there was but one realm of truth from which art and nature both derive. For Kandinsky, art and nature were independent, separate, and not necessarily equal. He wrote in 1911, "That art is above Nature is no new discovery,"[31] and in 1926 in *Point and Line to Plane*, long after his move into nonobjective art, he used illustrations from biology and physics to demonstrate how nature might aid the artist in the formulation of new laws. As previously discussed, Dove too saw that the scientific study of nature offered the artist a rich guide, but he never went to Kandinsky's extreme. He never strayed too far from the motif, believing as he did that "what we call modern should go smack to nature as a source."[32]

Dove and Klee

Resolving the opposition between art and nature was for artists in the early decades of this century a virtually ubiquitous concern, demanding in each instance personal resolution. It is also a main current in the artistic theories of

Paul Klee, an artist whom Dove very much admired.[33] Frequent references to Klee occur in Dove's writings, and pointed similarities to Klee's art can be found in the paintings Dove did after 1929. There is good reason for this affinity.

Deriving ultimately from the same German Romantic heritage, both artists were preoccupied with metaphors of growth and genesis. Both sought to express nature's invisible forces which give form to external phenomena. Both explored that mysterious link between the terrestrial and celestial and saw universal design in the smallest bits of nature. Because they both had an innate interest in the natural sciences, the biological paradigm often served them as an artistic stimulus, yet they put this knowledge to different artistic ends. Whereas Dove would employ the organic analogy in such works as *Plant Forms* or *A Walk Poplars* by using forms which suggest the forces of growth or in later works by retaining a landscape context for his abstract compositions, Klee would characteristically embed the organic analogy within the pictorial elements or structure. In his *Growth of Nocturnal Plants* (fig. 82), waving columns of small stacked shapes create the unmistakable impression of reeds in the wind while the distribution of colors reinforces the idea of nature's incremental growth. In Klee's later work, such as *Individualized Measurement of Strata,* the idea of movement and growth becomes even more implicit, more integrated with the surface itself, as references to objects in the world disappear altogether. Thus Klee located his pictorial elements in an autonomous, nonnaturalistic space while Dove, for the most part, conceived of the picture plane in a highly traditional way—as a window through which we view the artist's vision of the world.

Still, there are several instances when Dove's work assumes distinctly Klee-like qualities. For example, *Sun on Water* (fig. 83) is a painting whose quiet power derives less from its associations with landscape than from the rich syntax of its pictorial elements—subtly colored fragile shapes and delicate incisive lines like those seen in Klee's "Polyphonic Paintings" of the late 1920s and early 1930s. These pictures were also a useful precedent for the work Dove began doing after 1940 because they suggested a way to introduce "the sensation of space" without "monumental bulk." For example, in *Anonymous* (fig. 84), irregular, translucent planes of orange, yellow, green, blue, purple, and tan interlock and overlap on a turquoise ground. They, at once, break up the surface into multiple layers of solid color and yet are bound to it, adding movement and depth with the static frame. The effect here and in others like it (*Through a Frosty Moon, On the Bank*) is closely related to Klee's paintings (fig. 85) in which continuous lines intersect to form translucent planes. Dove would have had ample opportunity to study Klee's work, for it was exhibited in New York galleries and museums during the 1920s and 1930s and was frequently illustrated in *Cahiers d'Art.*[34]

However, despite such similarities, an important difference must be noted in how these two artists conceived of the relationship of art and nature. Although Klee often espoused the importance of nature to the artist and was himself a student of the natural sciences, all his research into organic form was ultimately directed towards the illumination of the creative process.[35] As he said, nature is "the art of Someone Else, but it is an instructive example when we are attempting to realize something analogous with the formal elements of pictorial art."[36] To Klee, whose range of philosophic reference was large, nature was one kind of creation, art another. Like Kandinsky, he cut the umbilical cord between the two, putting nature in the service of art. To Dove, nature was more than "an instructive example." It was the locus of authority, the wellspring of reality. Thus, Dove put art in the service of nature and located his meaning in specific forms and themes which direct the viewer to some aspect of life beyond the picture frame. The significance of this difference between Klee and Dove cannot be overstressed, for it bears directly on the character of their entire oeuvres.

Surrealism

For Dove, being a modern artist meant staying abreast of significant developments and changes within the vanguard movement. It was not a static condition but a process of change and assimilation. In addition to the influences of Picasso, Picabia, Dada, Klee, and Kandinsky, his art was also, for a brief time, affected by Surrealism.

By the early 1930s Surrealist art was easily available to Dove in New York.[37] In 1932 Julien Lévy held the first exhibition of it in America and continued to sponsor the movement throughout the decade. In 1933 Miró and Masson were given shows at the Pierre Matisse Gallery, and in 1934 Dali made his well-publicized appearance in this country (which Dove noted in his diary). Even before these exhibitions were initiated, however, Dove's appetite for Surrealist art had been whetted by the illustrations in *Cahiers d'Art* and by the steady stream of Surrealist literature which began to appear in the late 1920s in the little magazines—*Broom, Secession, transition*—which Dove read with enthusiasm. In addition, Stieglitz was friends with Lévy and was occasionally involved with the artists and events at Lévy's gallery.[38]

Surrealist art represented a number of pictorial possibilities, but not all were apropos to Dove's own purpose. The irrational illusionism of Salvador Dali and René Magritte did not appeal because it smacked of the illustrative work he so detested, nor did the psychic automatism of André Masson and Max Ernst, designed to release the mind's unconscious resources. What Dove most clearly responded to in Surrealism was Joan Miró's and Jean Arp's use of biomorphic form.[39]

Biomorphism suggested to Dove a means to experiment with a new style while continuing to work within the framework of organic expression. It demonstrated formal and expressive possibilities which were consistent with his own artistic philosophy, and also represented a significant change of orientation. In Dove's earlier works, the organic forms are derived from a close scrutiny of external phenomena—plants, leaves, shells. However, the focus of biomorphism is inward; it is an evocation of the inner, physical life of living beings. Recruited from the body's interior, the forms are suggestive of organs, tissues, ligaments, follicles, and so on—the whole invisible network which exists behind the flesh. Having their roots in the vitalism of art nouveau, biomorphic forms are evocative of organic processes and are used to reveal life at its most primal level. They are forms we instinctively identify with visceral sensation. However, in Dove's art, as is the case with all his other adaptations of vanguard innovations, they function in a highly idiosyncratic way.

Dancing (M.34.4), for example, is a profusion of protoplasmic forms which seem swollen and afloat within the ambient space. While the particular character of the forms and their colors—deep purple, dull yellow, some red and blue—do evoke the thought of gastronomic processes, the composition has been anchored on the low horizontal axis, seen throughout Dove's oeuvre, which automatically creates the context of landscape. In other paintings of the middle 1930s—*Tree Forms, Life Goes On, Cows in a Pasture* (fig. 86)—just the reverse is true. Instead of locating interior biomorphic forms in the outer world, Dove begins with the external phenomena of nature and reforms them in the name of biomorphism with meandering lines and eyelike slits which suggest the formative principle.

Overall, Surrealism afforded Dove a new pictorial opportunity for his continuing meditations on the forces of nature. Though it offered no lasting solutions, it did prove to be an important stimulus in his artistic evolution; for his experiments with biomorphism are the logical consequence of his earlier preoccupation with themes of organic growth and also the harbingers of the sexual imagery which occurs in his paintings of 1935 through 1937.

A Nature-Oriented Vision

In Dove's art, the dialectic between modernism and nativism is, in essence, that between style and content. It was his imagination's discourse with the European vanguard which strengthened his formal awareness and stimulated him to aesthetic exploration. It was the sheer force of nativist traditions which determined his highly personal response to the vanguard. To study Dove's work closely is to see how he steps out of the past, overcoming limitations which crippled other American painters, and to see how the past persists.

While Dove recognized America's need for a cultural independence, his experiences abroad had taught him the lesson of historically significant art. For this reason he could never follow the isolationist tack which the majority of American artists adopted in the 1920s and 1930s. Thus, parallels and influences abound in the relationship between his work and the work of his European contemporaries. This relationship points to his continuing involvement with vanguard developments and a healthy intellectual curiosity, but it represents only one level of his art. To see Dove as still another follower of the European mainstream is to ignore the substance and values of his work. It is to ignore the fact that he had different goals and distinct ambitions and ideals—all of which centered on the transcendental value of nature. Though his style profited from the innovations of the Europeans, it was guided by the requirements of his thought. More important than the fact of European influence is how he consistently adapted foreign styles to his own nature-oriented vision. Whether it be the faceted spaces of Cubism or the biomorphic forms of Surrealism, a vanguard innovation was inevitably transposed by Dove into a landscape context. Though the Hudson River School aesthetic underwent radical changes with the onslaught of modernism, the concept of nature upon which it was based remained remarkably intact in Dove's abstractions—as he well knew. Among his personal writings there is this rather rambling, but seminal statement:

> If France has become a religion in art, it is quite time that any new feeling that was not quite built on the old as the French have built their painting, each one of them on the earlier, finer things...then it is quite time that what we call modern should go smack to nature at its source.[40]

Hardly the innocent naif, Dove knew what he was about.

While the French turned to the past, that is, the art-historical past, he went to nature—not only because his own past was "not great enough," but as a way to achieve for his art a living immediacy and a timeless, universal meaning. Grounding his work in nature, the forms and forces of organic life, was an expression of personal value; it was as well the means to the national identity which his generation so self-consciously pursued. Thus, the modernism of Dove's highly personal style can be measured by his quest for pictorial means which could embody his consciousness of the present; his Americanism is evidenced by an inherited commitment to nature; and his individualism lies in the way he created an art that was modern *and* American.

6

Conclusion

To find a pictorial language which could encompass his idealistic vision of life and be as well aesthetically convincing, humanly moving, and responsive to the artistic situation in which he worked—this was Dove's quest. He identified wholly with modernism as a cause, seeing it as a means of embodying in art what he called "the new feeling" while invoking the timeless order of things. Thus he could write Stieglitz on June 19, 1939, "Am getting some new directions, so we think. Of course we are always liable to wake up and find the same thing done a few thousand years ago Q.E.D." Grounded in the most important intellectual and artistic issues of his day, Dove's art is an idiosyncratic fusion of diverse stimuli which he adapted to the needs of his personal vision. Returning to one of his most exemplary works, which has been discussed piecemeal in the previous chapters, can reveal how this integration and adaptation occur: *Golden Sun* (fig. 34) demonstrates how Dove's thematic and stylistic concerns coalesce in a single painting.

On a purely formal level, the radical simplicity of this composition, limited to three distinct forms which are afloat on a brilliant yellow field, is indebted to the stylistic innovations of his European contemporaries—the vivid, free color of the Fauves and Miró's floating forms which activate a surrounding space. However, these means have been put to an original end. The composition represents one of those cosmogonic visions which are recurrent in Dove's oeuvre. Characteristically Romantic and modern, it is a vision analogous to his contemporaries' interest in primitivism and children's art by suggesting the effort to reach life at its least conditioned point.

Inspired by a passage from *The Secret Doctrine* as previously discussed, the painting presents nature's four primal elements—water, earth, fire, and air—as the sun, the world-egg (as Blavatsky calls it), and the sea contained within the immensity of yellow space and painted from a god's-eye view which lets us see them all at once. The egg is one of those organic forms which make up what Dove called his "universal language." Its geometric proportions attest to nature's laws of harmonic growth, and in conjunction with the circles of the

sun, it also suggests theosophy's dualistic cosmogony—the earthly and eternal aspects of life, the noumena and phenomena of the world. As the sun emits its vital rays, black lines drawn from its center fertilize the egg and continue into the sea. Pictorially, they are an effective foil to the rounded and undulant forms and at the same time make visible that Hermetic bond between the celestial and terrestrial realms.

The painting is constructed from the discrete, pulsing brushstrokes characteristic of Dove's mature work, which have been radially positioned to make the surface appear energized and expansive. These strokes, made discernible by a thin layer of black on the white ground, are the common denominator of the picture surface. They provide a coherent structure which unifies the dramatic opposition between the forms and the field. In this way they suggest modern physics' concept of nature as a continual field of energy which is radiated in different concentrations as matter and space. As these strokes coalesce to form the vibrating bands of the sun, earth, and sea, they become what Dove called "force lines, growth lines," alluding to the concept of an electromagnetic field and also to those formations in organic matter which result from nature's periodic rhythms. On still another level, they suggest theosophy's concept of a vibrating cosmos which is activated by waves of consciousness.

The enormous size of the forms, their frontal arrangement and neutral colors were designed to maximize the impact of the surrounding space and reinforce the sense of its charged potency. Because they are not attached to the frame at any point, the space seems to continue into infinity, invoking those discussions of the fourth dimension which were current in Dove's milieu. As the interface between physics and metaphysics, the fourth dimension was a concept which Dove used to reconcile his attraction to science and his need to believe in a transcendental reality. On a practical level, it inspired him to imbue his picture with dynamic spatial presence.

Although the painting corresponds to a passage in theosophical literature and demonstrates the artist's penchant for visualizing text, it is not "literary" in any way. Because they deny a fixed meaning, the forms and their associative values are completely intelligible within the pictorial context. They are large and close to the surface, giving the composition the impact of sudden realization, and yet the thematic content invites prolonged meditation. As a conflation of multiple influences, the painting is distinctively Dove's in the way these have been located in the context of nature.

Heir to the Romantic tradition, Dove accepted the gnostic function of art while he wrestled with the possibilities of abstraction. Although he was a pioneering member of America's first vanguard, Dove still had one foot in the nineteenth century. Relying on form as a vessel or carrier of content, he was, like many artists in this tradition, an iconographer. He clung to the symbolic

image as a way to insure that his art, though abstract and highly personal, still had the power to communicate. However, his imagery was modern in every sense, vacillating as it does between the poles of nature and art, visual fact and autonomous form.

Because Dove strove to develop an iconography which could encompass his idealistic vision, he did not subordinate his subject matter to the requirements of an overall pictorial structure. With each new painting, he faced the challenge of integrating the nature motif with the demands of art, never having devised a consistent foundation for the evolution of his style. Every painting was like beginning all over again. At his best, forms and surface reinforce each other as in *Golden Sun, Moon, Goat,* and the *Sunrise series.* These compositions, all different, have a powerful visual presence quite apart from their thematic content and connotative implications because the imagery is successfully integrated within the picture surface. At other times, those same forms sit uncomfortably in their assigned field because the structure is ambiguous and unresolved.

A notable example of this difficulty can be observed in *Snowstorm* (fig. 18). This composition is dominated by a large, brown, pronged form which seems to be advancing through a landscapelike setting. Its uncertain relation to the ground of shifting colors gives the picture an erratic and inconsistent effect. Similarly, *Cow No. 1* (fig. 20), one of Dove's Surrealist-inspired canvases, contains biomorphic forms in addition to the symbolic spiral. These coexist uneasily with the very gestural passages like the one in the upper right corner. In the art of Klee and Miró, for example, a high degree of aesthetic unity has been imposed upon the surface and the spiral functions in a pictorial way—as a graphic sign which activates space. Paintings like *Snowstorm* and *Cow No. 1* lack this kind of integrated structure; they suffer from the absence of a governing style which could make form and surface coincident.

One of the problems which has colored the critical assessment of Dove's oeuvre is that while it evidences a remarkable inventiveness and impressive continuities, it also has, like most oeuvres, uneven moments. Because there has not previously been a means to distinguish his most serious efforts from those which are less significant, they have been grouped of-a-piece without any distinctions of quality among them. This naturally tends to diminish the artist's real achievement. Though Dove relied on a symbolic imagery to carry his meaning, it was no aesthetic solution. As was the case with his American predecessors, the issue of style remained problematic for him, an inherited difficulty. He never aspired to the kind of overall structural unity seen in the work of his European contemporaries because he would never fully separate nature from art.

Not until the last few years of his life did Dove attempt to make this separation and treat the picture surface as an autonomous entity which is in no

way analogous to physical space. There had been, of course, intermittent efforts, as in the music paintings of the late 1920s, but for the most part these excursions were short-lived. Landscape contexts endure; nature maintains its priority over art. As Dove grew older and his health declined, he was more physically removed from nature. He could no longer go "prowling" for motifs, so he became an armchair observer, still recording in his log the weather, the first signs of spring, the direction of wind currents. Though his feeling for the world remained as keen as it ever was, the diary entries from 1941 through 1944 document the struggle, so apparent in his paintings, to achieve a greater degree of artistic autonomy:

> Until painting frees itself from the necessity of form, there cannot be the thing that music gives.
>
> Did small sketch in four colors. Go ahead now with finer choices. Letting go tenacious hold of substance as a relic of representation.
>
> Not so much drawing from the object. Am now trying to work out each area in all directions. [1]

He even made a list of titles for what he called "pure painting" which included such terms as Formation, Venture, Adventure, Arrangement, Polychrome, and Textures. [2] His struggle was to eliminate the nature motif and replace it with autonomous pictorial relations, but it was a process never fully resolved. What happens is that the pendulum swings and art gains priority over nature. Dove struggled with the concept of pictorial autonomy his whole life, but the idea did not have the definition for him that it has today. Thus he could write in 1944, "Paintings seem closer to nature in choice of motif and freer in construction," instinctively conjoining these two pictorial directions.

As his diaries indicate, Dove made a concerted effort at this same time to replace the organic analogy with the musical analogy. He had titled works with reference to music as early as 1913, but it was not until late in his career that he began thinking of how musical qualities could inform the actual structure of an art now freed from representation: "Made pencil drawing in rhythmic c beat," "straight gouache in 1/2 time," "related gradation gave the rhythm." [3] While it is difficult to ascertain how the musical qualities were applied, it is clear that Dove was using the *idea* of music as a means to achieve greater artistic autonomy without sacrificing a rationale.

Though Dove's modernism is an overt criticism of the realist tradition which had prevailed in American art, it is so on only one level. There is something ultimately metaphysical about American realism. It demonstrates a desire to reach beyond the surface reality and a refusal to mollify or aestheticize the facts of vision by subjecting them to the felicities of the paint medium. A portrait by Copley or Eakins, a landscape by Kensett or Durand, is, finally,

about something else, something larger. So is a painting by Dove. Like the tradition from which it emerged his art represents a way of locating meaning in reality and a way of structuring reality into art. As Dove wrote Stieglitz in July 1942, "I am always trying to make my things more real, though you may smile when I say it." Abstraction for him was not only a style; it was a strategy, a way of bonding his art with the underlying essence of life. To give his paintings the power of revelation and illumination, it was necessary to divert the viewer's attention from the surface appearances and destroy those mental barriers which keep us from seeing the essential reality. Such is the nature of Dove's realism.

In an essay entitled "The Artist and Society," William Gass wrote:

> You can measure the reality of an act, a man, an institution, custom, work of art in many ways: by the constancy and quality of its effects, the depth of the response which it demands, the kinds and range of values it possesses, the actuality of its presence in space and time, the multiplicity and reliability of the sensations it provides, its particularity and uniqueness on the one hand, its abstract generality on the other.... [4]

Clearly, these are not the criteria that are usually discussed in most recent art criticism—a criticism which still labors under the pall of formalist aesthetics. In its view, modern art possesses an exclusive genealogy which depends solely on a structural format that begins with Impressionism and continues through Cézanne and Cubism to Abstract Expressionism; and it denies credence to those who do not comply with this parentage. Formalism is a convenient facade, at times an insidious one, which has been imposed on the richness of modern painting to extract order at all cost. In regard to this manner of assessing an artist's work, Dove presents an interesting "case." His oeuvre does not conform to any of the established canons of style, while evidencing something of them all; Impressionism, Fauvism, Cubism, Kandinsky's expressionism, Dada, and Surrealism—each left its mark. Shall he be deemed an eccentric departure? Or worse, still another provincial imitator who "apes the French"? Or must a separate category be invented, allowing him his "handicap" of being American? Because of his bold move into abstract art in 1910, Dove is guaranteed a position of historical significance, albeit an ambiguous one in the context of current art criticism; but to judge his art by formalist criteria is to lose much of his importance and most of his meaning.

All the conceptual concerns which find expression in Dove's art—biology and physics, theosophy, the pictorial inventions of his contemporaries, Freud and Bergson, the fourth dimension and higher space, the musical paradigm and primitivism—place his art right on the pulse of contemporary intellectual life. The concurrence of interests among his generation of abstract painters was less a matter of mutual influence than it was a common experience in the social and intellectual milieu. As *Golden Sun* demonstrates, Dove's pictures invoke the

myths characteristic of much American art and they also provide an important precedent for the next generation of vanguard Americans, Abstract Expressionists such as William Baziotes and Theodore Stamos. Like other first-generation modernists with whom his art shares so much, Dove feared that unless his abstractions were grounded in significant ideas which go beyond the realm of art, art itself would suffer a loss of meaning. Still, ideals do not art make. Dove understood that however lofty his intentions, his paintings had to stand on their own—as paintings, and his best do.

With the Gass quotation in mind, and using *Golden Sun* as a yardstick, the success of Dove's art can be measured in several ways: by its kind and range of values and their distillation into potent visual form; by the evocative force of its imagery and its power to kindle the imagination; for the way it imbues the world with meaning and at the same time suggests ultimate value; by the dramatic presence of its pictorial space and its ability to open up the mind's eye; for its originality and freshness of vision, avoiding always a literal manner so as to make the pictures rich in association. In addition, there are those numerous and elusive subtleties—the irradiations and modulations of color, the density of light, the saturation of hue, the tension of line and contrasts of value, size, and proportion which make a painting live.

Though Dove's art is experimental and assimilative—absorbing from his artistic and intellectual environment those ideas which could broaden his own range of thought—it has an implicit coherence and a distinctive identity. Dense with metaphor, it addresses experience on many levels as the artist consciously explored new avenues of expression. It has been said that in this way modern art exemplifies an ethical content, by suggesting that artistic integrity requires a permanent concern with self-development.[5] Dove's oeuvre is exemplary in this way. Creatively receptive to new ideas, it evolved through time to accommodate his changing world view, the maturation of his personal vision.

1. Photograph of Arthur Dove, Art Institute of Chicago

2. Asher B. Durand, *Kaaterskill Clove*, 1866

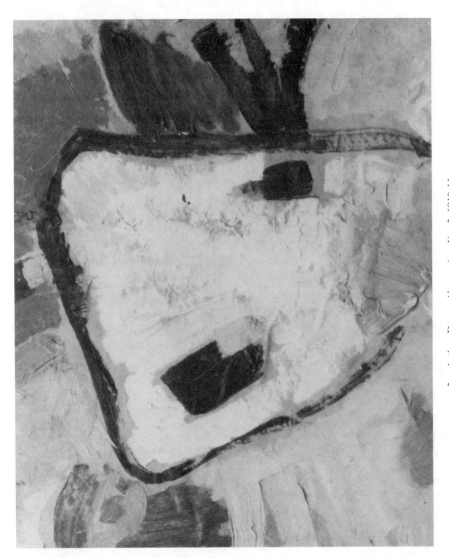

3. Arthur Dove, *Abstraction No. 2*, 1910-11

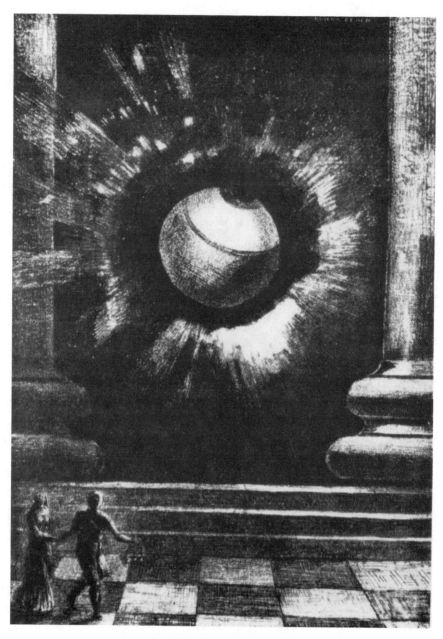

4. Odilon Redon, *Vision*, 1879

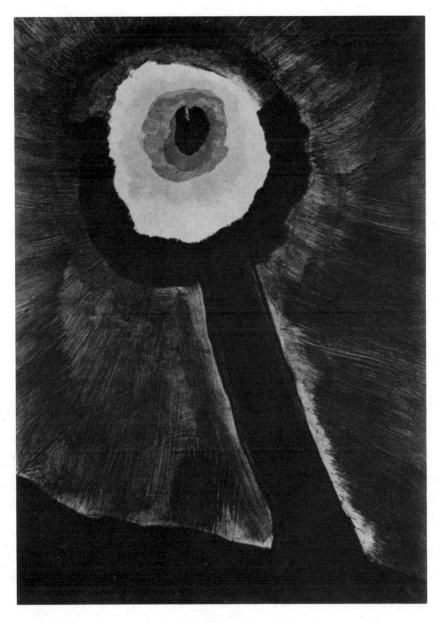

5. Arthur Dove, *Moon*, 1936

6. Arthur Dove, *Team of Horses*, 1911-12

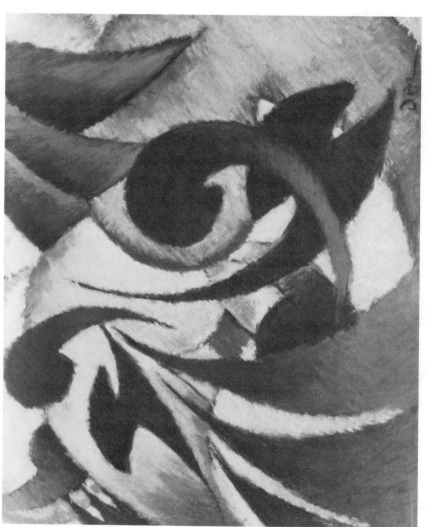

7. Arthur Dove, *Nature Symbolized No. 2,* 1911-12

8. Arthur Dove, *Sails*, 1911-12

9. Illustration from David Lowe, *Practical Geometry and Graphics*, 1912

10. Arthur Dove, *Plant Forms*, 1911-12

11. Arthur Dove, *Golden Storm*, 1925

12. Arthur Dove, *A Walk Poplars*, 1911-12

13. Illustration of phyllotaxis, from Roger Jean, *Mathematical Approach to Pattern and Form in Plant Growth*, 1984

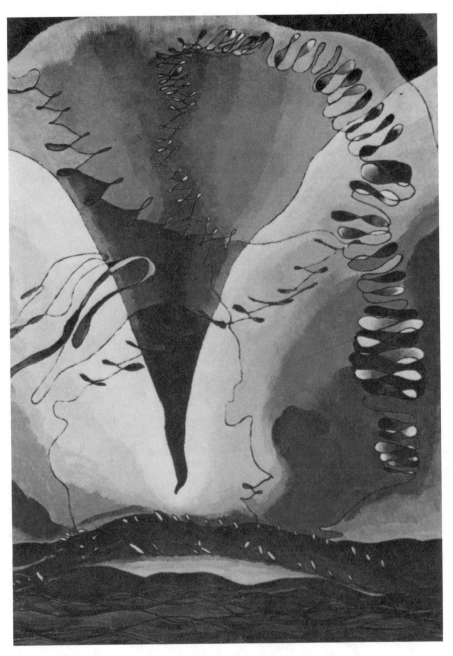

14. Arthur Dove, *Violet and Green*, 1928

15. Illustration of spiral motion of a bird's wing, from Theodore Cook, *Spirals in Nature and Art*, 1903

16. Arthur Dove, *From a Wasp*, 1912-14

17. Illustration of insect wing, from D'Arcy Thompson, *Growth and Form*, 1942

18. Arthur Dove, *Snowstorm*, 1935

19. Photograph of shell, from *Scientific Monthly*, December 1955 (p. 286)

20. Arthur Dove, *Cow No. 1*, 1936

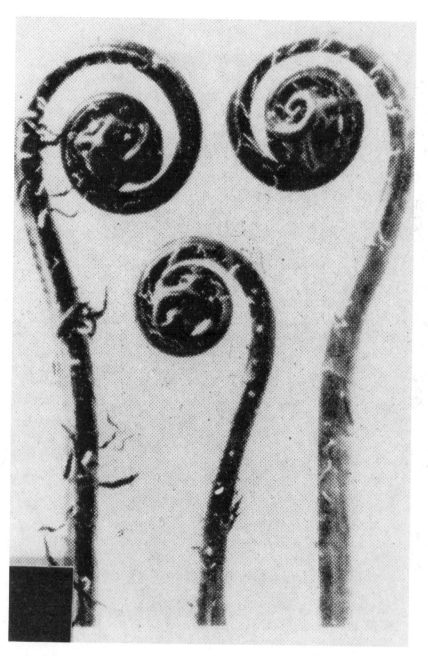

21. Photograph of young fern fronds, from Karl Blossfeldt, *Art Forms in Nature*, 1967

22. Arthur Dove, *Summer Orchard*, 1937

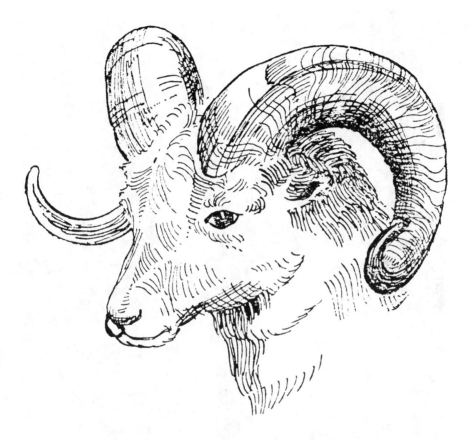

23. Illustration of Alaskan bighorn, from Theodore Cook, *Spirals in Nature and Art*, 1903

24. Arthur Dove, *Sunrise No. 2,* 1936

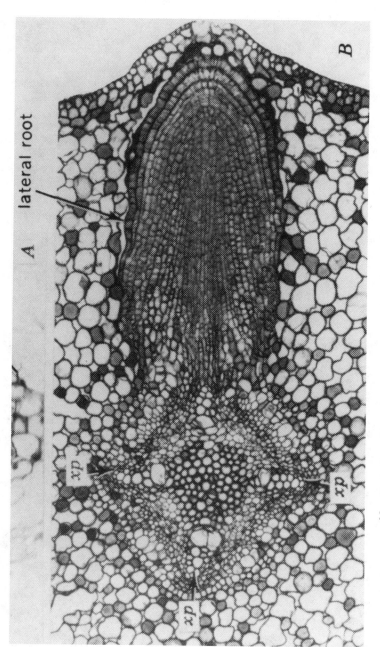

25. Illustration of lateral root cap, from Katherine Esau, *Plant Anatomy*, 1960

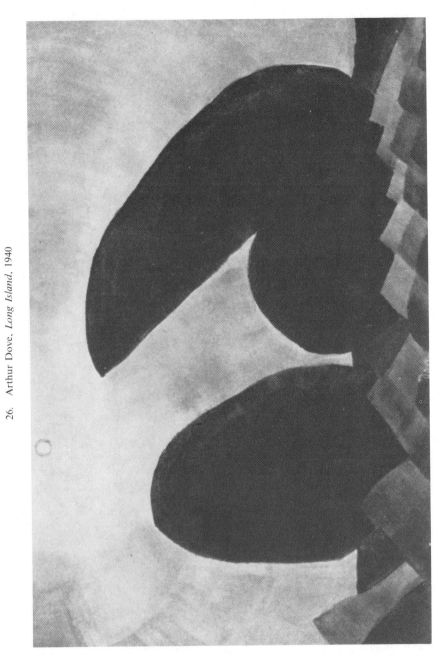

26. Arthur Dove, *Long Island*. 1940

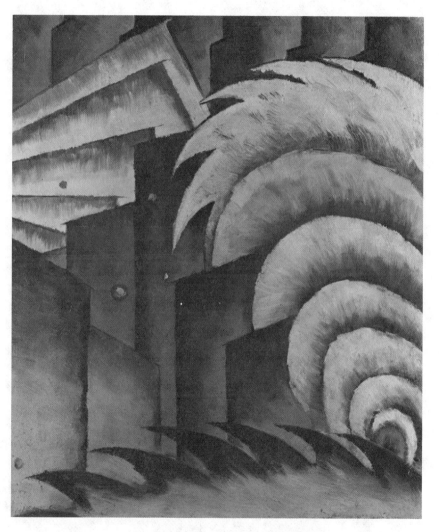

27. Arthur Dove, *Chinese Music*, 1923

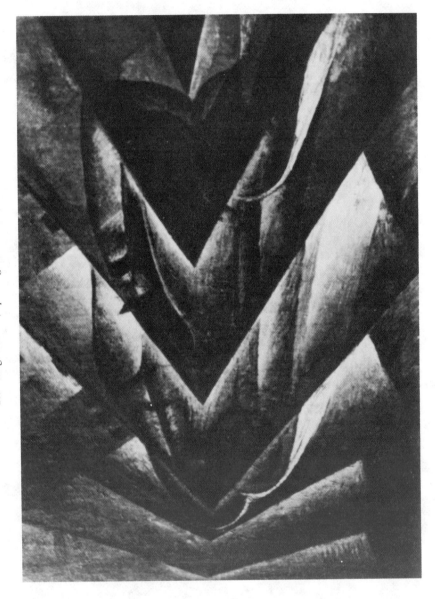

28. Luigi Russolo, *Speeding Automobile*, 1913

29. Photograph of shell, from *Scientific Monthly*, December 1955 (p. 287)

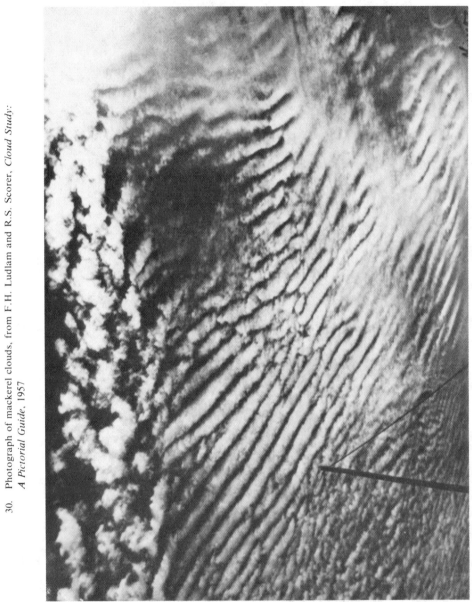

30. Photograph of mackerel clouds, from F.H. Ludlam and R.S. Scorer, *Cloud Study: A Pictorial Guide*, 1957

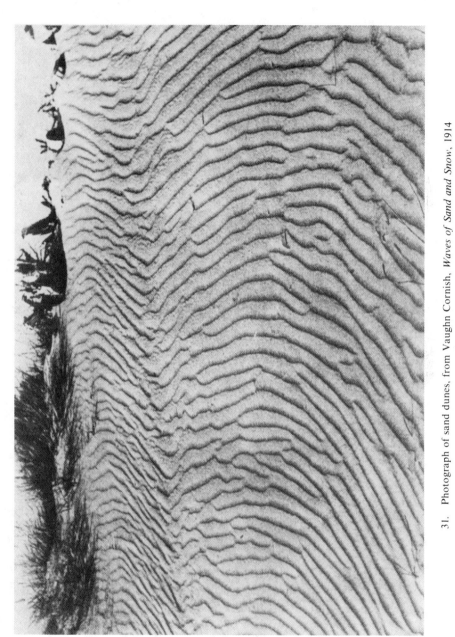

31. Photograph of sand dunes, from Vaughn Cornish, *Waves of Sand and Snow*, 1914

32. Arthur Dove, *Sunrise No. 3*, 1936

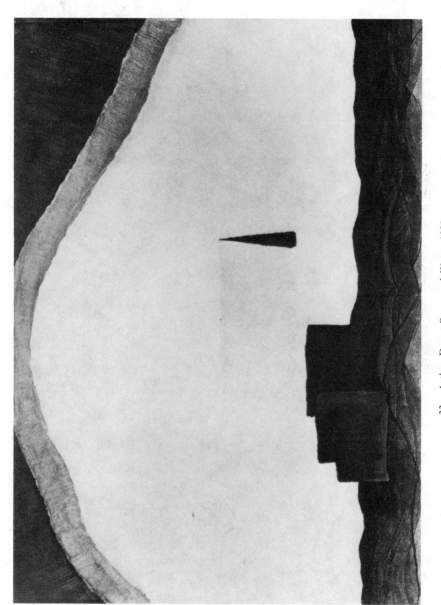

33. Arthur Dove, *Snow and Water*, 1928

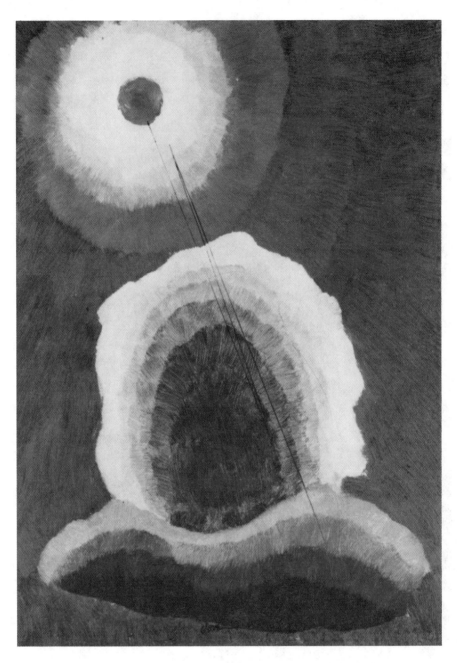

34. Arthur Dove, *Golden Sun*, 1937

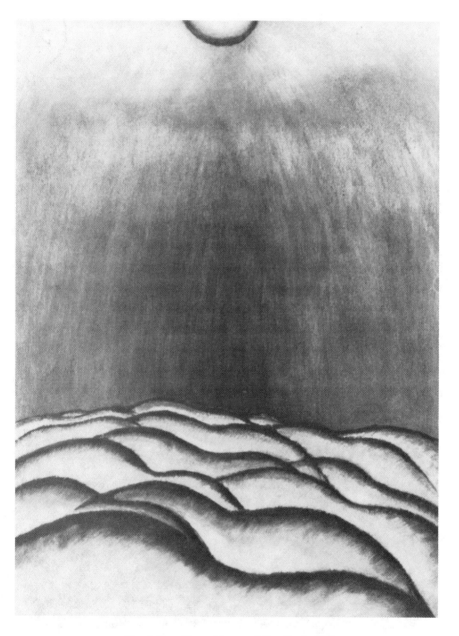

35. Arthur Dove, *Moon and Sea No. 2*, 1925

36. Arthur Dove, *The Wave*, 1926

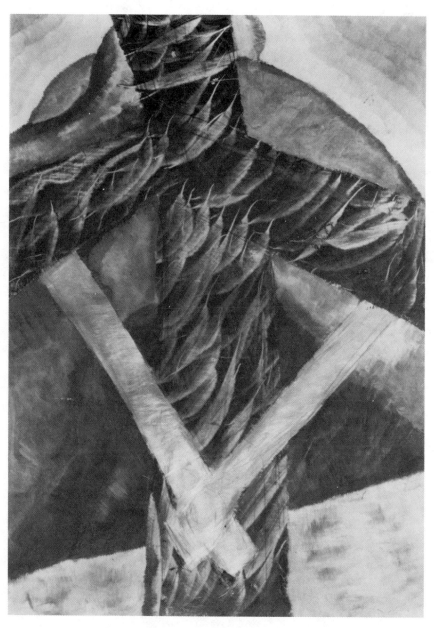

37. Arthur Dove, *Telegraph Pole*, 1929

38. Illustration from Claude Bragdon, *A Primer of Higher Space*, 1923

39. Illustration from Adolph Best-Maugard, *A Method for Creative Design*, 1926

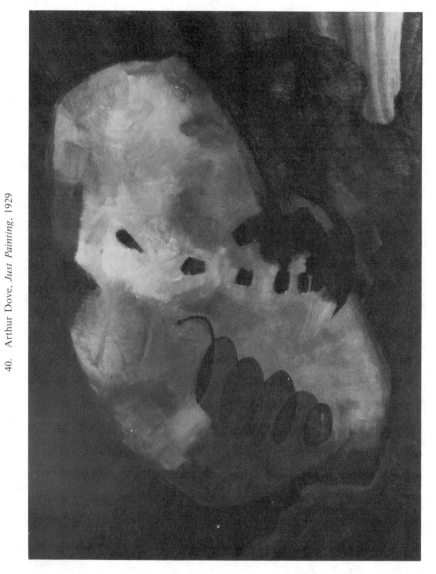

40. Arthur Dove, *Just Painting*, 1929

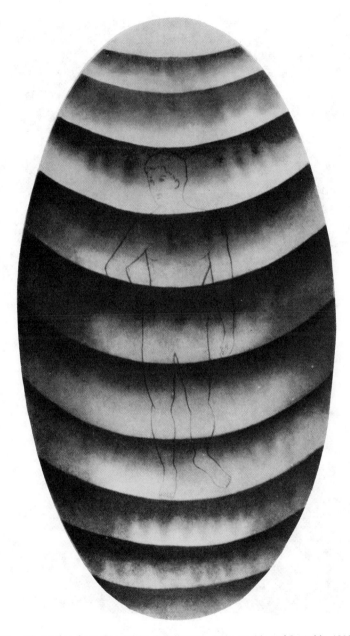

41.　Illustration from Charles W. Leadbeater, *Man Visible and Invisible*, 1903

42. Arthur Dove, *Holbrook's Bridge, Northwest*, 1938

43. Illustration from *The Diagonal*, 1920 (fig. 6)

44. Illustration from *The Diagonal*, 1920 (fig. 1)

FIG. 1 *A diagram of the Fourth Dimension in Nature*

45. Illustration from P.D. Ouspensky, *New Model of the Universe*, 1931

46. Arthur Dove, *Electric Peach Orchard*, 1935

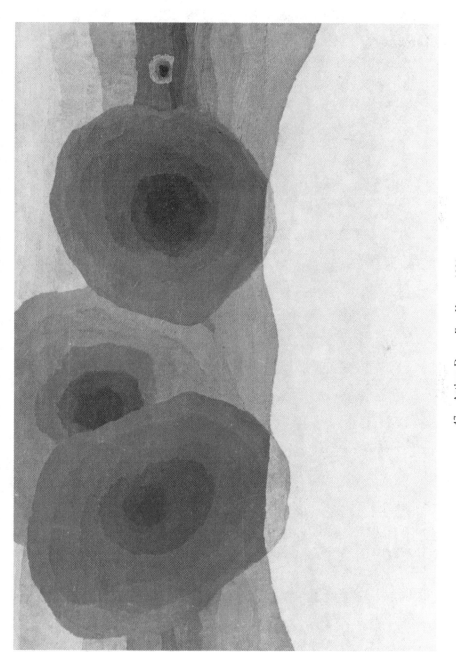

47. Arthur Dove, *Fog Horns*, 1929

48. Arthur Dove, *Thunder Shower*, 1938

49. Arthur Dove, *Distraction*, 1929

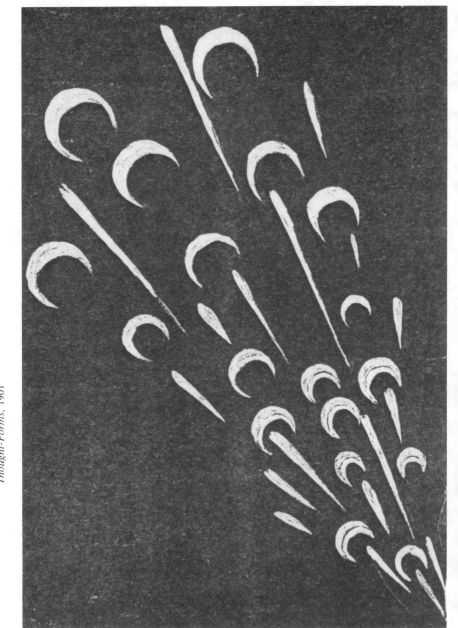

50. Illustration of "sudden fright," from Annie Besant and Charles Leadbeater, *Thought-Forms*, 1901

51. Arthur Dove, *Sunset*, 1930

52. Arthur Dove, *Cross in the Tree*, 1935

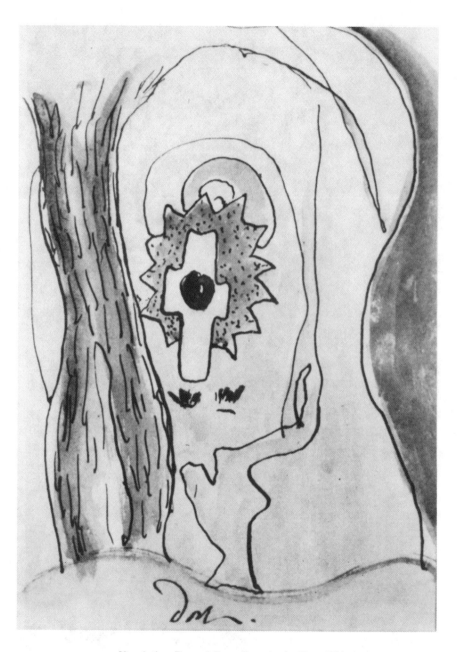

53. Arthur Dove, *I Put a Cross in the Tree*, 1934

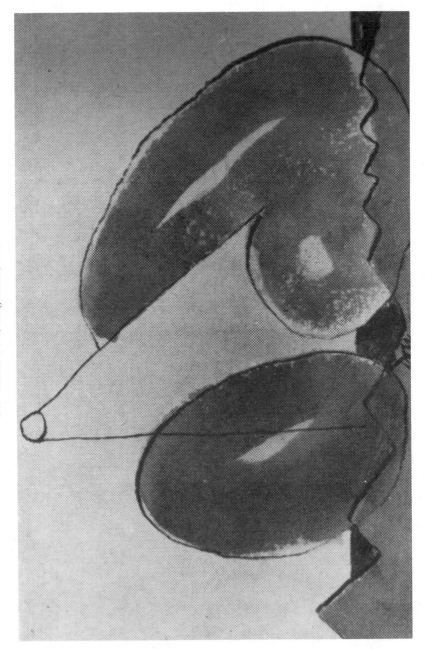

54. Arthur Dove, *Long Island*. 1940

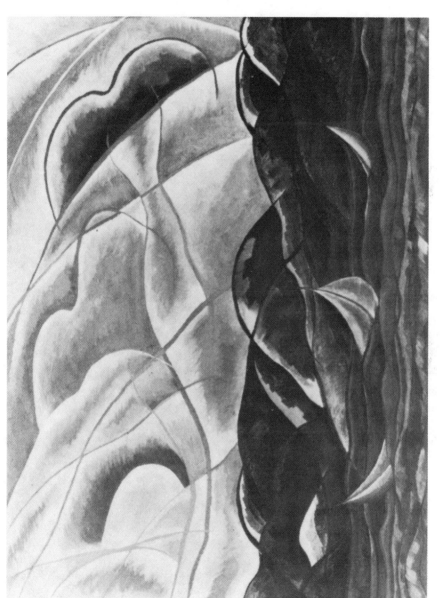

55. Arthur Dove, *Wind and Clouds*, 1930

56. Arthur Dove, *Willow Tree,* 1937

57. Arthur Dove, *Goat*, 1935

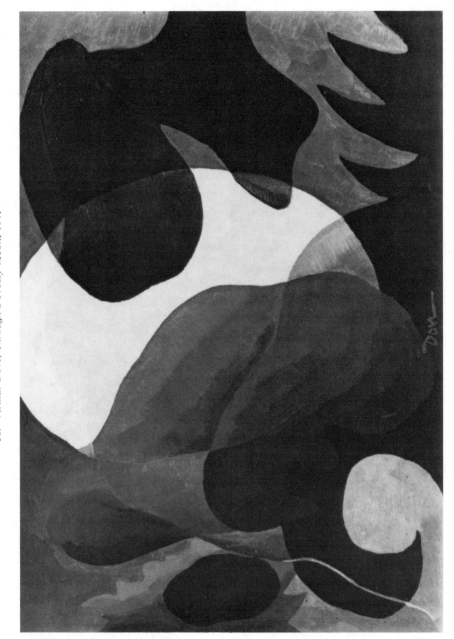

58. Arthur Dove, *Through a Frosty Moon*, 1941

59. Arthur Dove, *Willows*, 1940

60. Arthur Dove, *No Feather Pillow*, 1940

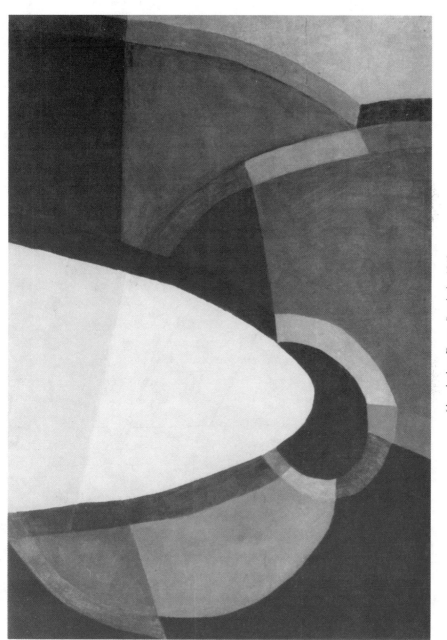

61. Arthur Dove, *Parabola*, 1942

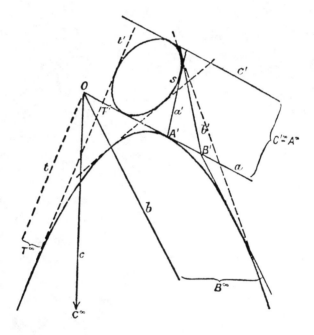

62. Illustration from L. Filon, *Introduction to Projective Geometry*, 1921

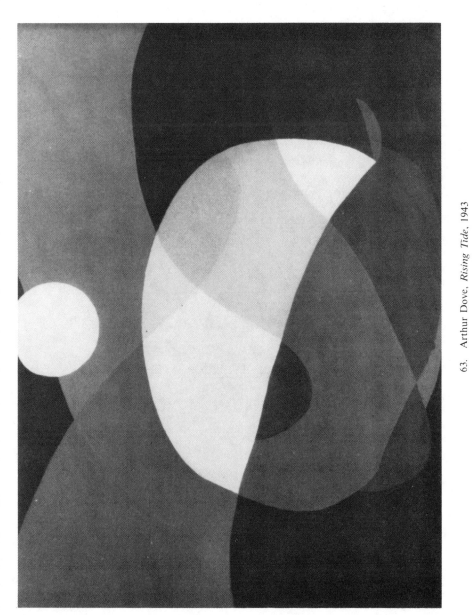

63. Arthur Dove, *Rising Tide*, 1943

64. Illustration of Riemann's manifold, from David Eugene Smith, *Source Book of Mathematics*, 1929

65. Illustration from Bertrand Russell, *Analysis of Matter*, 1927

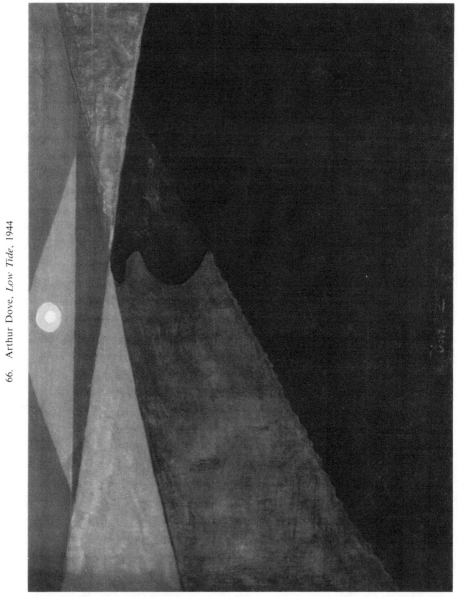

66. Arthur Dove, *Low Tide*, 1944

67. Illustration from Veblen and Young, *Introduction to Projective Geometry*, 1938

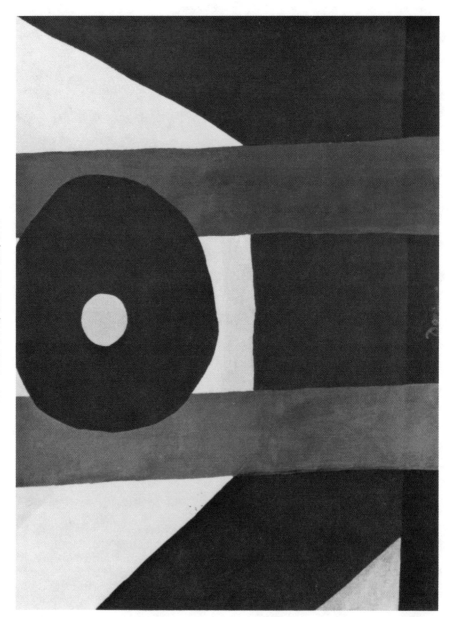

68. Arthur Dove, *That Red One*, 1944

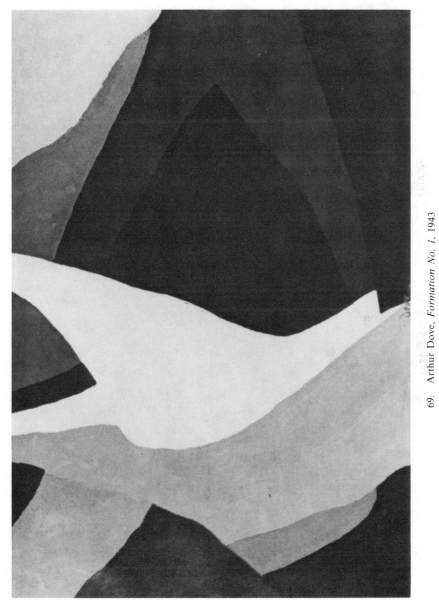

69. Arthur Dove, *Formation No. 1*, 1943

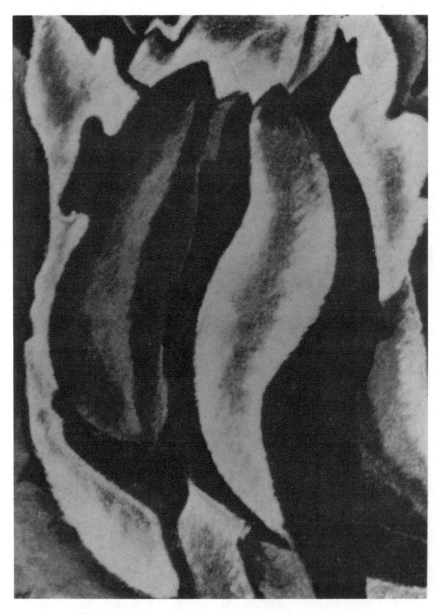

70. Arthur Dove, *Based on Leaf Forms and Spaces*, 1911-12

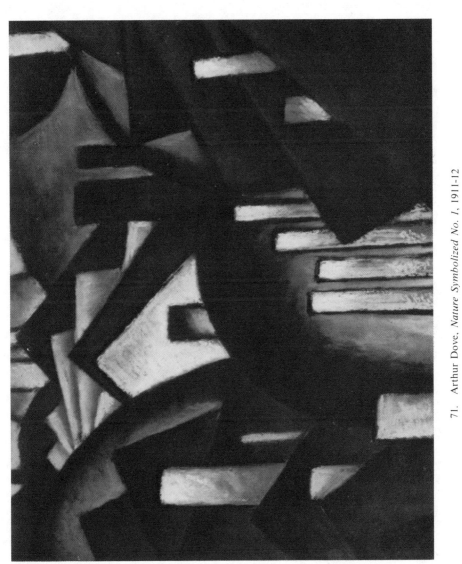

71. Arthur Dove, *Nature Symbolized No. 1*, 1911-12

72. Pablo Picasso, *Factory at Horta de Ebro*, 1909

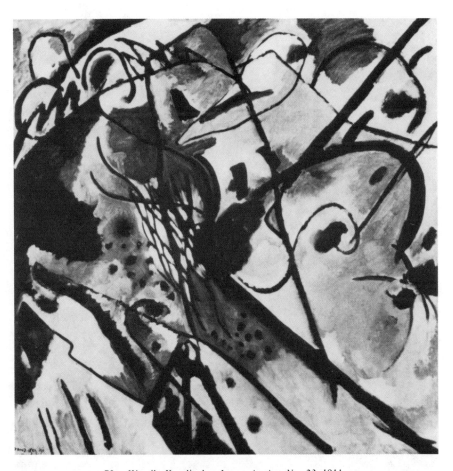

73. Wassily Kandinsky, *Improvisation No. 23*, 1911

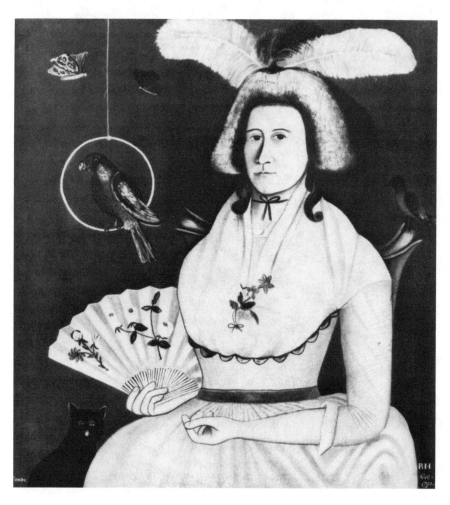

74. Rufus Hathaway, *Lady with Her Pets*, 1790

75. Arthur Dove, *Silver Tanks and Moon*, 1930

76. Georgia O'Keeffe, *City Night*, 1926

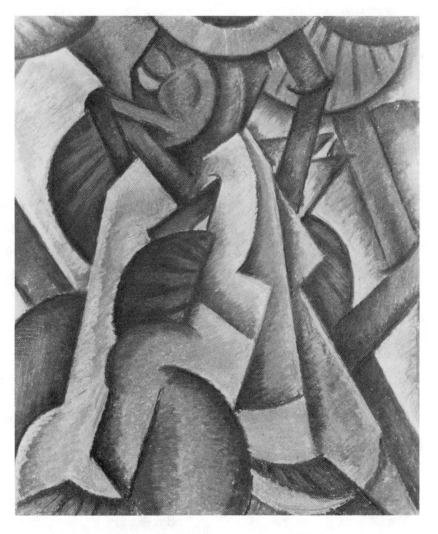

77. Arthur Dove, *Pagan Philosophy*, 1913

78. Arthur Dove, *Huntington Harbor No. 2*, 1926

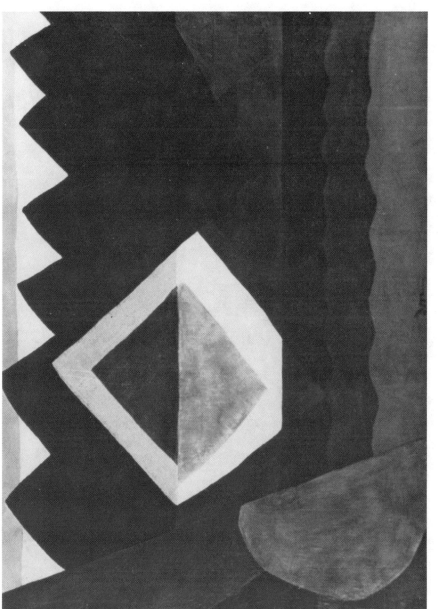

79. Arthur Dove, *Square on the Pond*, 1942

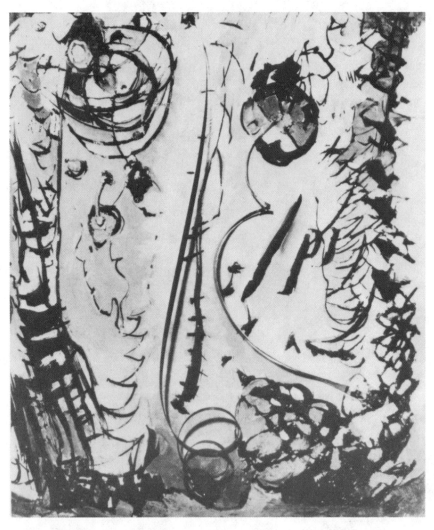

80. Arthur Dove, *George Gershwin, "Rhapsody in Blue," Part I*, 1927

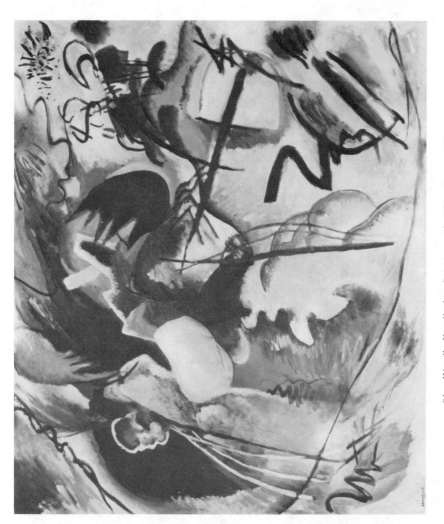

81. Wassily Kandinsky, *Painting with White Form*, 1913

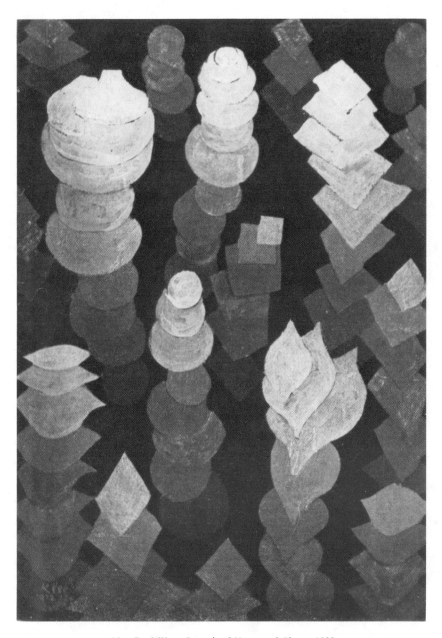

82. Paul Klee, *Growth of Nocturnal Plants*, 1922

83. Arthur Dove, *Sun on Water*, 1929

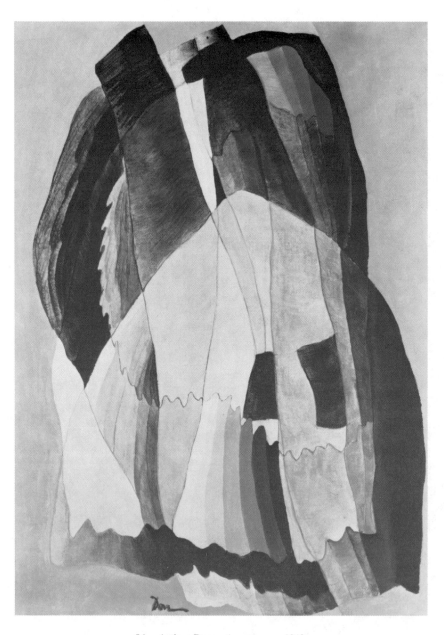

84. Arthur Dove, *Anonymous*, 1942

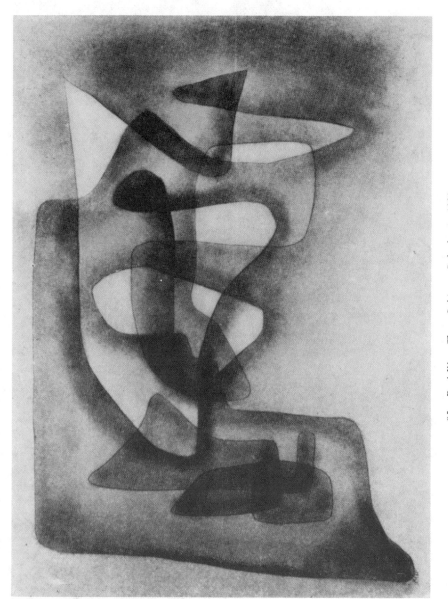

85. Paul Klee, *Three Subjects, Polyphonic*, 1930

86. Arthur Dove, *Cows in a Pasture*, 1935

Notes

Chapter 1

1. Barbara Novak, *American Painting of the Nineteenth Century* (New York: Praeger, 1969), p.105. This study demonstrates just how endemic is the dual concept of nature in American art.

2. Novak, pp. 268-70, mentions Dove in the epilogue as a continuation of the "hybrid aesthetic," on the basis of what she calls "the vitalism" and "comtemplative quietism" of his art.

3. William Levi, "The Concept of Nature," in John Weiss, ed., *Origins of Modern Consciousness* (Detroit: Wayne State University Press, 1965), p. 47. Levi writes that there is a "profound dualism which underlies every treatment of nature.... For the idea of nature... is both the object of exact science and a literary art; it belongs both to the most extreme efforts to formalize the structure of our experience and to project into it our deepest intuitions of feeling and emotion and value."

4. Although Dove's relation with Romanticism must be recognized, it was not one which the artist himself espoused. The word was to his generation (and still is in some contexts) one of ill repute, implying an undisciplined style in which a reasoning intelligence is conspicuously absent. See, for example, Samuel Kootz, *Modern American Painting* (New York: Brewer and Warren, 1930), p. 10. The objection registered was to the style, not the ideas behind it.

5. Letter to Stieglitz, March 25, 1938.

6. Morton and Lucia White, *The Intellectual Versus the City* (Cambridge: Harvard University Press, 1962), p. 2.

7. Letter to Stieglitz, August 1925.

8. Letter to Elizabeth McCausland, ca. 1934.

9. Letter to Stieglitz, December 14, 1943.

10. Interview with William Dove, January 22, 1980.

11. Helen Torr Dove diaries, April 24, 1929.

12. Letter to Elizabeth McCausland, ca. 1934.

13. Letter to Stieglitz, December 9, 1934.

14. The nature of this relationship is discussed in Sasha Newman, *Arthur Dove and Duncan Phillips: Artist and Patron* (New York: Braziller, 1981).

15. Letter to Dorothy Rylander Johnson, quoted in her *Arthur Dove: The Years of Collage* (College Park, Maryland: University of Maryland), p. 14.

16. Dove's writings.

17. Richard Hofstadter, *Anti-Intellectualism in American Life* (New York: Knopf, 1963), pp. 47-51.

18. Letter to Stieglitz, May 5, 1931.

19. Letter to Elizabeth McCausland, ca. 1935.

20. The original copy of this letter is in the Beinecke Rare Book and Manuscript Library, Yale University. It is reprinted in Arthur Jerome Eddy's *Cubists and Post-Impressionism* (Chicago: A. C. McClurg, 1914), pp. 48-49.

21. For a discussion of the impact of this philosophy on American culture, see Donald Drew Egbert, "Organic Expression in American Architecture," in Stow Persons, ed., *Evolutionary Thought in America* (New Haven: Yale University Press, 1955), pp. 355-96. For a more general discussion of this philosophy, see Meyer Abrams, *The Mirror and the Lamp* (Oxford: Oxford University Press, 1953), pp. 201-13.

22. In fact, he did state, "All colors are made of light and are part of the universe," quoted in Haskell, *Arthur Dove* (San Francisco: San Francisco Museum of Art, 1975), appendix, p. 137.

23. Haskell, appendix, p. 135.

24. Letter to Jeanne Kantor Landon, 1937, AAA.

25. The Phillips Collection, archives.

26. For example, Haskell, p. 7.

27. Letter to Suzanne Mullett, 1944, AAA.

28. Kootz, p. 36.

29. Letter to Stieglitz, September 28, 1931.

30. Quoted in Frederick Wight, *Arthur Dove* (Berkeley: University of California Press, 1958), p. 37.

31. Letter to Elizabeth McCausland, ca. 1935.

32. Haskell, p. 16, claims as much. Throughout the catalogue she conflates the distinction between art which is abstracted from nature and art which is autonomous. Similarly, Morgan writes: "the two major ingredients" of Dove's art are "nature imagery and pure, abstract form." Ann Lee Morgan, *Arthur Dove: Life & Work: A Catalogue Raisonné* (Newark: University of Delaware Press, 1984). More precisely, he based his art on forms and laws observed in nature and only occasionally experimented with compositions which are autonomous and nonreferential.

33. See Frank Kermode, *The Romantic Image* (New York: Macmillan, 1957), p. 92, for a discussion of the organic analogy in Romantic thought.

34. Quoted in Meyer Abrams, *The Mirror and the Lamp,* p. 207. This is a key work on Romantic theory.

35. Quoted in Haskell, appendix, p. 136.

36. Ibid.

37. For example, even the most cursory reading of *Camera Work,* which reprinted articles from the various newspapers, shows how *modern, post-impressionist,* and *post-cubist* are often used interchangeably. For a discussion of the semantic confusion which exists in current usage of the word *abstract,* see Andrew Kagan, "Representation, Abstraction and the Absolute in Art," *Arts Magazine,* vol. 52 (November 1977), pp. 136-40.

38. For a discussion of this relationship, see E. H. Gombrich, "Iconae Symbolicae: The Neo-Platonic Tradition in Art," *Journal of the Warburg and Courtauld Institute,* vol. 11 (1948), p. 187.

39. Dove's connection with Symbolism is mentioned by Haskell, p. 15; Newman, p. 15; Jim Jordan, "Arthur Dove and the Nature of the Image," *Arts Magazine,* vol. 50 (February 1976), p. 90; and Morgan, pp. 74-75. The most developed and valuable discussion of this relationship is to be found in Charles Eldredge, *The American Imagination and Symbolist Painting* (New York: New York University, 1979), pp. 117-20.

40. The first quotation in this sentence is from the catalogue of The Forum Exhibition of American Art of 1916, and the second is from Dove's writings.

41. As Charles Eldredge, p. 45, has shown, there was a strong current of Symbolist-inspired art in this country which paralleled that in France and was manifested primarily in the rise of figure painting. Dove's aversion to the figure and the hothouse sensibility of Symbolist thought are important factors in locating him on the Romantic/Symbolist continuum. Key aspects of Symbolism—the fatalism, physical passivity, decadence, celebration of artifice, and feverish devotion to obscure perceptions—were of no relevance to his modernism. For a fundamental exposition of Symbolist thought, see Anna Balakian, *The Symbolist Movement* (New York: New York University Press, 1977). On p. 208, she discusses the relation of the poet Wallace Stevens to this tradition and adds, n. 6, "Perhaps America was the differential factor."

42. John Higham, "The Re-Orientation of American Thought in the 1890s," in John Weiss, ed., *Origins of Modern Consciousness* (Detroit: Wayne State University Press, 1965), p. 46.

43. Art-historical discussions of Romanticism rarely touch upon its philosophic underpinnings. For a discussion of this aspect of the movement, see Marcel Raymond, *From Baudelaire to Surrealism* (London: Peter Owen, 1933); Frank Kermode, *The Romantic Image;* and Meyer Abrams, *Natural Supernaturalism* (New York: W. W. Norton & Company, 1971).

44. Arthur Dove diaries, August 20, 1942.

45. Letter to Stieglitz, January 8, 1932.

46. Frank Kermode, pp. 44, 92, 102.

Chapter 2

1. Information was provided by Sue Davidson Lowe, interview with author on October 15, 1980. Ms. Lowe is the grandniece of Alfred Stieglitz and daughter of Donald Davidson,

Dove's closest friend. She attended the soirées at the galleries and frequently visited the family home at Lake George where such discussions took place. For an excellent study of the photographer, see her *Alfred Stieglitz: Memoir/Biography* (New York: Farrar, Straus & Giroux, 1983).

2. For a survey of the various critical interpretations of modern art published in New York and Chicago newspapers, books and articles, see Howard Risatti, "American Critical Reaction to European Modernism 1908-1917" (Ph.D. dissertation, University of Illinois, 1978).

3. Charles Caffin, "A Note on Paul Cézanne," *Camera Work* (April 1911), p. 49.

4. Marius De Zayas, "The Evolution of Form," *Camera Work* (January 1913), p. 44.

5. Marius De Zayas, "Modern Art Theories and Representations," *Camera Work* (October 1913), p. 44.

6. Sadakichi Hartmann, "Structural Units," *Camera Work* (October 1911), p. 18.

7. Hutchins Hapgood, in *The New York Globe and Commercial Advertiser* (October 24, 1911), wrote that "the scientific artist tries to see only the essential forms" and "must dig a little deeper to find the laws of nature," quoted in Risatti, p. 136. See also Walter Pach, "The Point of View of the Moderns," *Century Magazine*, vol. 65 (November 1913), pp. 863-64. A. J. Eddy, p. 101, discusses Picasso as being "scientifica."

8. Willard H. Wright, *Modern Painting: Its Tendency and Meaning* (New York: John Lane & Co., 1915), p. 216.

9. In fact, Stieglitz once refused to exhibit some photographs submitted to him because, "I do not see any deep searching into the fundamental truths underlying nature." Letter to Walter C. Baker, April 15, 1915, the Beinecke Rare Book and Manuscript Library, Yale University.

10. From Dove's scrapbook, AAA.

11. Ibid.

12. My discussion of organic form here and throughout is indebted to Paul Weiss, "Beauty and the Beast: Life and the Rule of Order," *Scientific Monthly*, vol. 81 (December 1955), pp. 286-99; D'Arcy Wentworth Thompson, *Growth and Form* (New York: Macmillan, 1942, sec. ed.); and Philip Ritterbush, *The Art of Organic Forms* (Washington, D.C.: Smithsonian Institution, 1968).

13. Ritterbush, pp. 3-15, provides an exhaustive history of organic form. For its importance to Romantic nature philosophers, see Meyer Abrams, *The Mirror and the Lamp*, pp. 180-225.

14. D'Arcy Thompson, "Magnalia Naturae: Or the Greater Problem of Biology," *Nature*, vol. 87 (October 1911), p. 324.

15. Sixten Ringbom, "Paul Klee and the Inner Truth to Nature," *Arts Magazine*, vol. 52, (September 1977), p. 115.

16. Ernst Haeckel, *The Wonders of Life* (New York: Harper and Brothers, 1905), p. 456.

17. Ibid., pp. 170 and 188.

18. For example, I. Bickerstaffe, "Some Principles of Growth and Beauty," *Field* (December 1912); George Wherry, "The Spiral," *Notes on a Knapsack* (Cambridge: Bowes and Bowes,

1909); "Mathematics and Engineering in Nature," *Popular Science Monthly,* vol. 79 (November 1911), pp. 450-58.

19. D'Arcy Thompson, *Growth and Form,* p. 1096.

20. William Homer attempted to clarify this matter. See his "Identifying Arthur Dove's *The Ten Commandments,*" *The American Art Journal,* vol. 12 (Summer 1980), pp. 21-32. Using the artist's note cards, and the file of Suzanne Mullett, which was based on the artist's cards plus some additional information derived from personal interviews with him, Homer suggested a list of which pastels were in the original ten. However, the list is not definitive since one of the pastels, *Calf,* was never exhibited and Dove did others which conform to the same medium and dimensions. Morgan, pp. 43-46, also discusses the problem, adding that with few exceptions, the work Dove did before 1922 cannot be precisely dated.

21. See, for example, William Homer, *Alfred Stieglitz and the American Avant-Garde* (Boston: New York Graphic Society, 1977), p. 115. In her M.A. thesis on Dove (The American University, 1944), Suzanne Mullett stated that Dove told her he had read the design handbook of Denman Ross, *On Painting and Drawing* (1910), which illustrates such saw-toothed shapes as a means of showing motion on a flat surface. Ross's idea derives from the work of Marey, Crane, and others. The reviewer's comment came from *The Chicago Evening Post* of March 16, 1912: "At another time the horse suggested a design. Taking the curving line and playing with it, the resulting pattern appeared upon the canvas." Quoted in Homer, "Identifying Arthur Dove's *The Ten Commandments,*" p. 23.

22. Transcript of Arthur Dove, Cornell University.

23. See, for example, the supplement to *Scientific American,* "How to Construct an Egg Shaped Oval," vol. 70 (July 30, 1910), p. 69. The supplement was the more popular version of the periodical.

24. In the card file of Suzanne Mullet, AAA, this statement was applied to an unidentified pastel called *The Ten Commandments.* Mullett noted that it "looks like *Plant Forms.*" However, Homer, "Identifying Arthur Dove's *The Ten Commandments,*" p. 29, states that the pastel which named the series is "in all probability the work referred to as *Circles and Squares* in Dove's own card catalogue."

25. The first person to establish a connection between logarithmic proportion in nature and art was Adolph Zeising in 1854. Contemporary discussions of phyllotaxis occur in Theodore Cook's *Spirals in Nature and Art* (New York; E. P. Dutton, 1903), pp. 183-84; D'Arcy Thompson, *Growth and Form,* pp. 912-33; and Samuel Colman, *Proportional Form* (New York: G. P. Putnam's Sons, 1920), p. 150.

26. Mullet's card file reads: "Violet and Green: Sea Gulls 'flight of sea gull in tornado.' "

27. F. Schmutzler, *Art Nouveau* (New York: Abrams, 1962), p. 260.

28. Draft of letter to Samuel Kootz, Dove's writings. Other artists working around the turn of the century were also preoccupied with the idea of a universal language, but they did not necessarily turn to nature to find it, e. g., Paul Sérusier and the Puteaux cubists, who formed the Salon de la Section d'Or in 1912, the same year that the *Ten Commandments* were exhibited at 291. The search for some fundamental law which could be used for the creation of art was a significant cultural phenomenon.

29. Dove's writings.

30. Several biologists, including David Ramsey Hay and Sir John Goodsir, devoted extensive study to this configuration, believing it to be a visual symbol of nature's invisible unity. In fact, Goodsir had it inscribed on his tombstone because of what he perceived to be its cosmic ramifications. See Ritterbush, p. 50.

31. Theodore Cook was the first to give aesthetic application to the spiral in his *Spirals in Nature and Art* (1903) and *The Curves of Life* (New York: H. Holt, 1914). Cook believed that everything in nature is capable of mathematical expression and that the spiral, which is the symbolic expression of the cosmos itself, should be the basis of art. It is interesting to note the similarity between the title of Cook's book of 1914 and Dove's interest in those "curves so to speak representing instincts from all of life." Samuel Colman, *Proportional Form,* p. 253, notes that displays of the spiral in natural phenomena could be seen in the Museum of Natural History in New York City, an institution which William Dove has said (interview of January 22, 1980) that Dove liked to frequent.

32. Letter to Stieglitz, March 5, 1941.

33. Paul Rosenfeld, "The World of Arthur G. Dove," *Creative Art,* vol. 10 (June 1932), p. 428; and respectively, Jim Jordan, "Arthur Dove and the Nature of the Image," *Arts Magazine,* vol. 50 (February 1976), p. 90; Haskell, p. 76; and Milton Brown, *American Painting from the Armory Show to the Depression* (Princeton: Princeton University Press, 1955), p. 106.

34. Statement in an exhibition catalogue, the Intimate Gallery, 1927. Quoted in Haskell, appendix, p. 135.

35. Eddy, *Cubists and Post-Impressionism,* p. 48.

36. Marianne Martin, *Futurist Art* (Oxford: Clarendon Press, 1968), p. 111.

37. As Martin, ibid., acknowledges, the Futurists knowingly borrowed this term from physics.

38. For a discussion of the importance of German *natur-philosophie* to Faraday, see L. Pearce Williams, *Michael Faraday* (New York: Basic Books, 1965), pp. 137-41.

39. For a discussion of the popular interest in scientific discovery and discovers, see Ernest V. Heym's *Fire of Genius: Inventors of the Past Century* (New York: Doubleday, 1976).

40. Wassily Kandinsky, *Concerning the Spiritual in Art* (New York: Dover Publications, 1977), p. 32.

41. Wassily Kandinsky, *Point and Line to Plane* (New York: Dover Publications, 1979), p. 53.

42. Sara Lynn Henry, "Form-Creating Energies: Paul Klee and Physics," *Arts Magazine,* vol. 52 (September 1977), pp. 118-21.

43. Willy Rotzler, *Constructivist Concepts: A History of Constructivist Art* (New York: Rizzoli, 1977), pp. 114-15.

44. John Marin letter to Alfred Stieglitz, quoted in Mackinley Helm, *John Marin* (Boston: Institute of Contemporary Art, 1977), p. 28.

45. Arthur Dove transcript, Cornell University.

46. Kootz, p. 38.

47. Statement in an exhibition catalogue, the Intimate Gallery, 1929. Quoted in Haskell, appendix, p. 135.

48. Paul Weiss, pp. 290-99.

49. Dove's writings.

50. A draft of the letter to Dorothy Norman is amongst Dove's writings; and letter to Elizabeth McCausland, ca. 1935.

51. Letters to Stieglitz, May 17, 1920 and February 2, 1932.

52. Letter to Stieglitz, December 1934; letter to Duncan Phillips, the Phillips archive.

53. Letter to Stieglitz, September 6, 1929.

54. See Max Jammer, *Concepts of Space* (Cambridge: Harvard University Press, 1954).

55. In addition, two little magazines published in the 1930s were entitled *Space*. One, edited by H. Cahill, was "devoted to contemporary American art and related subjects," and the other, edited by B. A. Botkin, dealt with poetry and culture.

56. For my knowledge of the fourth dimension—its history and its meaning to modern artists— I am indebted to Linda Henderson, *The Fourth Dimension and Non-Euclidean Geometry in Modern Art* (Princeton: Princeton University Press, 1983). Henderson's research played a catalytic role in my own thinking and made the interpretation of Dove's often cryptic remarks much easier.

57. Max Weber, "The Fourth Dimension from a Plastic Point of View," *Camera Work* (July 1910), p. 25.

58. Statement in an exhibition catalogue, the Intimate Gallery, 1929, quoted in Haskell, appendix, p. 135.

59. Henderson, pp. 218-30 and pp. 203-10.

60. For this information I am indebted to Sue Lowe, interview with author, October 15, 1980.

61. Helen Torr Dove diaries, June 20, 1924. For Dove's statement on 291, see *Camera Work* (January 1915), p. 37.

62. A diary entry dated February 14, 1942, states: "Julia wants info. on 'Futurism', the 4th dimension, etc." Another, on May 29, 1942, states: "Julia brot [sic] back all art books."

63. Henderson, "Italian Futurism and 'The Fourth Dimension,'" *Art Journal,* vol. 41 (Winter 1981), p. 320.

64. Henderson traces the impact of Einstein's physics on the popular conception of the fourth dimension in America, pp. 358-59.

65. James Jeans, *The New Background of Science* (New York: Macmillan, 1933), pp. 208-29.

66. Lowe, pp. 210-12.

67. My knowledge of the contents of Stieglitz's library comes from Lowe's letter to the author, January 11, 1981.

68. Dove made this remark to his son, who repeated it to the author in an interview of October 14, 1980.

69. Dove's writings.

Chapter 3

1. Havelock Ellis, *The Dance of Life* (Boston: Houghton Mifflin, 1923), p. 209.

2. Sheldon Cheney, *Expressionism in Art* (New York: Liveright Publishing Corp., 1934), p. 100. Another member of the American avant-garde who shared this world view based on the reconciliation of science and mysticism was Hilla Rebay. See Joan M. Lukach, *Hilla Rebay: In Search of the Spirit in Art* (New York: Braziller, 1983), p. 144.

3. References to "talked religion" in the Dove diaries: May 18, 1924; May 17, 1928; July 19, 1933; March 21, 1942; and June 20, 1942. The reference to "the whys of existence" is in a diary entry of April 7, 1925.

4. These diary entries are dated respectively, June 20, 1924; March 21, 1942; September 28, 1931.

5. For an early example, see Paul Rosenfeld's essay on Dove in his *Port of New York* (Urbana and London: University of Illinois Press, 1966), pp. 167-74; also, Alan Solomon, *Arthur Dove* (Ithaca: Cornell University Press, 1954); Novak, p. 270; Robert Rosenblum, *Modern Painting and the Northern Romantic Tradition: Friedrich to Rothko* (New York: Harper & Row, 1975), p. 207. Oddly, Morgan states, p. 74, "Dove was not a pantheist," and then in the next paragraph, p. 75, goes on to connect his art with transcendentalism, which is, of course, a profoundly pantheistic philosophy.

6. For the importance of theosophy to Kandinsky, see Rose-Carol Washton Long, *Kandinsky: The Development of an Abstract Style* (Oxford: Clarendon Press, 1980) and Sixten Ringbom, *The Sounding Cosmos* (Abo, Finland: Abo Akedemi, 1970); to Mondrian, see Robert Welsh, "Mondrian and Theosophy," *Piet Mondrian 1872-1944, Centennial Exhibition* (New York: The Solomon R. Guggenheim Museum, 1971); to Malevich, see Robert Williams, *Artists in Revolution: Portraits of the Russian Avant-Garde 1910-1925* (Bloomington and London: Indiana University Press, 1977), pp. 102-21 and Henderson, pp. 276-90.

7. Arthur Christy, *The Orient in American Transcendentalism* (New York: John Day, 1945), chapter 5.

8. Romain Rolland, *Prophets of a New India* (New York: Albert and Charles Boni, 1930), p. 329.

9. Henderson, p. 179.

10. Gershom Scholem, "Religious Authority and Mysticism," *On the Kabbalah and Its Symbolism* (New York: Schocken Books, 1965), pp. 16-17. Also, Raymond Nelson, "American Mysticism," in *Kenneth Patchen and American Mysticism* (Chapel Hill: University of North Carolina Press, 1984), pp. 3-23.

11. Letter to Elizabeth McCausland, ca. 1935.

12. Arthur Christy, pp. 38 and 43.

13. Marianne W. Martin, "Some American Contributions to Early Twentieth Century Abstraction," *Arts Magazine,* vol. 54 (June 1980), pp. 158-65.

14. Charles Caffin, "Of Verities and Illusions," *Camera Work* (October 1905) and Caffin, "The New Thought which is Old," *Camera Work* (July 1910), pp. 21-24.

15. Eddy, p. 48 and Dove's writings.

16. Henri Bergson, "What is the Object of Art?" from *Laughter,* in *Camera Work* (January 1912), p. 24. As various scholars have discussed, Bergson's was a mysticism based on recent scientific thought; biological metaphors especially lie behind his concept of creative evolution and the *élan vital.*

17. Maurice Aisen, "The Latest Evolution in Art and Picabia," *Camera Work* (November 1913), pp. 14-21.

18. John Weichsel, "Cosmism or Amorphism," *Camera Work* (November 1913), pp. 69-82.

19. Dove's writings.

20. Cheney, p. 321.

21. Helen Torr Dove diaries, July 21, 1930.

22. Ibid., August 3, 1933.

23. My information about Donald Davidson came from his daughter, Sue Lowe, interview, October 15, 1980, and from William Dove, interview, October 14, 1980.

24. Interview with William Dove, January 22, 1980.

25. Arthur Dove diaries, June 28, 1924.

26. Kandinsky, *Concerning the Spiritual in Art,* p. 13.

27. Interview with William Dove, October 14, 1980.

28. Arthur Dove diaries, October 30, 1924.

29. Ibid., October 23, 1924.

30. Robert Rosenblum, pp. 23-24 and passim.

31. Letter to Stieglitz, September 16, 1919.

32. Interview with William Dove, January 22, 1980 and interview with Sue Lowe, October 15, 1980.

33. Dove's writings.

34. Kandinsky, *Concerning the Spiritual in Art,* p. 13.

35. Respectively, Ruth Bohan, *The Société Anonyme's Brooklyn Exhibition: Katherine Dreier and Modernism in America* (Ann Arbor: UMI Research Press, 1982), pp. 15-21; Joan M. Lukach, p. 144; and Henderson, p. 222.

36. For the interest of Lawrence and Huxley in occultism, see William York Tindall, "Transcendentalism in Contemporary Literature," in Arthur Christy, ed, *The Orient in American Transcendentalism,* pp. 175-92. For Toomer, Frank, and Crane, see Raymond Nelson, p. 8.

37. Henderson, pp. 175-77.

38. Claude Bragdon, *More Lives than One* (New York: Knopf, 1938), pp. 51-55. Though not well known today, Bragdon's books were reviewed consistently and sold well. See Henderson, p. 195.

39. In *The New Image* (New York: Knopf, 1928), p. 146, Bragdon wrote that "the animating spirit of modern art is increasingly abstract," but as Henderson notes, p. 196, Bragdon's taste in art was initially conservative and only gradually broadened, due to his friendship with Stieglitz and O'Keeffe. She also suggests, p. 197, that Bragdon's books may have been introduced to 291 by way of Max Weber.

40. Dorothy Norman, *Alfred Stieglitz: An American Seer* (New York: Random House, 1973), p. 259.

41. Helen Torr Dove diaries, June 12, 1929.

42. For an interesting account of the role of the TS in America in the 1920s and its associations with spiritualism and psychic research, see R. Laurence Moore, *In Search of White Crows* (New York: Oxford University Press, 1977), p. 232 and passim.

43. Bruce Campbell, *Ancient Wisdom Revised: A History of the Theosophical Movement in America* (Berkeley: University of California, 1980), p. 78, and also Robert Ellwood, *Religious and Spiritual Groups in Modern America* (Englewood, New Jersey: Prentice Hall, 1973), pp. 88-100.

44. Moore, pp. 221-43.

45. Ibid.

46. Interview with William Dove, October 14, 1980. Also, a letter of 1938 from Donald Davidson to his wife Elizabeth (in the possession of Sue Lowe) documents this fact. Davidson wrote that the Doves "were too much into science now and that leaves me out in a nice way."

47. Interview with William Dove, October 14, 1980.

48. Letter to Stieglitz, December 23, 1935.

49. Dove's writings.

50. Ibid.

51. C. W. Leadbeater, *Man Visible and Invisible* (Adyar, India: Theosophical Publishing House, sec. ed., 1925), p. 15. See also Claude Bragdon, *Four-Dimensional Vistas* (New York: Knopf, 1916), p. 110, and Rudolf Tischner, *Telepathy and Clairvoyance* (New York: Harcourt & Brace, 1925), p. 191.

52. Nancy Ketchiff, "The Invisible Made Visible: Sound Imagery in the Early Watercolors of Charles Burchfield" (Ph.D. dissertation, University of North Carolina at Chapel Hill, 1977).

53. Published in Samuel Kootz, p. 37.

54. Letter to Stieglitz, July 25, 1930. Morgan, p. 77, discusses this letter as evidencing Dove's "desire to find an irreducible law of color and form," and discusses the widespread interest in formulas and systems for the creation of the new art. It is of course a desire which originates in the Symbolist quest for a universal language which plumbs the essence of the manifested world. However, for Dove, laws of art and laws of nature were analogous. His theories are not just about art but about the relation between art and nature. In his words, "Paintings are mirrors...."

 For future reference, conic sections are symmetrically curved shapes derived from truncating a cone by a plane. Depending on the angle at which the cone is cut, there are three possible results: the ellipse, the hyperbola, and the parabola. The ovoid is derived from an extension of the parabola but is not a section. These curves are of central importance in geometry (and Dove's theory) because they demonstrate the mathematical and spatial relations between two-dimensional planes and three-dimensional forms.

55. Claude Bragdon, *The New Image*, p. 140.

56. Helena Blavatsky, *The Secret Doctrine*, vol. 2 (Pasadena: Theosophical University Press, 1952), p. 97.

57. Bragdon, *The Frozen Fountain* (Freeport, New York: Books for Libraries Press, 1970; first ed. 1932), p. 9.

58. Marjorie Nicolson, *The Breaking of the Circle* (New York: Columbia University Press, 1960), p. 8. The image of the spiral is the opposite, Nicolson wrote, of the Plotinian conceit in which existence is analogized to a circle, The Circle of Perfection, which begins and ends at the same point. See also Meyer Abrams, *Natural Supernaturalism,* p. 184, where the ascending spiral is described as "a distinctive figure of Romantic thought and imagination."

59. Blavatsky, vol. 1, p. 119.

60. Ibid.

61. Adolph Best-Maugard, *A Method for Creative Design* (New York: Knopf, 1926), p. 155.

62. Interview with William Dove, January 22, 1980.

63. Arthur Dove diaries, respectively, May 14, 1940; September 26, 1927; October 31, 1939; and July 19, 1939.

64. Blavatsky, vol. 2, p. 65.

65. Blavatsky, *Key to Theosophy* (London: The Theosophical Publishing Society, 1893), p. 40.

66. Bragdon, *The Eternal Poles* (New York: Knopf, 1931), p. 65 and *Old Lamps for New* (New York: Knopf, 1925), p. 107.

67. Dove's writings.

68. Haskell, p. 7, makes the comparison between Dove's "condition of light" and auras but does not discuss the relationship of these ideas to theosophy. Morgan, p. 79, says that "'Condition of light' probably resembles Sherwood Anderson's notion that a person has 'a certain tone, a certain color,'" and on p. 82, n. 37, states, erroneously I believe, that "'the condition of light' and 'white light' seem not to have been related in Dove's mind."

69. For example, see A. A. Hopkins, "The Human Atmosphere," *Scientific American,* vol. 125 (March 1921), p. 126 and "Auras: Fact or Fancy," *Scientific American,* vol. 146 (May 1932), pp. 303-4.

70. Letter to Elizabeth McCausland, ca. 1935.

71. Annie Besant and C. W. Leadbeater, *Thought-Forms* (London: The Theosophical Publishing Society, 1901), p. 37.

72. Dove's writings.

73. Besant and Leadbeater, *Thought-Forms,* p. 32.

74. Annie Besant, *Thought-Power* (Los Angeles: Theosophical House, 1918), pp. 13 and 17.

75. Besant and Leadbeater, *Thought-Forms,* pp. 28 and 29.

76. Bragdon, *Beautiful Necessity* (Rochester, New York: The Manas Press, 1910), p. 60.

77. Maurer's interest in dynamic symmetry is discussed in Elizabeth McCausland, *Alfred Maurer* (New York: A. A. Wyn, 1951), p. 146.

78. Bragdon, *The New Image,* p. 158.

79. P. D. Ouspensky, *A New Model of the Universe* (New York: Knopf, 1969; first ed. 1931), p. 90.

80. Rosenblum, passim; Kermode, p. 92; and Balakian, p. 203.

81. Ouspensky, pp. 62 and 96.

82. Kermode, p. 112.

83. Ibid., p. 113.

84. Howard Risatti, "Music and the Development of Abstraction in America," *Art Journal,* vol. 39 (Fall 1979), pp. 8-13. See also Eldredge, p. 43, for a discussion of the revived interest in the concept of correspondences in turn-of-the-century America.

85. Blavatsky, *Isis Unveiled* (Pasadena: Theosophical University Press, 1950), vol. 1, p. 514.

86. Besant and Leadbeater, *Thought-Forms,* the last chapter of which is entitled "Forms Built by Music."

87. Bragdon, *Old Lamps for New,* p. 106; Henderson, pp. 194-95.

88. However, in a fragmentary essay called "Me and Modern Art," Dove did write that every object in nature has a "condition of existence" which is "a certain condition of Red, Green and Violet. They cut the color cone with their own individual curve," Dove's writings. It is a statement which suggests the noumena/phenomena polarity and which sounds like a variation on Bragdon's idea that the primary colors are red, green, and blue. See Bragdon's *Old Lamps for New,* pp. 105-6.

89. Dove's writings. The statement occurs in an essay entitled "20th Century Limited or the Train Left without Them."

90. Statement in an exhibition catalogue, the Intimate Gallery, 1929. Quoted in Haskell, appendix, p. 135.

91. Blavatsky, *The Secret Doctrine,* vol. 2, pp. 106-7.

92. Leadbeater, *The Hidden Side of Things* (Adyar, India: Theosophical Publishing House, 1919), p. 206.

93. Leadbeater, *Man Visible and Invisible,* p. 60.

94. Blavatsky, *The Secret Doctrine,* vol. 1, p. 97.

95. Ibid., vol. 1, p. 201.

96. Ibid., vol. 2, p. 588 (note).

97. Ibid., vol. 1, p. 64.

98. Ibid., vol. 1, p. 531.

99. Johann Eckermann, *Conversations with Goethe,* trans. S. M. Fuller (Boston: Hilliard Gray and Co., 1839), p. 212.

100. *The Secret Doctrine,* vol. 1, p. 64.

101. Bruce Weber, curator of the Norton Gallery of Art, which owns this painting, wrote me in a letter of December 20, 1984, that he disagrees with this interpretation and does not see a snake or a serpentine form within the egg shape. Because Dove's imagery is never literal, vacillating as it does between natural fact and abstract form, it will, like much of the art of his contemporaries, provoke multiple readings.

102. *The Secret Doctrine,* vol. 1, p. 65.

103. Charles Brooks, the son of Van Wyck Brooks and a good friend of Dove's, writes interestingly of Dove the man and this painting in his *Sensory Awareness* (New York: Viking Press, 1974), p. 219.

104. For the impact of Freudian thought in America, see Frederic Hoffmann, *Freud and the Literary Mind* (Boston: Houghton Mifflin, 1955); Henry May, *The End of American Innocence* (New York: Knopf, 1959), pp. 233-36; and Benjamin Nelson, ed., *Freud and the Twentieth Century* (New York: Meridian Books, 1958).

105. For the importance of Freud to Stieglitz, see Lowe, p. 211.

106. Malcolm Cowley, *After the Genteel Tradition* (Gloucester, Massachusetts: Peter Smith, 1957), pp. 214-16.

107. Frederick Wight, p. 68.

108. Cowley, p. 215.

Chapter 4

1. H. S. M. Coxeter, *The Real Projective Plane* (New York: Blaisdell Publishing Co., 1946), p. 9. Serving as an important precedent, the connection between the new geometries, art, and mystical thought had been established during the days of 291 by some of Dove's colleagues, Max Weber and Benjamin de Casseres, who were probably influenced by the writings of the French mathematician, Henri Poincaré. Poincaré, who was responsible for the popularizing of non-Euclidean geometry, was highly regarded in this country and was introduced to the Stieglitz circle by the Picabias in 1912. See Henderson, pp. 167-82.

2. Bragdon, *Old Lamps for New*, p. 109.

3. Ibid., p. 110.

4. Respectively, letter to Stieglitz, August 15, 1924; Helen Dove diaries, February 20, 1938, where she describes Dove's new work.

5. Arthur Dove diaries, respectively: July 29, 1941; May 4, 1942; July 30, 1942; February 2, 1944; July 22, 1944; and January 1, 1944.

6. Haskell, appendix, p. 135.

7. Dove's writings.

8. Letter to Stieglitz, July 25, 1930.

9. Arthur Dove diaries, February 28, 1942 and November 16, 1943.

10. Henry Parker Manning, *A Geometry of Four Dimensions* (New York: Macmillan Company, 1914), p. 18.

11. As discussed in chapter 2, the diaries indicate that Dove purchased "Russell's interpretation of relativity" on February 5, 1929. By this date, Russell had written two expositions of Einstein's theory—*The Analysis of Matter*, published in 1927, and *The ABC of Relativity*, published in 1925. The illustration of topological space is in *The Analysis of Matter*.

12. Dove's writings.

Chapter 5

1. Alfred Werner, *Max Weber* (New York: Abrams, 1978), p. 33.

2. From *The Seven Arts* (November 1916), p. 52, cited in Arthur Wertheim, *New York's Little Renaissance* (New York: New York University Press, 1976), p. 178.

3. Eddy, p. 48.

4. George Cram Cook, *Chicago Evening Post Literary Review,* March 29, 1912, quoted in Homer, "Identifying Arthur Dove's *The Ten Commandments,*" p. 24.

5. Meyer Schapiro, "The Armory Show," *Modern Art* (London: Chatto and Windus, 1978), pp. 135-78.

6. Judith Zilczer, "The Armory Show and the American Avant-Garde: A Re-evaluation," *Arts Magazine,* vol. 53 (September 1978), pp. 126-30.

7. John White Alexander, "Is Our Art American?" *Century Magazine,* vol. 87 (April 1914), 826-36.

8. Milton W. Brown, *American Painting from the Armory Show to the Depression* (Princeton: Princeton University Press, 1955); Arthur Wertheim, pp. 167-87.

9. William Rasmussen, "The Forum Exhibition," in William Homer, ed., *Avant-Garde Painting and Sculpture in America, 1910-1925* (Wilmington: Delaware Art Museum, April 4-May 18, 1975), pp. 24-25.

10. Wertheim, pp. 163-83.

11. Wanda Corn, "Apostles of the New American Art: Waldo Frank and Paul Rosenfeld," *Arts Magazine,* vol. 54 (February 1980), pp. 159-63.

12. Van Wyck Brooks, *The Days of the Phoenix: The 1920s I Remember* (New York: E. P. Dutton, 1957), p. 2.

13. Wertheim, p. 178.

14. Dove's writings.

15. Ibid.

16. Patrick Stewart and Gilbert Vincent, "Changing Patterns in the American Avant-Garde, 1917-25," in William Homer, ed., *Avant-Garde Painting and Sculpture in America, 1910-1925,* pp. 27-28.

17. Quoted in Bram Dijkstra, *Hieroglyphics of a New Speech* (Princeton: Princeton University Press, 1969), p. 94, from "Ten Stories," *Twice a Year,* vol. 5-6 (1940-41), pp. 135-63.

18. This brochure is illustrated in Dorothy Norman, *Alfred Stieglitz: An American Seer* (New York: Random House, 1973), p. 169.

19. The importance of locale to these artists is discussed by Dickran Tashjian, *William Carlos Williams and the American Scene, 1920-40* (Berkeley: Whitney Museum of American Art in Association with the University of California Press, 1978), p. 98.

20. Dove's writings.

21. This comparison was noted by Charles Child Eldredge, III, "Georgia O'Keeffe: The Development of an American Modern" (Ph.D. dissertation, University of Minnesota, 1971), p. 133.

22. This story was recounted by Samuel Swift in *The New York Sun* and was reprinted in *Camera Work* (April-July 1913), pp. 48-49.

23. Dove's relation to New York Dada is discussed by Dickran Tashjian, *Skyscraper Primitives* (Middletown, Connecticut: Wesleyan University Press, 1975), pp. 198-202; William Agee, "New York Dada, 1910-30," in Thomas Hess and John Ashberry, eds., *Avant-Garde Art*, pp. 125-54; and Morgan, p. 51.

24. Dove's assemblages have been variously accounted for. In Dorothy Rylander Johnson, *Arthur Dove: The Years of Collage* (College Park, Maryland: University of Maryland, 1967), they are connected to the contemporary interest in folk art. Haskell, p. 55, denies this relationship and relates them to the "portraits" of Picabia and Gertrude Stein. Tashjian and Agee view them in the context of Dada, while Morgan, p. 51, stresses their "originality," stating that as Dove "borrowed ideas, he transformed them." Newman, p. 44, cites the important precedent of the folk art which was published in *Der Blaue Reiter* almanac. All of these explanations serve to emphasize the diversity of Dove's artistic situation.

25. Ian Quimby and Scott Swank, *Perspectives on Folk Art* (New York: Norton & Co., 1980), pp. 16-21.

26. This essay was first published in *Art and Archaeology* in 1919 and was reprinted in Hartley's *Adventures in the Arts* (New York: Boni and Liveright, 1921), a copy of which was sent to Dove by Stieglitz. See p. 27 for the quotation.

27. This relationship is mentioned by Wight, p. 76 and Newman, p. 44.

28. Kandinsky, *Concerning the Spiritual in Art*, p. 13.

29. Sixten Ringbom, "Art in 'The Epoch of the Great Spiritual,'" *Journal of the Warburg and Courtauld Institute*, vol. 29 (1966), pp. 386-418; and also Rose-Carol Washton Long, pp. 13-51.

30. Long, pp. 15-16 and 41.

31. Kandinsky, *Concerning the Spiritual in Art*, p. 52. For a fuller discussion of the changing relation between art and nature in Kandinsky's theory, see Beeke Sell Tower, *Klee and Kandinsky in Munich and at the Bauhaus* (Ann Arbor: UMI Research Press, 1981), pp. 164-75.

32. Dove's writings.

33. For a discussion of this aspect of Klee's art, see Dore Ashton, "Klee and Goethe: The Organic Imagination," *A Reading of Modern Art* (Cleveland: Press of Case Western Reserve University, 1969), pp. 45-53. See also Sixten Ringbom, "Paul Klee and the Inner Truth to Nature," *Arts Magazine*, vol. 52 (September 1977), pp. 112-17.

34. Klee's art was exhibited in a group show at the Société Anonyme in 1921 and in a one-man show in 1924. Klee also was a participant in "The Blue Four" at the Daniel Gallery in 1925 and the subject of a retrospective exhibition at the Museum of Modern Art in 1930.

35. Ashton, pp. 46-50.

36. Quoted in Werner Haftmann, *The Mind and Art of Paul Klee* (New York: Praeger, 1967), p. 117.

37. Jeffrey Weshsler, *Surrealism and American Art* (New Brunswick, New Jersey: Rutgers University Press, 1976). Morgan, p. 53, briefly discusses Dove's relation to this movement.

38. Julien Lévy, *Memoirs of an Art Gallery* (New York: G.P. Putnam's Sons, 1977), passim.

39. Another somewhat different slant on this idea is in Robert P. Metzger, "Biomorphism in American Painting" (Ph.D. dissertation, University of California at Los Angeles, 1973).

40. Dove's writings.

Chapter 6

1. Arthur Dove diaries, respectively: July 5, 1943; May 19, 1942; and January 23, 1940.

2. Ibid., December 17, 1942. The list is entitled "Names for Pure Paintings."

3. Ibid., respectively: June 28, 1943; June 11, 1942; and February 27, 1942.

4. William Gass, "The Artist and Society," *Fiction and the Figures of Life* (Boston: Nonpareil Books, 1971), p. 280.

5. For example, Meyer Schapiro, "The Armory Show," *Modern Art* (London: Chatto and Windus, 1978), p. 152.

Bibliography

Arthur Dove Monographs

Haskell, Barbara. *Arthur Dove.* San Francisco: San Francisco Museum of Art, distributed by New York Graphic Society, Boston, 1974.
Johnson, Dorothy Rylander. *Arthur Dove: The Years of Collage.* College Park, Maryland: University of Maryland, 1967.
Morgan, Ann Lee. *Arthur Dove: Life & Work: A Catalogue Raisonné.* Newark: University of Delaware Press, 1984.
Newman, Sasha. *Arthur Dove and Duncan Phillips: Artist and Patron.* New York: Braziller, 1981.
Solomon, Alan. *Arthur G. Dove.* Ithaca, New York: Cornell University Press, 1954.
Wight, Frederick. *Arthur Dove.* Berkeley: University of California Press, 1958.

Books and Catalogues

Abrams, Meyer. *The Mirror and the Lamp: Romantic Theory and the Critical Tradition.* Oxford: Oxford University Press, 1953.
_____. *Natural Supernaturalism.* New York: W. W. Norton & Co., 1971.
Ashton, Dore. *A Reading of Modern Art.* Cleveland: Press of Case Western Reserve University, 1969.
_____. *The Unknown Shore.* Boston: Little, Brown & Co., 1962.
Balakian, Anna. *The Symbolist Movement.* New York: New York University Press, 1977.
Besant, Annie. *A Study in Consciousness.* Adyar, India: Theosophical Publishing House, 1954 (1st ed. 1904).
_____. *Thought-Power.* Los Angeles: Theosophical House, 1918.
Besant, Annie and Leadbeater, C. W. *Thought-Forms.* London: The Theosophical Publishing Society, 1901.
Best-Maugard, Adolph. *A Method for Creative Design.* New York: Knopf, 1926.
Blavatsky, Helena P. *Key to Theosophy.* London: The Theosophical Publishing Society, 1893.
_____. *Isis Unveiled.* 2 vols. Pasadena: Theosophical University Press, 1950.
_____. *The Secret Doctrine.* 2 vols. Pasadena: Theosophical University Press, 1952.
Bohan, Ruth. *The Société Anonyme's Brooklyn Exhibition: Katherine Dreier and Modernism in America.* Ann Arbor: UMI Research Press, 1982.
Bragdon, Claude. *Beautiful Necessity.* Rochester, New York: The Manas Press, 1910.
_____. *A Primer of Higher Space: The Fourth Dimension, to which is added, Man the Square, A Higher Space Parable.* New York: Knopf, 1923 (1st ed. 1911).
_____. *Four-Dimensional Vistas.* New York: Knopf, 1916.

_____. *Old Lamps for New.* New York: Knopf, 1925.

_____. *The New Image.* New York: Knopf, 1928.

_____. *The Eternal Poles.* New York: Knopf, 1931.

_____. *The Frozen Fountain.* Freeport, New York: Books for Libraries Press, 1970 (1st ed. 1932).

_____. *More Lives than One.* New York: Knopf, 1938.

Brooks, Charles. *Sensory Awareness.* New York: Viking Press, 1974.

Brooks, Van Wyck. *The Wine of the Puritans.* New York: Mitchell Kennerly, 1909.

_____. *The Days of the Phoenix: The 1920s I Remember.* New York: E. P. Dutton, 1957.

Brown, Milton W. *American Painting from the Armory Show to the Depression.* Princeton: Princeton University Press, 1955.

Camfield, William. *La Section d'Or.* New Haven: Yale University Press, 1961.

_____. *Picabia.* Princeton: Princeton University Press, 1979.

Campbell, Bruce. *Ancient Wisdom Revised: A History of the Theosophical Movement in America.* Berkeley: University of California, 1980.

Cheney, Sheldon. *Expressionism in Art.* New York: Liveright Publishing Corp., 1934.

Chiari, Joseph. *Symbolism from Poe to Mallarmé.* London: Rockcliff, 1956.

Chisolm, Lawrence. *Fenollosa; the Far East and American Culture.* New Haven: Yale University Press, 1963.

Christy, Arthur. *The Orient in American Transcendentalism.* New York: John Day, 1945.

Church, A. H. *On the Interpretation of Phenomena of Phyllotaxis.* New York: Hafner Publishing Co., 1968.

Collingwood, R. G. *The Idea of Nature.* Oxford: The Clarendon Press, 1949.

Colman, Samuel. *Nature's Harmonic Unity.* New York: G. P. Putnam's Sons, 1912.

_____. *Proportional Form.* New York: G. P. Putnam's Sons, 1920.

Cook, Sir Theodore Andrew. *Spirals in Nature and Art.* New York: E. P. Dutton & Co., 1903.

_____. *The Curves of Life.* New York: H. Holt and Co., 1914.

Cowley, Malcolm. *After the Genteel Tradition.* Gloucester, Massachusetts: Peter Smith, 1957.

Coxeter, H. S. M. *The Real Projective Plane.* New York: Blaisdell Publishing Co., 1946.

Darwin, C. G. *New Conceptions of Matter.* New York: Macmillan, 1931.

Dijkstra, Bram. *The Hieroglyphics of a New Speech: Cubism, Stieglitz and the Early Poetry of William Carlos Williams.* Princeton: Princeton University Press, 1969.

Eckermann, Johann. *Conversations with Goethe.* Trans. by S. M. Fuller. Boston: Hilliard, Grey and Co., 1839.

Eddington, Arthur. *The Nature of the Physical World.* New York: Macmillan, 1948 (1st ed. 1927).

Eddy, Arthur Jerome. *Cubists and Post-Impressionism.* Chicago: A. C. McClurg and Company, 1914.

Einstein, Albert. *The Meaning of Relativity.* Princeton: Princeton University Press, 1953.

Eldredge, Charles. *The American Imagination and Symbolist Painting.* New York: New York University Press, 1979.

Ellis, Havelock. *The Dance of Life.* Boston: Houghton Mifflin, 1923.

Ellwood, Robert. *Religious and Spiritual Groups in Modern America.* Englewood, New Jersey: Prentice Hall, 1973.

Esau, Katherine. *Anatomy of Seed-Plants.* New York: John Wiley & Sons, 1960.

Filon, L. *Introduction to Projective Geometry.* New York: Arnold & Co., 1921.

Frank, Waldo. *Our America.* New York: Boni and Liveright, 1919.

Frank, Waldo; Mumford, Lewis; Norman, Dorothy; Rosenfeld, Paul; and Rugg, Harold. *America and Alfred Stieglitz: A Collective Portrait.* New York: Doubleday, Doran and Company, 1934.

Gass, William. *Fiction and the Figures of Life.* Boston: Non-pareil Books, 1971.

Geelhar, Christian. *Paul Klee and the Bauhaus.* Greenwich, Connecticut: New York Graphic Society, Ltd., 1973.

Ghyka, Matila. *The Geometry of Art and Life*. New York: Sheed and Ward, 1946.

Goodrich, Lloyd and Bry, Doris. *Georgia O'Keeffe*. New York: Whitney Museum of American Art, 1970.

Green, Jonathan, ed. *Camera Work: A Critical Anthology*. Millerton, New York: Aperture, 1973.

Grohmann, Will. *Paul Klee*. New York: Abrams, 1954.

_____. *Wassily Kandinsky*. New York: Abrams, 1958.

Haeckel, Ernst. *Kunstformen der Natur*. Leipzig and Wien: Verlag des Bibliographischen Instituts, 1904.

_____. *The Wonders of Life*. New York: Harper and Brothers, 1905.

Haftmann, Werner. *The Mind and Art of Paul Klee*. New York: Praeger, 1967.

Hambidge, Jay. *The Diagonal*. New Haven: Yale University Press, 1920.

Hartley, Marsden. *Adventures in the Arts*. New York: Boni and Liveright, 1921.

Henderson, Linda Dalrymple. *The Fourth Dimension and Non-Euclidean Geometry in Modern Art*. Princeton: Princeton University Press, 1983.

Hess, Thomas and Ashberry, John, eds. *Avant-Garde Art*. New York: Macmillan, 1968.

Hoffmann, Frederic. *Freud and the Literary Mind*. Boston: Houghton Mifflin, 1955.

Hofstadter, Richard. *Anti-Intellectualism in American Life*. New York: Knopf, 1963.

Hollander, A. N. J. *Diverging Parallels: A Comparison of European Thought and Action*. Leiden: E. J. Brill, 1971.

Homer, William Inness, ed. *Avant-Garde Painting and Sculpture in America 1910-1925*. Wilmington: Delaware Art Museum, 1975.

_____. *Alfred Stieglitz and the American Avant-Garde*. Boston: New York Graphic Society, 1977.

Jammer, Max. *Concepts of Space*. Cambridge: Harvard University Press, 1954.

Jeans, James. *The New Background of Science*. New York: Macmillan, 1933.

Josephson, Matthew. *Life Among the Surrealists*. New York: Holt, Rinehart & Winston, 1962.

Kandinsky, Wassily. *Concerning the Spiritual in Art*. New York: Dover Publications, 1977 (1st ed. 1912).

_____. *Point and Line to Plane*. New York: Dover Publications, 1979 (1st ed. 1926).

Kazin, Alfred. *On Native Grounds*. New York: Reynal and Hitchcock, 1942.

Kermode, Frank. *The Romantic Image*. New York: Macmillan, 1957.

Kootz, Samuel. *Modern American Painting*. New York: Brewer and Warren, 1930.

Leadbeater, Charles Webster. *Man Visible and Invisible*. Adyar, India: Theosophical Publishing House, 1903.

_____. *The Hidden Side of Things*. Adyar, India: Theosophical Publishing House, 1919 (2nd ed.).

Lehmann, A. G. *The Symbolist Aesthetic in France*. Oxford: Basil Blackwell, 1968.

Levi, William Albert. *Philosophy and the Modern World*. Bloomington: Indiana University Press, 1959.

Lévy, Julien. *Memoir of an Art Gallery*. New York: G. P. Putnam's Sons, 1977.

Lipman, Jean and Winchester, Alice. *The Flowering of American Folk Art 1776-1876*. New York: Viking Press, 1974.

Long, Rose-Carol Washton. *Kandinsky: The Development of an Abstract Style*. Oxford: Clarendon Press, 1980.

Lowe, David A. *Practical Geometry and Graphics*. London, New York: Longmans, Green & Co., 1912.

Lukach, Joan M. *Hilla Rebay: In Search of the Spirit in Art*. New York: Braziller, 1983.

Manning, Henry Parker. *The Fourth Dimension Simply Explained*. New York: Dover Publications, 1960 (1st ed. 1910).

_____. *A Geometry of Four Dimensions*. New York: Macmillan, 1914.

Martin, Marianne. *Futurist Art*. Oxford: Clarendon Press, 1968.

Marx, Leo. *The Machine in the Garden.* London: Oxford University Press, 1964.

May, Henry Farnham. *The End of American Innocence: A Study of the First Years of Our Time, 1912-17.* New York: Knopf, 1959.

McCausland, Elizabeth. *Alfred Maurer.* New York: A. A. Wyn, Inc., 1951.

McCoubrey, John. *The American Tradition in Painting.* New York: Braziller, 1963.

Mellquist, Jerome. *The Emergence of an American Art.* New York: Charles Scribner's Sons, 1942.

Moore, R. Laurence. *In Search of White Crows.* New York: Oxford University Press, 1977.

Needham, Joseph, ed. *Science, Religion and Reality.* New York: Macmillan, 1925.

Nelson, Benjamin, ed. *Freud and the Twentieth Century.* New York: Meridian Books, 1958.

Nelson, Raymond. *Kenneth Patchen and American Mysticism.* Chapel Hill: University of North Carolina Press, 1984.

Nicolson, Marjorie. *The Breaking of the Circle.* New York: Columbia University Press, 1960.

Norman, Dorothy. *Alfred Stieglitz: An American Seer.* New York: Random House, 1973.

Novak, Barbara. *American Painting of the Nineteenth Century.* New York: Praeger, 1969.

———. *Nature and Culture.* New York: Oxford University Press, 1980.

Ouspensky, P. D. *Tertium Organum.* New York: Vintage Books, 1970 (1st ed. in English 1920).

———. *A New Model of the Universe.* New York: Knopf, 1969 (1st ed. 1931).

Pettigrew, J. Bell. *Design in Nature.* New York: Longmans, Green & Co., 1908.

Pierrot, Jean. *Le Rêve, de Milton aux Surréalistes.* Paris: Bordes, 1972.

Powell, Arthur E. *The Mental Body.* London: The Theosophical Publishing House, 1956 (1st ed. 1927).

Quimby, Ian and Swank, Scott. *Perspectives on Folk Art.* New York: Norton & Co., 1980.

Raymond, Marcel. *From Baudelaire to Surrealism.* London: Peter Owen, 1933.

Ringbom, Sixten. *The Sounding Cosmos: A Study in the Spiritualism of Kandinsky and the Genesis of Abstract Painting.* Vol. 38, No. 2. Abo, Finland: Abo Akademi, 1970.

Ritterbush, Philip. *The Art of Organic Forms.* Washington, D.C.: Smithsonian Institution, 1968.

Rolland, Romain. *Prophets of a New India.* New York: Albert and Charles Boni, 1930.

Rosenblum, Robert. *Modern Painting and the Northern Romantic Tradition: Friedrich to Rothko.* New York: Harper & Row, 1975.

Rosenfeld, Paul. *Port of New York.* Urbana and London: University of Illinois Press, 1966.

Rotzler, Willy. *Constructivist Concepts: A History of Constructivist Art.* New York: Rizzoli, 1977.

Rougier, Louis. *Philosophy and the New Physics.* Philadelphia: P. Blakiston's Son and Co., 1921.

Russell, Bertrand. *The ABC of Relativity.* London: George Hillen and Unwin, Ltd., 1958 (1st ed. 1925).

———. *The Analysis of Matter.* New York: Harcourt, Brace & Co., 1927.

Schapiro, Meyer. *Modern Art.* London: Chatto and Windus, 1978.

Schmutzler, F. *Art Nouveau.* New York: Abrams, 1968.

Scholem, Gershom. *On the Kabbalah and its Symbolism.* New York: Schocken Books, 1965.

Scott, Nathan. *The Broken Circle.* New Haven: Yale University Press, 1966.

Seidenberg, A. *Lectures in Projective Geometry.* Princeton: D. Van Nostrand Co., Inc., 1962.

Seligmann, Herbert. *Alfred Stieglitz Talking: Notes on Some of his Conversations, 1925-31.* New Haven: Yale University Press, 1966.

Sérusier, Paul. *ABC de la peinture.* Paris: Librairie Floury, 1942.

Smith, David Eugene. *A Source Book of Mathematics.* New York: McGraw-Hill, 1929.

Spiller, Jurg. *Paul Klee: The Thinking Eye.* London: Lund Humphries, 1961.

Steinmetz, Charles Proteus. *Four Lectures on Relativity and Space.* New York: McGraw-Hill, 1923.

Sullivan, J. W. N. *The Bases of Modern Science.* New York: Doubleday, 1929.

Tashjian, Dickran. *Skyscraper Primitives: Dada and the American Avant-Garde, 1910-25.* Middletown, Connecticut: Wesleyan University Press, 1975.

_____. *William Carlos Williams and the American Scene, 1920-40.* Berkeley: Whitney Museum of American Art in Association with the University of California Press, 1978.

Thompson, D'Arcy. *Growth and Form.* New York: Macmillan, 1942 (1st ed. 1917).

Thomson, J. Arthur. *Science and Religion.* New York: Scribner's, 1925.

Tischner, Rudolf. *Telepathy and Clairvoyance.* New York: Harcourt & Brace, 1925.

Tower, Beeke Sell. *Klee and Kandinsky in Munich and at the Bauhaus.* Ann Arbor: UMI Research Press, 1981.

Trachtenberg, Alan, ed. *Critics of Culture.* New York: John Wiley and Sons, Inc., 1976.

Veblen, Oswald and Young, John Wesley. *Projective Geometry.* New York: Gunn & Co., 1938.

Wechsler, Jeffrey. *Surrealism and American Art.* New Brunswick, New Jersey: Rutgers University Press, 1976.

Weiss, John, ed. *The Origins of Modern Consciousness.* Detroit: Wayne State University Press, 1965.

Werner, Alfred. *Max Weber.* New York: Abrams, 1978.

Wertheim, Arthur. *New York's Little Renaissance.* New York: New York University Press, 1976.

West, Richard. *Painters of the Section d'Or; or The Alternatives to Cubism.* Buffalo: Albright Knox Gallery, 1967.

Wherry, George. *Notes On a Knapsack.* Cambridge: Bowes and Bowes, 1909.

White, Morton and White, Lucia. *The Intellectual Versus the City.* Cambridge: Harvard University Press, 1962.

Whyte, Lancelot Law, ed. *Aspects of Form: A Symposium on Form in Nature and Art.* Bloomington: Indiana University Press, 1966.

Williams, Robert C. *Artists in Revolution: Portraits of the Russian Avant-Garde 1910-1925.* Bloomington and London: Indiana University Press, 1977.

Wright, Willard Huntington. *Modern Painting: Its Tendency and Meaning.* New York: John Lane Co., 1915.

Yale University Art Gallery, Collection of the Société Anonyme: Museum of Modern Art 1920. New Haven: Yale University Art Gallery, 1950.

Articles

Aisen, Maurice. "The Latest Evolution in Art and Picabia," *Camera Work* (November 1913), 14-21.

Alexander, John White. "Is Our Art American?" *Century,* Vol. 87 (April 1914), 826-36.

"Auras: Fact or Fancy," *Scientific American,* Vol. 146 (May 1932), 303-4.

Barry, Roxanna. "The Age of Blood and Iron: Marsden Hartley in Berlin," *Arts,* Vol. 54 (October 1980), 166-71.

Bickerstaffe, I. "Some Principles of Growth and Beauty," *Field* (December 1912).

Bohn, Willard. "In Pursuit of the Fourth Dimension: Guillaume Apollinaire and Max Weber," *Arts,* Vol. 54 (June 1980), 166-69.

Caffin, Charles. "Of Verities and Illusions," *Camera Work* (October 1905).

_____. "The New Thought which is Old," *Camera Work* (July 1910), 21-24.

_____. "A Note on Paul Cézanne," *Camera Work* (April 1911).

Camfield, William. "Juan Gris and the Golden Section," *Art Bulletin,* Vol. 47 (March 1965), 128-34.

Corn, Wanda. "Apostles of the New American Art: Waldo Frank and Paul Rosenfeld," *Arts,* Vol. 54 (February 1980), 159-63.

De Zayas, Marius. "The Evolution of Form," *Camera Work* (January 1913).

_____. "Modern Art Theories and Representations," *Camera Work* (October 1913), 44.

_____. "How, When and Why Modern Art Came to America," *Arts,* Vol. 54 (April 1980), 96-126.

Egbert, Donald Drew. "Organic Expression in American Architecture," *Evolutionary Thought in America.* Edited by Stow Persons. New Haven: Yale University Press, 1955, pp. 355-96.

Frank, Waldo. "Seriousness and Dada," *1924,* No. 3 (September 1924), 70-73.

Goldwater, Robert. "Arthur Dove," *Perspectives,* No. 2 (Winter 1973), 78-88.

Gombrich, E. H. "Iconae Symbolicae: The Neo-Platonic Tradition in Art," *Journal of the Warburg and Courtauld Institute,* Vol. 11 (1948), 163-92.

Gould, Stephen Jay. "D'Arcy Wentworth Thompson and the Science of Form," *New Literary History* (Winter 1971), 229-59.

Haines, Robert E. "Alfred Stieglitz and the New Order of Consciousness in American Literature," *Pacific Coast Philology* (April 1971), 26-34.

Hartmann, Sadakichi. "Structural Units," *Camera Work* (October 1911).

Haskell, Barbara. "Arthur G. Dove, 1880-1946," *American Art Review,* Vol. 2 (January-February 1975), 130-43.

Heisenberg, Werner. "The Representation of Nature in Contemporary Physics," *Symbolism in Religion and Literature.* Edited by Rollo May. New York: Braziller, 1960.

Henderson, Linda. "A New Facet of Cubism: 'The Fourth Dimension' and 'Non-Euclidean Geometry' Reinterpreted," *The Art Quarterly,* Vol. 34 (Winter 1971), 410-33.

_____. "Italian Futurism and 'The Fourth Dimension,'" *Art Journal,* Vol. 41 (Winter 1981).

Henry, Sara Lynn. "Form-Creating Energies: Paul Klee and Physics," *Arts,* Vol. 52 (September 1977), 118-21.

Higham, John. "The Re-Orientation of American Thought in the 1890s," *Origins of Modern Consciousness.* Edited by John Weiss. Detroit: Wayne State University Press, 1965, pp. 25-48.

Homer, William Inness. "Identifying Arthur Dove's *The Ten Commandments,*" *The American Art Journal,* Vol. 12 (Summer 1980), 21-32.

Hopkins, A.A. "The Human Atmosphere," *Scientific American,* Vol. 125 (March 1921), 126.

"How to Construct an Egg Shaped Oval," *Scientific American,* Vol. 70 (July 30, 1910), 69.

Jordan, Jim. "Arthur Dove and the Nature of the Image," *Arts Magazine,* Vol. 50 (February 1976), 89-91.

Kagan, Andrew. "Representation, Abstraction and the Absolute in Art," *Arts,* Vol. 52 (November 1977), 136-40.

Kramer, Hilton. "The World of Arthur Dove," *The Age of the Avant-Garde.* New York: Farrar, Straus & Giroux, 1973, pp. 278-81.

Kuspit, Donald. "Delaunay's Rationale for *Peinture Pure,* 1909-1915," *Art Journal,* Vol. 34 (Winter 1974-75), 108-14.

Lancaster, Clay. "Synthesis: The Artistic Theory of Fenollosa and Dow," *Art Journal,* Vol. 28 (Spring 1969), 286-87.

Levi, William. "The Concept of Nature," *The Origins of Modern Consciousness.* Edited by John Weiss. Detroit: Wayne State University Press, 1965.

Levin, Sandra Gail. "Hidden Symbolism in Marsden Hartley's Military Pictures," *Arts,* Vol. 54 (October 1979), 154-58.

Long, Rose-Carol Washton. "Kandinsky's Hidden Imagery," *Art Forum,* Vol. 10 (June 1972), 42-49.

Martin, Marianne W. "Some American Contributions to Early Twentieth Century Abstraction," *Arts,* Vol. 54 (June 1980), 158-65.

"Mathematics and Engineering in Nature," *Popular Science Monthly,* Vol. 79 (November 1911), 450-58.

Mauner, George. "The Nature of Nabi Symbolism," *Art Journal,* Vol. 23 (Winter 1963-64), 96-103.

McCausland, Elizabeth. "Dove: Man and Painter," *Parnassus,* Vol. 9 (December 1973), 3-6.

Pach, Walter. "The Point of View of the Moderns," *Century Magazine* (November 1913), 863-64.

Phillips, Duncan. "Arthur G. Dove, 1880-1946," *Magazine of Art,* Vol. 40 (May 1947), 192-97.

Rasmussen, William. "The Forum Exhibition," *Avant-Garde Painting and Sculpture in America, 1910-1925.* Edited by William Homer. Wilmington: Delaware Art Museum, 1975.

Ringbom, Sixten. "Art in 'The Epoch of the Great Spiritual,'" *Journal of the Warburg and Courtauld Institute,* Vol. 29 (1966), 386-418.

_____. "Paul Klee and the Inner Truth to Nature," *Arts,* Vol. 52 (September 1977), 112-17.

Risatti, Howard. "Music and the Development of Abstraction in America," *Art Journal,* Vol. 39 (Fall 1979), 8-13.

Rosenfeld, Paul. "American Painting," *The Dial,* Vol. 71 (December 1921), 649-70.

_____. "The World of Arthur G. Dove," *Creative Art,* Vol. 10 (June 1932), 426-30.

Scott, Gail R. "Marsden Hartley at Dogtown Common," *Arts,* Vol. 55 (October 1980), 159-65.

Stewart, Patrick and Vincent, Gilbert. "Changing Patterns in the American Avant-Garde, 1917-25," *Avant-Garde Painting and Sculpture in America, 1910-1925.* Edited by William Homer. Wilmington: Delaware Art Museum, 1975.

Tanner, Tony. "Notes for a Comparison Between American and European Romanticism," *Diverging Parallels.* Leiden: E. J. Brill, 1971.

Thompson, D'Arcy. "On the Shape of Eggs and the Force which Determines Them," *Nature,* Vol. 85 (1908), 111.

_____. "Magnalia Naturae: Or the Greater Problem of Biology," *Nature,* Vol. 87 (October 1911), 324.

Tindall, William York. "Transcendentalism in Contemporary Literature," *The Orient in American Transcendentalism.* Edited by Arthur Christy. New York: Octagon Books, 1963.

Weber, Max. "The Fourth Dimension from a Plastic Point of View," *Camera Work* (July 1910), 25.

Weichsel, John. "Cosmism or Amorphism," *Camera Work* (November 1913), 69-82.

Weiss, Paul. "Beauty and the Beast: Life and the Rule of Order," *Scientific Monthly,* Vol. 81 (December 1955), 286-99.

_____. "Organic Form: Scientific and Aesthetic Aspects," *Daedalus* (Winter 1960), 177-90.

Welsh, Robert. "Mondrian and Theosophy," *Piet Mondrian 1872-1944, Centennial Exhibition.* New York: The Solomon R. Guggenheim Museum, 1971.

Wittkower, Rudolph. "The Changing Concept of Proportion," *Daedalus* (Winter 1960), 199-215.

Zilczer, Judith. "The Armory Show and the American Avant-Garde: A Re-evaluation," *Arts Magazine,* Vol. 53 (September 1978), 126-30.

Unpublished Sources

Diaries of Arthur Dove. Archives of American Art. Microfilm Roll No. 70-52, 725.

Diaries of Helen Torr Dove. Archives of American Art. Microfilm Roll No. 38-40.

Collected Writings of Arthur Dove. Archives of American Art (not yet microfilmed).

Arthur Dove's Card Catalogue. Archives of American Art. Microfilm Roll No. 2803.

Arthur Dove/Duncan Phillips Correspondence. The Phillips Collection, Archives.

Arthur Dove/Alfred Stieglitz Correspondence. The Beinecke Rare Book and Manuscript Library. Yale University.

Elizabeth McCausland Papers. Archives of American Art. Microfilm Roll No. D384B.

Smith, Suzanne Mullet. The Card Catalogues of Arthur Dove. Archives of American Art. Microfilm Roll No. 1043.

Dissertations and Theses

Eldredge, Charles Child, III. "Georgia O'Keeffe: The Development of an American Modern." Ph.D. dissertation, University of Minnesota, 1971.

Henderson, Linda. "The Artist, 'The Fourth Dimension' and Non-Euclidean Geometry 1900-1930; A Romance of Many Dimensions." Ph.D. dissertation, Yale University, 1975.

Ketchiff, Nancy. "The Invisible Made Visible: Sound Imagery in the Early Watercolors of Charles Burchfield." Ph.D. dissertation, University of North Carolina at Chapel Hill, 1977.

Levin, Sandra Gail. "Wassily Kandinsky and the American Avant-Garde 1912-50." Ph.D. dissertation, Rutgers University, 1976.

Metzger, Robert P. "Biomorphism in American Painting." Ph.D. dissertation, University of California at Los Angeles, 1973.

Morgan, Ann Lee. "Toward the Definition of Early Modernism in America: A Study of Arthur Dove." Ph.D. dissertation, The University of Iowa, 1973.

Mullett, Suzanne. "Arthur Dove." M.A. thesis, The American University, 1944.

Risatti, Howard. "American Critical Reaction to European Modernism 1908-1917." Ph.D. dissertation, University of Illinois, 1978.

Sihare, Laxni P. "Oriental Influences on Kandinsky and Mondrian." Ph.D. dissertation, New York University, 1967.

Szekely, Gillian M. Hill. "The Beginning of Abstraction in America: Art and Theory in the Stieglitz Circle." Ph.D. dissertation, University of Edinburgh, 1971.

Zilczer, Judith Kay. "The Aesthetic Struggle in America 1913-18: Abstract Art and Theory in the Stieglitz Circle." Ph.D. dissertation, University of Delaware, 1975.

Subject Index

Index of Names

Index of Dove's Paintings